The Christian Year
in Painting

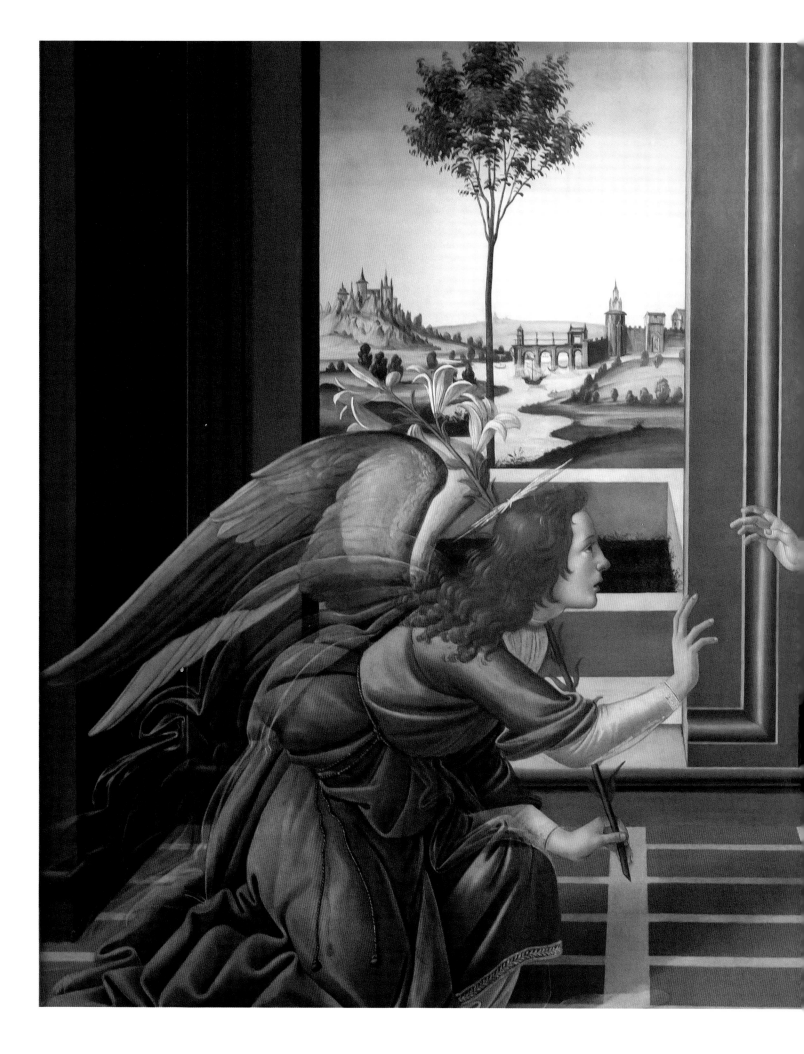

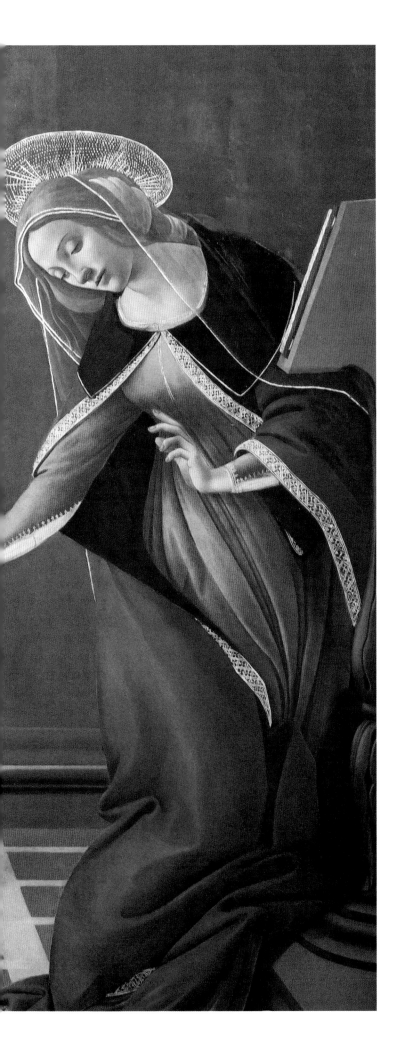

The Christian Year
in Painting

John S. Dixon

ART/BOOKS

CONTENTS

 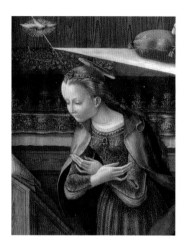

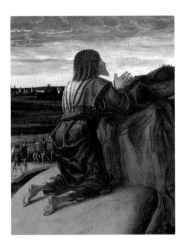

HOLY WEEK AND EASTERTIDE

ORDINARY TIME

INTRODUCTION

All societies try, at some level, to come to terms with the mysteries of the human situation. Often they have employed the visual arts as a means to do so in the most immediate and direct of ways. For the last two thousand years, Christianity has provided the dominant world view in Europe, and much great art has been dedicated to its service. If one were to walk through the rooms of the world's major art museums – such as the Prado in Madrid, the Louvre in Paris, the Uffizi in Florence, the National Gallery in London, or the Metropolitan Museum in New York – in chronological order, one would see a visual history of Western painting from the middle of the thirteenth century to the early years of the twentieth. One would also be struck by the importance of the Christian faith to much of that history.

All of the paintings from the thirteenth and fourteenth centuries in London's National Gallery are religious works, as are the vast majority of its holdings from the fifteenth century, a sign of the ubiquity of Christian themes in Western art throughout the medieval period. The spread of Renaissance ideas and ideals from Italy to the rest of Europe from roughly 1450 onwards coincided with the rise of other pictorial genres, such as paintings based on classical myths and allegorical works, as well as episodes from contemporary history and literature, portraiture, and, later, landscape, still life, and depictions of everyday scenes.

Nonetheless, despite this diversity of subject matter, religious painting continued to be a significant part of the Western canon until the modern age. One finds major religious works from the seventeenth century by Rubens and Rembrandt in the Netherlands, by Nicolas Poussin in France, and by Francisco de Zurbarán and Bartolomé Esteban Murillo in Spain, for instance; there are important examples in the eighteenth century by Giovanni Battista Tiepolo and Francesco Guardi in Italy; and in the nineteenth, Eugène Delacroix and Puvis de

Chavannes in France, Caspar David Friedrich in Germany, and the Pre-Raphaelites in Britain all produced celebrated works on Christian themes. Even into the twentieth century, amid the artistic revolutions unleashed by modernism, artists such as Stanley Spencer, Georges Rouault, Marc Chagall, and Pablo Picasso painted images of Jesus and biblical stories, often fused with scenes from everyday life.

However, these examples notwithstanding, the gradual decline in importance of religious painting since the Renaissance is undeniable and mirrors the increasing secularization of Western society as a whole over that time. As a result, today we have a situation in which practising Christians can discover many works in galleries that offer inspiration and an affirmation of their religious faith, while the non-Christian finds it more and more difficult to identify the subject of a painting and to relate to the mindset or artistic purpose of the creator. Even the devout Christian visitor to a gallery, while able to recognize many of the individuals and scenes depicted, may have difficulties with paintings that employ conventions or symbols that are no longer current, or that depend on forgotten pious myths.

Some paintings illustrate an additional problem. For, while the fundamental and central beliefs of most Christians have changed little over the past seven hundred years, there have been some important divergences of tradition and practice. Most obviously, the pre-Reformation emphasis on the role of the Virgin Mary disappeared to a large extent within Protestantism but continued within Catholicism. Similarly, the relationship between the Eucharist and the Crucifixion is understood differently by the various denominations. Some Christians believe that the bread and wine is transformed into the body and blood of Christ, while others view the sacrament only as a symbolic reminder of the Crucifixion. From an art-historical perspective, one must be aware of these differences when looking at paintings

such as Giovanni Bellini's *The Blood of the Redeemer*, painted in Venice around 1460–5 (*see page 156*). Many twenty-first-century Christians still believe in 'the real presence' of Christ in the Eucharist and therefore see an intrinsic relationship between Christ's sacrifice on the cross and 'the sacrifice of the mass', but many do not hold that belief. We must, however, remember that Bellini and his contemporaries did believe this and so had a shared understanding of the picture's meaning. Furthermore, Christians today are used to having a range of New Testament translations available to them in their own languages, with quite a lot of minor variations in wording. We must not forget, though, that all artists before the middle of the sixteenth century would be almost entirely dependent for their knowledge of the Bible on a single version: the Latin Vulgate, St Jerome's translation from the original Greek.

In preparing this book on paintings related to different moments within the Christian year, I have tried to keep in mind at all times two principal groups of potential reader. On the one hand, Christians of all denominations may find points of relevance to their own faith, through considering the wonderful depictions of events celebrated in the liturgy. Some may also find their appreciation of the religious strengths of these paintings deepened by a greater awareness of certain historical or technical points. At the same time, by providing a Christian perspective, I hope to help non-Christians who appreciate the paintings as works of art to have a better understanding of what the artists may have been trying to say to their intended audience and how the pictures functioned within their original context. It is often difficult to understand elements in a religious painting without some knowledge of the faith that inspired it.

The painters we present here were people of both considerable intelligence and deep faith. So too were many of those who commissioned the paintings and those who advised both the patrons and the artists. Earlier, we spoke about the mysteries of the human situation. Within Christianity, the word 'mystery' has a special sense. It refers to a truth that is above reason but revealed only by God. So, for example, we speak of the mystery of the Holy Trinity, that is, of the belief that there are three persons in the one God. In a slightly different way one can speak of the mystery of the Crucifixion: why was it necessary for Christ to die on the cross? In both of these examples, we are dealing with concepts that are not fully fathomable to the human mind. Our painters, like their patrons, were conscious of the ultimate impossibility of doing full justice to the subjects that they were tackling. However, the greatest masters among them produced works that are themselves, in some respects, also unfathomable. They were able to say things with paint that were impossible with words alone. No critical analysis can ever fully describe or explain the significance of an important poem, a great piece of music, or a Shakespeare play. In the same way, a major religious painting creates associations and produces resonances that are inexhaustible. While very conscious, therefore, that in the brief discussions offered here we can never do anything like full justice to the pictures we are considering, we hope to provide some starting points, both religious and art historical, for lovers of paintings, both Christian and non-Christian, to expand their appreciation of these magnificent works of art.

THE CHRISTIAN LITURGICAL YEAR

The word 'liturgical' derives from 'liturgy', meaning the standardized form of service or worship, particularly Christian worship, conducted in a church. Both words come from the ancient Greek *leitourgia*, 'work done on behalf of the people' or 'public service', including that of the priests. The liturgy of Christian services depends on the feast being observed and so changes through the year. The most obvious difference between services is in the biblical readings, which relate to the event or person being celebrated on a particular day.

The Western liturgical year focuses on the two great celebrations of Christmas and Easter, the former celebrating the birth of Jesus and the latter observing his death and resurrection. This year is divided into six periods, starting with Advent, the time of expectant waiting and preparation ahead of the Nativity that commences four Sundays before Christmas. Then comes the Christmas season itself, which begins at sunset on Christmas Eve and includes not only the Nativity on 25 December, but also the Protestant churches' celebration of the Circumcision of Christ and the Roman Catholic feast of the Solemnity of Mary, Mother of God, both of which are celebrated on 1 January. In the Anglican and Methodist churches, the Christmas season runs until Epiphany Day (traditionally 6 January), whereas in the Catholic tradition, it ends with the Feast of the Baptism of the Lord (the first Sunday after Epiphany). It is then followed by the first period of Ordinary Time, known in some traditions as the Epiphany season or Epiphanytide, which lasts until the Feast of the Presentation of Jesus on or around 2 February. In several denominations, the Epiphany season is seen as a continuation of Christmas, and together they last forty days. In this book, we have followed that practice and present Christmas and the Epiphany season as one section.

There are no major feasts in this first period of Ordinary Time, which continues until the start of Lent, the forty-day period of fasting and preparation for Easter that begins on Ash Wednesday. The following season, Holy Week and Eastertide, is the most important in the liturgical year. Holy Week includes the celebration of Palm Sunday (also known as Passion Sunday), which falls on the Sunday before Easter, Maundy Thursday, Good Friday, and the Easter Vigil on Holy Saturday. Eastertide begins on Easter Sunday and runs for fifty days until Pentecost Sunday. Easter is, of course, a moveable feast, because of its relation to the Jewish Passover. As established by the First Council of Nicaea in AD 325, Easter is the Sunday following the first full moon after the vernal equinox. It can, therefore, fall on any date between 22 March and 25 April.

Completing the Christian year is the second period of Ordinary Time, sometimes known as Trinitytide, which runs from the Monday after Pentecost and continues until the First Sunday of Advent, which marks the start of the new liturgical year. The expression 'Ordinary Time' is derived from the use of the ordinal numbers to identify the particular weeks, of which there are usually thirty-three each year, such as 'the Second Sunday of the year', 'Ninth Week in Ordinary Time', and so on. The term also helps to distinguish these two periods from the celebrations of Christmas and Easter. Several feasts of liturgical importance occur within the second period of Ordinary Time, including Trinity Sunday, the Assumption of the Virgin, and All Saints' Day.

Since the 1960s, the main Christian denominations have worked to bring their liturgical calendars closer together. This, in conjunction with the use of the Revised Common Lectionary, means that on many days of the year one will now hear almost identical readings in Anglican, Roman Catholic, Lutheran, and Presbyterian churches. Some minor variations still exist. For example, some denominations continue to celebrate particular feasts on

the actual date or day of the week traditionally associated with those feasts, such as Ascension Thursday, while others have moved the celebration to the nearest Sunday.

The one significant difference in the calendar of liturgical celebrations between the various denominations is the emphasis within the Roman Catholic tradition on the feast days of the Virgin Mary. These occasions are included in this book as they provide an exceptionally rich range of works of considerable art-historical interest. We hope to be excused for the one example where such interest has resulted in the inclusion of a painting even though the liturgical significance of the related feast (Our Lady of the Rosary) might not fully justify its presence.

Seeing these marvellous pictures in the present order makes one aware of the logic underpinning the arch of the liturgical year. We begin with John the Baptist going out into the desert to prepare for the coming of Jesus Christ. This is followed by the birth, life, death, and resurrection of Christ himself. Then comes the foundation of the Christian Church at Pentecost and the celebration of its early twin pillars, Peter and Paul. Finally, we have, for the feast of All Saints' Day, the opportunity for the Church Militant (the Christians on Earth) to share visually with the Church Triumphant in celebrating Christ's glory in heaven. What a wonderful cycle for a Christian; and surely even the non-Christian will rejoice that it has produced these superb paintings.

Some of the works of art created for the principal altars of major churches from roughly 1300 onwards were of a remarkable size. From the early sixteenth century, such works would most usually be on canvas, but before that time they were normally painted on wooden panels, consisting of several large planks fastened together and covered with gesso (a type of chalk-based plaster). These were extremely heavy. Even altarpieces consisting of a single wooden panel often required a special type of support at the base. The large, oblong, boxlike structure designed for this purpose was known as a predella. Further support could be provided by using pillars or pilasters (square part-pillars) as framing elements at the sides. Often the predella, and sometimes the pilasters, would be divided into sections with small paintings in the different sections.

Such supports were even more necessary with works involving two panels (diptychs), three panels (triptychs), or more than three (polyptychs). Whereas the panels of a diptych or triptych would be side by side on the same level, a polyptych might have a diptych or triptych as the principal element of the work, but one, two, or even three tiers of paintings on smaller panels above. The topmost panels are normally referred to as the pinnacle panels (*see, for example, pages 82–3 and 177*).

When such altarpieces went out of fashion, they were frequently cut up into their constituent elements, with the different panels becoming scattered among various collections, public and private, all over the world. In fact, many early religious paintings in major galleries and museums, and several included in this book, although they may seem at first glance to be individual paintings in their own right, were originally subsidiary elements of large polyptychs.

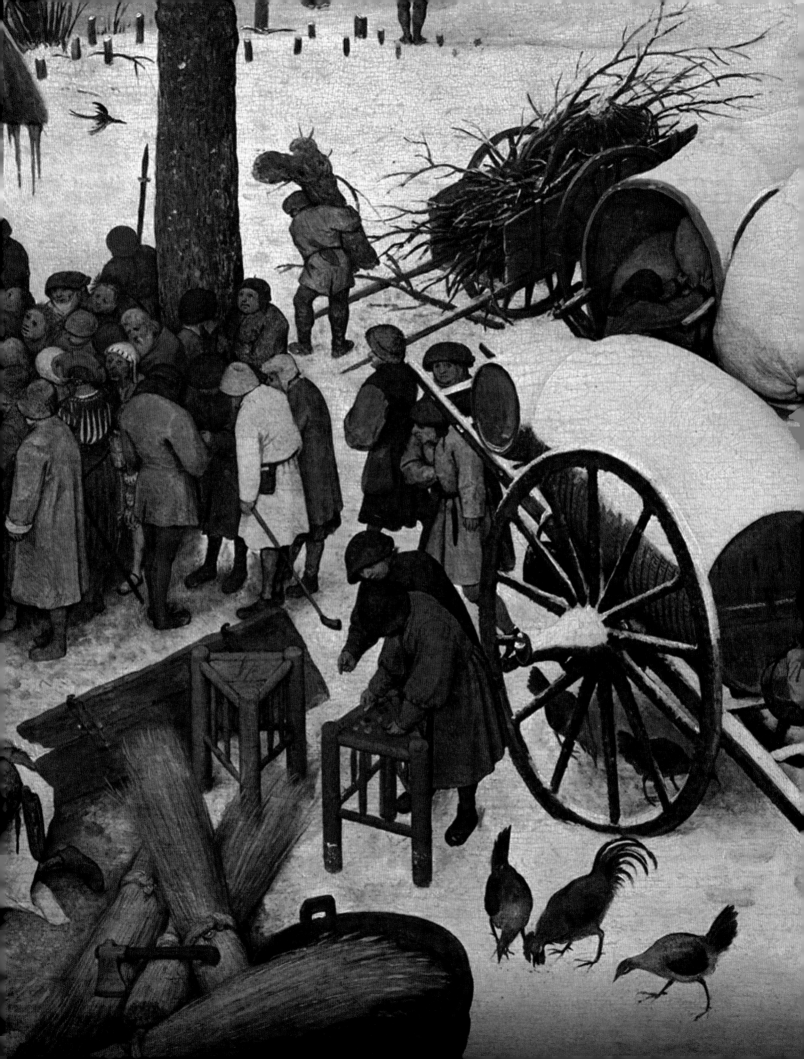

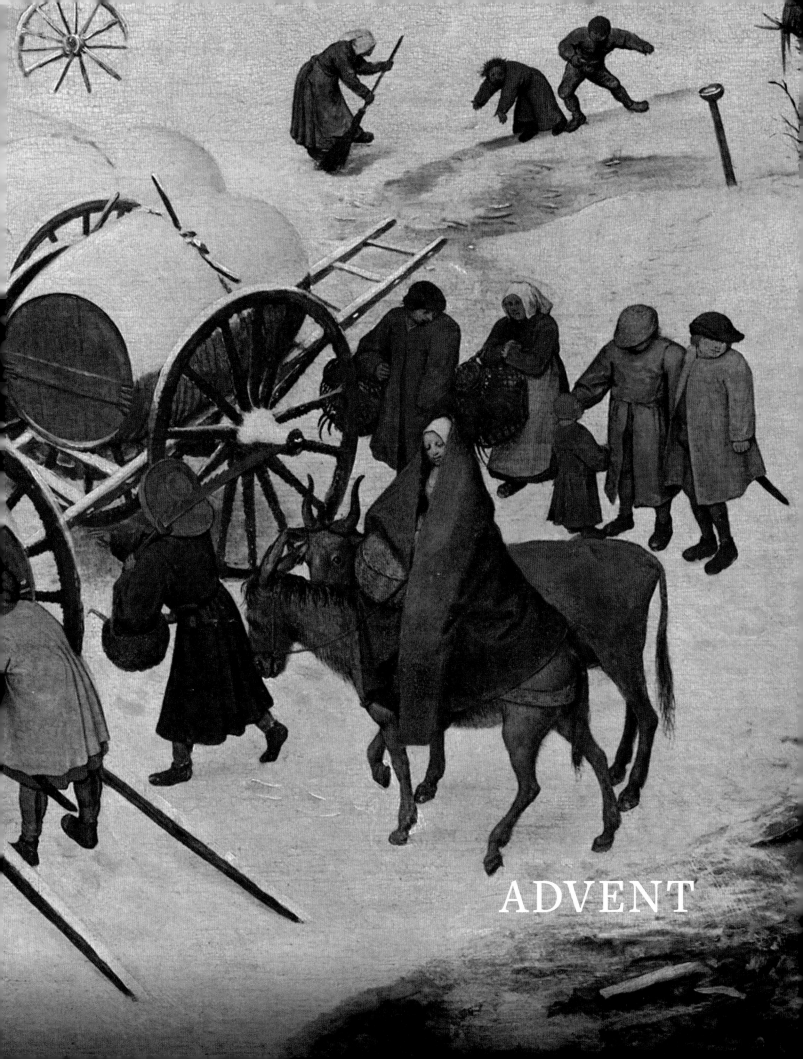

ADVENT

Giovanni di Paolo
St John the Baptist Retiring to the Desert
1454

Egg tempera on wood, 30.5 × 49 cm

Advent is the period of preparation for the celebration of the birth of Jesus Christ at Christmas. In most denominations, it begins four Sundays before Christmas. In other words, Advent Sunday is either the final Sunday of November or the first Sunday of December. The name of the season comes from the Latin word meaning 'coming', and the liturgy reflects this idea of expectant waiting for an imminent arrival. It is unknown precisely when the practice of observing a period of preparation for Christmas first began, but it certainly existed from the late fifth century.

The person most associated with Advent is John the Baptist. His importance is emphasized by the fact that the evangelists, at or near the beginning of their gospels, tell us about the saint and how he went into the wilderness to proclaim a baptism of repentance for the forgiveness of sins and thereby prepare the way for the public ministry of Jesus. Matthew preludes the start of the ministry of Jesus with John the Baptist's proclamation in the desert. Luke devotes the first chapter of his gospel to John's life 'until the day he appeared openly to Israel', framing the stories of the Annunciation and the Visitation with the early years of John. Mark opens his gospel with John's preaching in the desert about the one who is to come after him, and continues with the arrival of Jesus and his baptism in the River Jordan by John.

St John the Evangelist, in the powerful and poetic opening of his gospel, actually incorporates John the Baptist in the cosmological context of creation. Having told us that, 'In the beginning was the Word … and the Word was God.… In him was life … and the life was the light of men', he continues: 'A man came, sent by God. His name was John.' All four gospels quote the prophesy of Isaiah as relating to John the Baptist, but it is Luke who gives the fullest version of the quotation: 'A voice of one crying in the wilderness: Prepare ye the way of the Lord, make straight his paths. Every valley shall be filled; and every mountain and hill brought low; and the crooked shall be made straight; and the rough ways plain. And all flesh shall see the salvation of God.'

As we look at Giovanni di Paolo's painting, painted in Siena in the middle of the fifteenth century, we see the way in which the artist has given visual expression to the mission of John as expressed in the words from Luke's gospel. In the background on both left and right, we have the rugged hills, mountains, and valleys, with the rough path winding crookedly into them; in the right foreground, the land is flat and even, and the smooth paths are completely straight. As we know from the gospels, John will prepare the way for Christ by preaching a doctrine of repentance and God's forgiveness of sin, witnessed by the sign of baptism. He will emphasize that there is one much greater than himself coming after him, and will point to Jesus as that person with the words, 'Behold the Lamb of God.'

The image of John presented here by Giovanni di Paolo (*c.* 1403–82) is very different from the figure in a garment of camel's hair that is described in the gospels of Matthew and Mark, the form in which he is most commonly represented in painting. Here we see quite an elegant youth striding confidently out of what is probably intended to be the gate of Jerusalem. With his few worldly possessions hanging in a small bundle from a stick over his shoulder, he reminds us of a hero from a children's story, setting out to make his fortune and have adventures on the way.

Giovanni di Paolo was known for the fantastical quality of some of his works. One of the most striking aspects of this painting is that it presents an unrealistic view of the world. Unlike much Tuscan painting of the time, it does not use foreshortening and the rules of linear perspective, which had been theorized by the Italian architect Filippo Brunelleschi some forty years earlier. This technique allowed artists to create the illusion of distance and depth

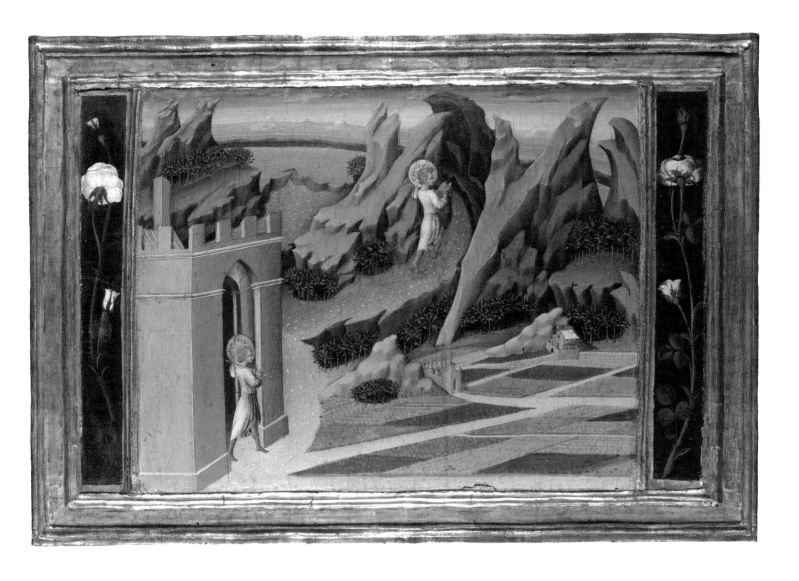

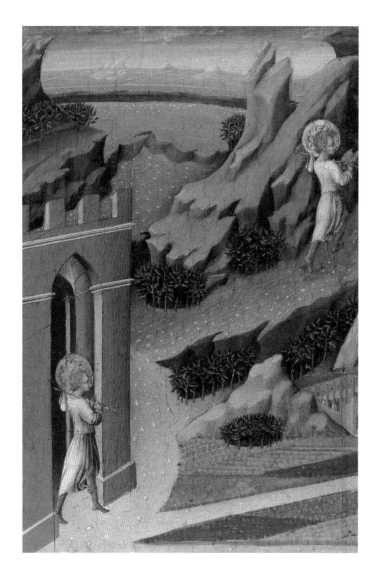

on a flat surface and to represent objects in space as they would appear in real life – which is to say that they would be smaller the farther they are from the observer. Under this system, all parallel lines or orthogonals in an image converge in a single vanishing point on the horizon.

Giovanni di Paolo seems not to have been interested in the type of realism that such new-fangled methods would permit. He chose other ways of conveying what he regarded as important. In order to create a sense of movement, time, and progression, we have two near-identical St Johns appearing simultaneously, the first stepping out of the building in the foreground, the second – equal in size although clearly intended to be at a distance and some time later – climbing a steep path on his way to the desert. There is no attempt to relate any of the features in the painting on a consistent scale. The structure on the left could be easily climbed if one of the figures stood on the other's shoulders. All of the trees are more or less the same size, no matter how far they are supposed to be from the picture plane, and none is more than half the size of St John, although most are taller than either of the two buildings in the distance. The more distant of these buildings is the same size as the nearer one, and appears to slope both forward and sideways. The chequerboard effect on the right to represent the plain was a device used frequently by Giovanni for its ability, in the words of British artist and art historian Timothy Hyman, 'to create an abstraction of space, whose appeal is not to the fixed optic of the spectator, so much as to the winged flight of the dream-voyager'.

Nonetheless, the fact that we are able to use such terms as 'nearer' and 'more distant' indicates that Giovanni's approach does not prevent us from reading the painting in the way the artist intended. We can see not only that St John is heading away from the city towards the wilderness but also, from the steepness and roughness of his path – a roughness

conveyed by the very formally arranged rows of white stones – that he is choosing a way of austerity for his life.

Particularly striking is the sense of dynamism conveyed by the figure on the path. An impression of strong forward movement is suggested by the curve of the lower half of John's red robe, as his right knee thrusts through the gap at the front of the garment; and the shape of the folds have a visual echo in the curve of John's left leg behind these and in the rock in front. One could compare Giovanni's technique here to that of a modern cartoonist using a series of simple repeated lines, curves, or arrow shapes to indicate force, noise, or speed. This may look an elegant youth, but he has the dynamic charisma to draw enormous crowds to confess their sins in public and be baptized. He also has the strength of character to call the Pharisees 'a brood of vipers' to their faces, as well as to rebuke a king to his face for stealing his brother's wife, even though this may, and indeed will, lead to his execution.

Although he ignores linear perspective, Giovanni di Paolo does make some use of a rather simplified form of aerial or atmospheric perspective. This technique relies on the fact that, on a clear day, the sky immediately above our heads will be its strongest blue, getting gradually paler in the distance, and becoming almost white on the horizon. At the same time, the green of the landscape will be at its most intense near to us, become paler in the distance, and have a markedly blue quality near the horizon. Giovanni is not subtle in the way he applies this concept. His sky is basically a blue band at the top and a white band at the bottom, with very little gradation of hue. But then, more bizarrely, having shown much greater gradation in regard to the flat piece of land on the upper left, until he arrives at a pale blue, he surrounds his whole landscape with a thick curved band of green. He matches this with a very pronounced curve on his horizon line on the left.

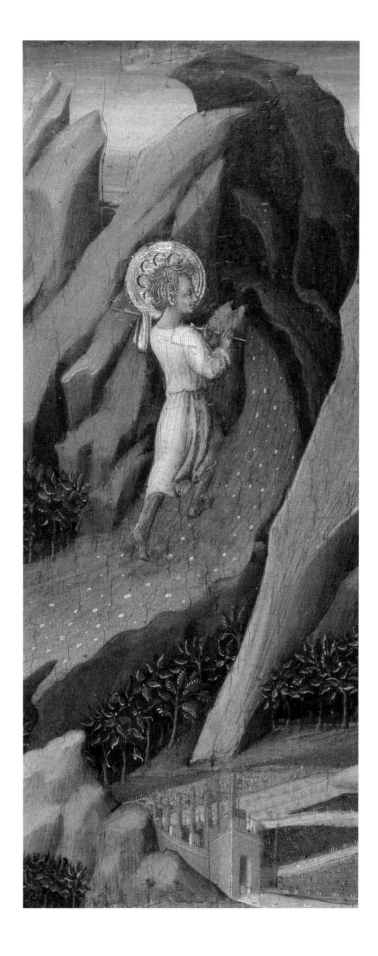

However, none of these oddities detract from the enormous visual charm of this painting, in which the overall balance of forms and colours is as delightful as the representation of the youthful St John. Moreover, while it may not quite put him in a cosmological context, it does show, with the great distant vistas that unfold over the hill, that John is emerging from the narrow confines of the city onto the world stage.

The fact that the whole movement of the painting is to the right and upwards, both in terms of the direction in which John is travelling, and of the slope of the diagonal lines within the work, gives a clue to its origin, particularly when combined with its size and shape. It was, in fact, one of the five panels of a predella, the long boxlike structure that supported a large altarpiece above. Five scenes from the life of St John were depicted here. Four are in the National Gallery in London. These show in order: the birth of the Baptist; the present scene of St John setting out for the wilderness; John's baptism of Christ; and Herod presented with the head of St John. The fifth panel, now lost, which was almost certainly of the beheading of John, would have come between the final two. The altarpiece above was the

Madonna and Child with Saints now in the Metropolitan Museum of Art in New York.

Our painting, then, had to lead the eye to the right along the predella to the central panel of Christ's baptism and beyond to John's death. It had also to take the spectator back to the main work of the altarpiece above. It certainly does that. Still more, it is able, after more than five centuries, to remind us very beautifully, of how the going out into the world of one great New Testament figure prepared the way for the coming of the greatest one. It is, indeed, a wonderful painting to represent the start of the Redemption narrative and of the Christian year. This dynamic youthful figure, determinedly striding out from the security of the city to face hardship, and ultimately death, in pursuit of his mission is truly at the beginning of an adventure that will change the world. No wonder his namesake, St John the Evangelist, introduced him in the context of the whole universe.

Giovanni di Paolo, *The Birth of Saint John the Baptist: Predella Panel*, 1454, tempera on wood, 30.5 × 36 cm, National Gallery, London

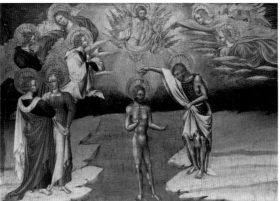

Giovanni di Paolo, *The Baptism of Christ: Predella Panel*, 1454, tempera on wood, 31 × 45 cm, National Gallery, London

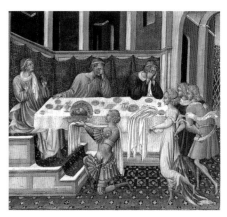

Giovanni di Paolo, *The Head of John the Baptist brought to Herod: Predella Panel*, 1454, tempera on wood, 31 × 37 cm, National Gallery, London

Giovanni di Paolo, *Madonna and Child with Saints*, 1454, tempera on wood, gold
ground, central panel 210.2 × 65.7 cm; left panels 180 × 42.9 cm, 180 × 42.5 cm; right
panels 180 × 42.9 cm, 180 × 42.5 cm, Metropolitan Museum of Art, New York

Diego Velázquez
The Immaculate Conception
1618–19

Oil on canvas, 135 × 101.6 cm

The idea that Mary, the mother of Jesus, was conceived free from original sin, may not be a subject of pressing concern to most practising Christians in the twenty-first century. It was, however, an issue that exercised the minds of many theologians of the past. Traces of the tradition are found as far back as St Augustine in the early fifth century. But it was from the twelfth to the nineteenth century that the doctrine was the subject of particular theological controversy.

As always when talking about spiritual issues, there is the problem that one has to resort to the imagery and language of the physical world. So the soul was often spoken of as if it were a white sheet of cloth or paper on which sin left a stain. *Macula* is the Latin for 'stain', and immaculate thus means literally 'stainless'. While all members of humankind, except Jesus Christ, were held to have, from the moment of their conception, souls that bore the stain of original sin, the view became common within the Church that there was one exception: the Blessed Virgin Mary.

Not all theologians agreed on this point, however. On the one hand, it was argued, particularly by the Franciscans, that it would have been impossible for the Son of God to have been born of a mother who was, in any sense, in a state of sin. On the other, it was maintained, especially by the Dominicans, that since Christ had died to free all humankind from sin, someone born before him could not already be in a totally sinless state. The attempt to reconcile the two positions hinged on the idea that, in order to be worthy to bear her Redeemer, Mary was granted the special privilege of receiving the fruits of his redemption in advance of his life and death. Her soul, it was suggested, was immaculate from the moment it existed within her body. In 1854, on 8 December, a date on which a feast for the Immaculate Conception had long been celebrated, Pope Pius IX declared the Immaculate Conception an article of faith for all Catholics. In many

Catholic countries, 8 December is a holy day of obligation, and in some it is a national holiday.

If it is difficult to speak of spiritual concepts without using concrete, physical imagery, it is virtually impossible to express these concepts in a purely visual medium without such resort. In his painting *The Immaculate Conception*, the Spanish painter Diego Velázquez (1599–1660) does not, therefore, attempt to offer us the representation of a state of being per se, but an image of the Virgin Mary in which he seeks to emphasize that state. He does this in a variety of ways, some of an artistically technical nature, others through traditional symbolism and biblical association.

Velázquez offers us a face that is serene and lovely, though perhaps not stunningly beautiful. Even though the Virgin is not shown in close-up, we can see that the flesh of her face and hands is totally without blemish, that it is, literally, immaculate – without stain. The distance at which the artist places her from the picture plane allows us to view the whole figure clearly but still with a lot of background. The emphasis in dress and posture is very much on modesty. Mary does not confront the viewer with her glance, but looks downwards. With her hands joined in prayer, that earthward gaze would suggest that she is praying for humanity.

Much of the imagery employed by Velázquez is taken from Chapter 12 of the Apocalypse (the Book of Revelation), where St John's references to 'a woman' are traditionally taken to refer to the Virgin Mary. St John in his great vision saw 'a woman clothed with the sun, and the moon under her feet, and on her head a crown of twelve stars'. In the painting, the Blessed Virgin might not seem actually 'clothed' with sunlight, rather she has the sun, edged with white clouds, immediately behind her. She does stand on the moon, however. Many painters and sculptors from the Renaissance on, when employing this motif to depict the Immaculate Conception, placed Mary on the

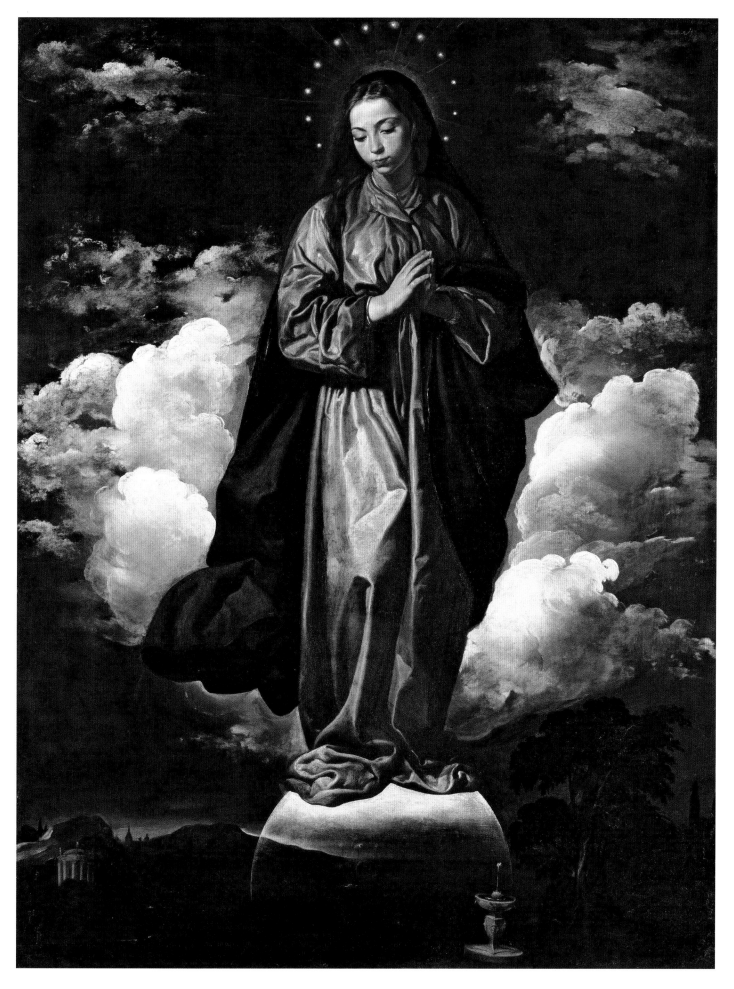

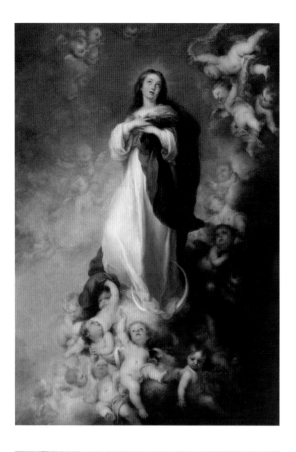

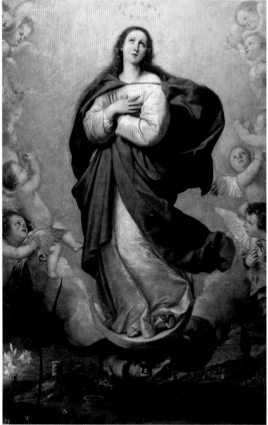

Bartolomé Esteban Murillo's *Immaculate Conception of Los Venerables* from *c.* 1678 (top) and José di Ribera's undated painting from the first half of the seventeenth century, both now in the Museo del Prado, Madrid, show the Virgin on top of a concave crescent moon, one of the most frequent treatments of the subject.

concave surface of a crescent moon. Velázquez is far more scientifically logical and accurate. When we see the moon as a crescent in real life, it is merely because part of the orb is lit by the sun while the rest is in shade. To stand on that concave surface would, therefore, in a literal sense, be impossible. Velázquez shows Mary standing on top of a circular moon, whose upper section is the only part to be illuminated. The artist's use of light and shade throughout the painting is full of significance. Although the sun with which Mary is 'clothed' shines through the clouds behind her, the fall of light on her robe and cloak shows that these are lit from above. We realize that neither the sun nor the moon can be the light source for her. Instead, it is radiance from her face that illuminates not only her garments, but also the moon itself. The Earth below is left in darkness. It is difficult to see in reproduction, but the twelve stars encircling Mary's head are joined by thin lines to a narrow band, or aura, of light, thereby composing both a crown and a halo.

In the foreground of the painting, we see, on the lower left, a temple; on the lower right but more centrally, a fountain; and slightly further right, a large tree. In the centre, set against the moon but scarcely visible even in the original work, is a sailing ship. The fact that Velázquez makes very little effort to integrate these into the landscape in any formal way suggests that they serve a symbolic purpose. A temple is sometimes used as a symbol of God himself; but as 'the house of God', it is also an appropriate image to use for the Virgin Mary, who was to house God made man in her own body.

The association of the fountain with the Madonna comes from the fact that certain passages in the Old Testament, particularly in the Psalms and in the Song of Songs, were taken as references to her. Verse 10 of Psalm 35 (Verse 9 of Psalm 36 in some versions of the Bible) reads:

'For with thee is the fountain of life; and in thy light we shall see light.' In Chapter 4, Verse 12 of the Song of Songs, we have: 'My spouse is a garden enclosed, a garden sealed up, a fountain sealed up'; and in Verse 15: 'The fountain of gardens; the well of living waters, which run with a strong stream from Libanus.' References to water are of great importance throughout the Bible. At the beginning of the Old Testament, in the second book of Genesis, we read of the spring that rose out of the Earth in Paradise, of the tree of life in the centre of Paradise, and of the river that went out from Paradise and divided into the four great rivers. Chapter 4 of St John's gospel tells of Christ's conversation on 'living water' with the woman of Samaria, beside Jacob's Well (for which 'Jacob's spring' would actually be a more accurate translation). And at the very end of the New Testament, in Chapter 22 of the Apocalypse, St John speaks of being shown the 'river of the water of life', flowing from the throne of God and the Lamb. This spring of living water flows, then, in imagery from the creation story in the first book of the Bible through to the final vision at the end of the last book, connecting the first Adam with Christ, the second Adam, and linking the physical mother of humankind, Eve, with our spiritual mother, Mary. There is a similar link between the tree in Paradise and the tree of the cross.

We must mention here the relationship our painting has to two other works produced just a few years earlier. The first is *The Immaculate Conception* by El Greco (1541–1614), painted in Toledo some time around 1608–14 and now in the Museo Thyssen-Bornemisza in Madrid (*see page 22*). The upper part of that painting is quite different from Velázquez's work. However, Velázquez has clearly borrowed directly from the lower section. There, in a band of landscape that also bears little relation to the representation of Mary above, El Greco places a temple, a ship, a well, a serpent, a combined bunch of lilies and roses,

Velázquez's transformation of the halo of twelve stars around Mary's head into a crown was a device used also by contemporary Spanish sculptors treating the subject, such as the *c.* 1628 sculpture in the church of the Anunciación in Seville, attributed to Juan Martinez Montañés.

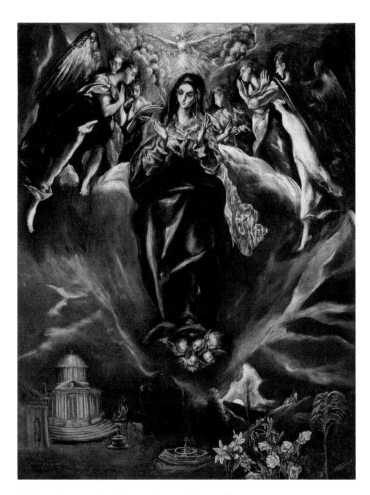

Juan Martinez Montañés, *Immaculate Conception*, 1606–8, polychromed wood, 134 × 53 × 43 cm, Nuestra Señora de la Consolación, El Pedrosa

El Greco, *Immaculate Conception*, c. 1608–14, oil on canvas, 108 × 82 cm, Museo Thyssen-Bornemisza, Madrid

and a tree. El Greco had used the same idea, but less developed, in two earlier paintings of the Immaculate Conception, both of which remain in Toledo.

The second work to be considered is the statue of the same subject by Juan Martinez Montañés (1568–1649) dating from 1606–8. As the 2009 exhibition at London's National Gallery 'The Sacred Made Real' demonstrated, the figure of the Virgin in our early Velázquez painting was almost certainly influenced by this statue, which was polychromed by Velázquez's teacher and later father-in-law, Francisco Pacheco. One might also note that it was Pacheco who admired the work of El Greco in Toledo and

brought it to the attention of the artists in Seville, no doubt including his young pupil. However, while the pose of the Virgin may be based on the work of Montañés, and the line of symbols on that of El Greco, our painting as a whole is very different from either of these partial sources. In fact, the nineteen-year-old artist who produced it was beginning to demonstrate the originality and prowess that would dominate Spanish painting for the next forty years.

Velázquez's *Immaculate Conception* was one half of a twin commission and had a pendant piece. This showed St John on the island of Patmos writing the Apocalypse, from which so much of our imagery comes. The actual details of that imagery would probably have been agreed between the artist and nuns of the Carmelite Order, for whose convent in Seville the pictures were commissioned. The Carmelites shared the enthusiasm of the Franciscans for the tradition of the Immaculate Conception. They must surely have been pleased with the manner in which the young Velázquez gave visual expression to the doctrine. To set the Virgin Mary in the heavens, surrounded by the sun, moon, and stars above a darkened Earth, offers more than references to the book of the Apocalypse. It emphasizes the place of the Virgin Mary within the whole created universe. It shows, indeed, how she was chosen from the beginning, in the great plan of creation, to be the immaculate temple from which would come the One True Light who would bring illumination and the living water of redemption to the world in darkness. The conception of Christ's mother is naturally a significant moment in the prelude to the Incarnation. So the appropriate season for it to be celebrated is Advent, when the world is preparing for his coming.

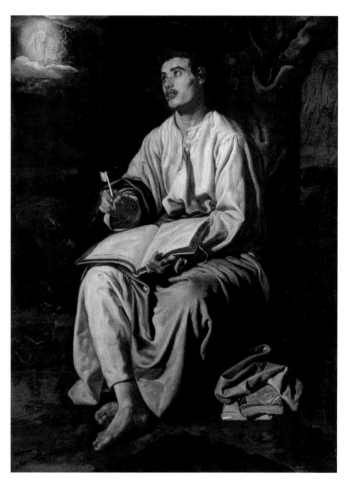

Diego Velázquez, *Saint John the Evangelist on the Island of Patmos*, c. 1618, oil on canvas, 135.5 × 102.2 cm, National Gallery, London. Velázquez painted this image of St John writing the final book of the New Testament as the companion piece of the *Immaculate Conception*. He shows John gazing upwards at his vision of the Woman of the Apocalypse, source for much of the imagery associated with the Immaculate Conception. Both paintings were commissioned by the convent of the Calced Carmelite nuns in Seville, founded by St Teresa of Ávila in 1575.

Hugo van der Goes
The Portinari Altarpiece
c. 1475

Oil on wood, 253 × 304 cm

Advent is a comparatively short period, with a minimum of twenty-two days and a maximum of twenty-eight. A word that appears frequently in a liturgical context with regard to Advent is 'moderation'. It is not like Lent. That season is a time of sorrow for sin, evidenced through fasting and self-sacrifice. The Lenten churches seem to be in a state of mourning: the organ is silent, bells are not rung, and flowers are few. Advent is a time of waiting with joyful expectation; but the evidence of joy must be moderate. Its full expression is reserved for the actual coming of Jesus at Christmas.

We have already noted that two of the gospels, those of Mark and John, begin their narratives with the preaching of John the Baptist. Only Matthew and Luke speak of the conception of Jesus and of his birth in Bethlehem. Matthew tells us also of the visit of the three magi after the Nativity and the Holy Family's subsequent flight into Egypt. Luke alone actually mentions the journey from Joseph and Mary's home city of Nazareth in Galilee to Bethlehem in Judea – the city of David and the ancestral home of Joseph – and tells of the shepherds coming to adore the newborn Christ Child, lying in a manger.

A painting that offers a visual account of these episodes from the Nativity story and a pleasing parallel to the first weeks of the liturgical year, from Advent to the Epiphany, is the *Portinari Altarpiece*, by the Netherlandish artist Hugo van der Goes (*c.* 1440–82). This magnificent oil-on-wood triptych, now in the Galleria degli Uffizi in Florence, is one of the greatest and most influential works of the Renaissance. It was commissioned by the Italian banker Tommaso Portinari for the church of the hospital of Santa Maria Nuova in Florence. Tommaso himself can be seen, as a small-scale 'donor figure' in the foreground of the left-hand panel kneeling in front of his two sons. Behind him is his patron, St Thomas the Apostle, with his attribute of a spear. Next to him, holding a bell and tau-shaped crutch, is St Anthony Abbot, the patron of the elder son. In the right-hand panel, Tommaso's wife, Maria, kneels in front of their daughter Margarita. Once again, their patrons stand behind them, recognizable by their attributes. St Mary Magdalene, in white and gold, holds a pot of ointment; St Margaret of Antioch, in a red robe, is known here by three attributes: a book, a crucifix, and the dragon, on the neck of whose fearsome head she stands. The central panel, showing the Adoration of the Shepherds, has, rather unusually, Jesus lying in straw on the ground, while the apocryphal ox and ass eat from the manger. This representation of the Nativity was probably inspired by the vision of fourteenth-century mystic and saint Bridget of Sweden, who shortly before she died described a vision that included the baby lying on the ground and emitting light.

It is, however, in the background of the panels that we are offered the sequence of events before and during Christmas. At the top of the left panel, we are shown Mary and Joseph on their journey to Bethlehem, a rare depiction of that subject. At the top right of the central panel, above the shepherds who have now arrived in the stable, we see the earlier moment of the angel's announcing the birth of Christ to them as they tend their flock. In the background of the right-hand panel are the three magi riding abreast towards Bethlehem on their horses. One of their retinue has gone ahead to ask a local for directions while their train, including camels, follows on behind. It is, of course, on the first of these scenes, the journey to Bethlehem, that we focus in Advent.

St Luke mentions 'the hill country of Judea'. Van der Goes offers us a tender moment as Joseph and Mary negotiate a steep slope on one of the hills. Mary, in the final days of her pregnancy, has dismounted to approach this challenge hesitantly. Joseph, who is shown as elderly but far from decrepit, looks upon his young wife with tenderness and concern, steadying her as he leads her gently forward. There are no human spectators of this intimate scene.

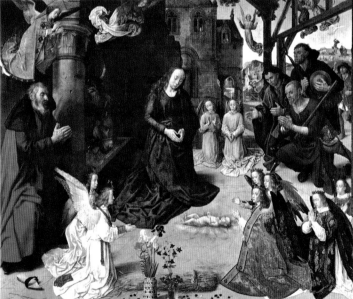

The other participants are the ass and the ox. Although there is no mention of either animal in the gospels, both are common in Nativity scenes. The origin of their supposed presence by the manger, at the birth of Jesus, probably comes from the wording in the first chapter of the book of Isaiah: 'The ox knows his owner and the ass his master's crib.' However, the most likely source upon which Hugo van der Goes is relying when including them here is *The Golden Legend*. That work, from the middle of the thirteenth century, is by the Dominican monk Jacobus de Voragine, subsequently Archbishop of Genoa. The book, which principally deals with the lives of the saints but incorporates apocryphal material and pious myths, had a major influence on Renaissance art. In his section on the birth of Christ, Jacobus writes: 'Setting out for Bethlehem with Mary ... Joseph took along an ox (perhaps to sell for money to pay the head tax and buy food and the like) and an ass.' There may be a further reason for the artist to include the ox, which we see peering round from behind the great boulder. The four evangelists each had a special symbol, based on 'the four living creatures' described in the Book of Revelation (which were themselves based on Ezekiel). Matthew's symbol was a man with wings (often changed into angel); Mark's was a lion; John's, an eagle; and Luke's, an ox. The artist may have wished to remind us of the importance of Luke for our knowledge of the Christmas story.

The distance from Nazareth to Bethlehem was some ninety miles, so the employment of a donkey would, in fact, be quite likely, particularly given the advanced state of Mary's pregnancy. Moreover, by the late fifteenth century, the association of the Holy Family with the animal was well established in the visual consciousness of western Europe, not least because of the many depictions of the Holy Family on their flight to Egypt soon after the birth of Jesus, which would remain a highly popular subject for painters.

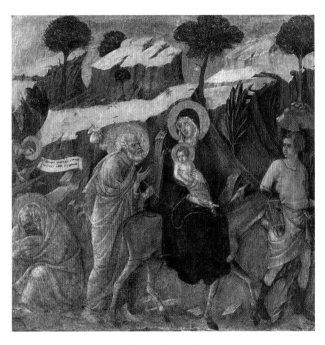

Duccio, *Flight into Egypt*, detail of predella of the front of the *Maestà*, 1308–11, tempera on wood, 43 × 44 cm, Museo dell'Opera del Duomo, Siena

Gentile da Fabriano, *Adoration of the Magi* altarpiece, detail of central panel of the predella, *The Flight in Egypt*, 1423, tempera on panel, 32 × 110 cm, Galleria degli Uffizi, Florence

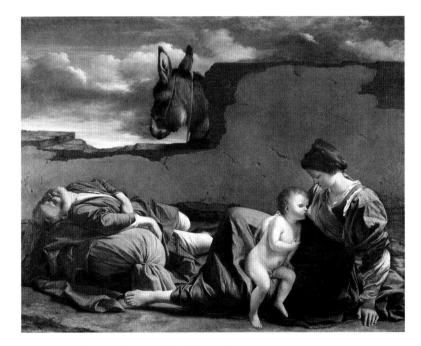

Orazio Gentileschi, *The Rest on the Flight into Egypt*, *c*. 1620, oil on canvas, 175.6 × 218 cm, Birmingham Museums and Art Gallery

Julius Schnorr von Carolsfeld, *Flight into Egypt*, 1828, oil on canvas, 120.5 × 114 cm, Museum Kunstpalast, Düsseldorf

Pieter Bruegel the Elder
The Census at Bethlehem
1566
Oil on wood, 116 × 164.5 cm

While paintings of Mary and Joseph's journey to Bethlehem, such as the *Portinari Altarpiece* (*see page 25*), are rare, there are many depictions of Joseph leading a donkey bearing Mary and the infant Jesus on their flight to Egypt, as we have just seen. Two major series from northern Italy in the early fourteenth century were influential in establishing this tradition: Giotto's frescoes for the Scrovegni Chapel in Padua (*see pages 96 and 145*) and Duccio's multi-panelled masterpiece from Siena, the *Maestà* (*see pages 70, 81–3, 93, 169, and 171*). The image of Mary on a donkey became so familiar that more than two and a half centuries later, Pieter Bruegel the Elder could expect viewers of this painting to recognize her easily, even though she is not a prominent figure in a busy picture that is rich in detail and activity.

Although at first glance, this picture may look like a scene from sixteenth-century Netherlandish life, in fact it depicts the biblical story of the census at Bethlehem, the reason for which Mary and Joseph were travelling to the city. At the time of Jesus' birth, Palestine was part of the Roman Empire. The holding of a census, for purposes of taxation and military service, had been introduced in Rome in the time of the early kings. It had gone out of use in the later Republic, but was reintroduced under Augustus. By that time, Rome itself, indeed the whole of Italy, was excluded from the need to pay taxes, but the provinces were not. St Luke tells us that Joseph had to go to his birthplace, Bethlehem, to register for the census, which took place when Quirinius was governor of Judea. This was, in fact, shortly after the province came under direct Roman rule in AD 6. Attempts to reconcile this timing with another key date, the death of Herod the Great in 4 BC, have led to confusion as to the actual year of Christ's birth. However, while that particular controversy may not have been in Bruegel's mind when he painted the picture, we shall see that some of the attendant facts undoubtedly were.

The traditional translations of St Luke's gospel tell us that when Mary gave birth to Jesus she 'laid him in a manger, because there was no room in the inn'. The word translated as 'inn' here is the relevant form of the original Greek *cataluma*, which is rendered with the corresponding part of *diversorium* in the Latin Vulgate translation of the Bible. While both of these words can have the sense 'inn', they can also mean simply the guest room of an ordinary house. Most modern scholars agree that it is this second meaning that Luke probably intended. Significantly, he later used the same word *cataluma* to describe the 'upper room' of the Last Supper, which the Vulgate again rendered as *diversorium*. A typical Palestinian home would have had the main living area either next to or above the animal quarters. It is probable that, when Joseph and his wife reached the family home, whatever space the house had for guests was already occupied by other relatives coming for the census. The latest arrivals were, therefore, accommodated with the animals. It is, however, towards the traditional inn, advertised as such by the wreath hung as a sign and barrel beneath the roof, that Joseph and Mary are heading in our painting by Bruegel. Since a census was an infrequent event, it would only necessitate the use of temporary premises for registration. A room in an inn would be an obvious choice.

As well as filling the scene with details of everyday life, Bruegel also gave this biblical story a contemporary edge by introducing subtle references to the political issues of the day. At the time that he was painting, the Low Countries were under the domination of the Spanish Habsburg king, Philip II, who was also the Holy Roman Emperor. In 1563, the Netherlands refused to pay the increased taxes demanded by Philip. Then in 1567, the year after this picture was painted, Philip sent the Duke of Alba with an army of sixty thousand to bring the rebellious provincial subjects to heel. Alba oversaw the execution of

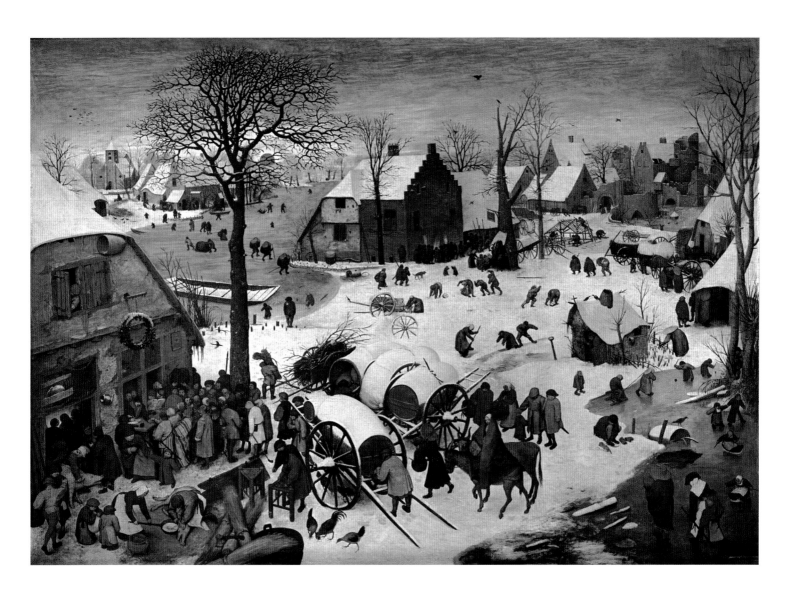

more than eight thousand suspected troublemakers. When Bruegel painted *The Massacre of the Innocents* soon after that event, he gave King Herod's soldiers a marked resemblance to Spanish troops, and their leader had the stature and white beard of the Duke of Alba. In *The Census at Bethlehem*, too, he conflates ancient and contemporary history in a number of ways. For instance, we can see that the folk gathered around the right-hand window of the inn appear to be having their names registered, as if taking part in a census, but those to the left of them seem to be handing over tax money, which an official is recording in a ledger. Importantly, the plaque on the wall above their heads bears the double-eagle insignia of the Habsburgs. While painting a religious scene, of a story based on the demands of an imperial master of Roman times, Bruegel is clearly also reminding his Dutch viewers of the parallel with their own situation under foreign oppressors.

We mentioned above that the most important element in this painting, the arrival of Joseph and Mary, is not made particularly prominent. This is quite a common feature in Bruegel's paintings. In a well-known poem, 'Musée des Beaux Arts', W. H. Auden wrote with approval of this approach, with particular reference to one of the artist's major non-religious paintings, *Landscape with the Fall of Icarus*. In that work, we do not see the boy falling as the sun melts off his wings, as one would expect, only his legs thrashing above the water in a corner of the picture, while a galleon sails serenely on and a farmworker in the foreground continues to plough. The opening part of the poem also seems to refer specifically to details from our painting:

About suffering they were never wrong,
The Old Masters: how well they understood
Its human position; how it takes place
While someone else is eating or opening a window or just walking
dully along;

How, when the aged are reverently, passionately waiting
For the miraculous birth, there must be
Children who did not specially want it to happen, skating
On a pond at the edge of the wood.

Indeed, we can see in *The Census* a figure opening the upper
window of the inn; many others 'walking dully along'; and
children playing and skating on the ice in both the upper left
and lower right sections.

 When we focus on the centre of the image, however,
several points stand out. From an art-historical point
of view, one might observe that, although the movement
here is from right to left, there is a very close resemblance
between Bruegel's image of Mary on the donkey and that
of Giotto referred to earlier. Then, when we are able to get a
close-up view of Joseph, we see that Bruegel imagines him to
have brought his carpenter's tools with him, as he has a long,
slim, broad-toothed saw across his shoulder, while what
appears to be the wooden handle of a chisel or similar tool
projects from the bag he carries. We also note the ox, which
now has not only the authority of *The Golden Legend* behind
it, but also the precedent set by that earlier great Flemish
work we have just considered, the *Portinari Altarpiece*, which
was famous throughout Europe by the time of Bruegel.

 Bruegel was himself acquiring quite a reputation
as a painter in several different fields: religious subjects,
landscapes, snow scenes, village life, children at play,
popular culture, the curious, and the supernatural.
In several of these genres, he was a major innovator. Nearly
all are combined in our present painting. What image could
be better for the end of Advent than that of Mary and Joseph,
already arrived in Bethlehem and just approaching the
door of the inn? For all Christians who are 'reverently,
passionately waiting for the miraculous birth', the wait is
almost over.

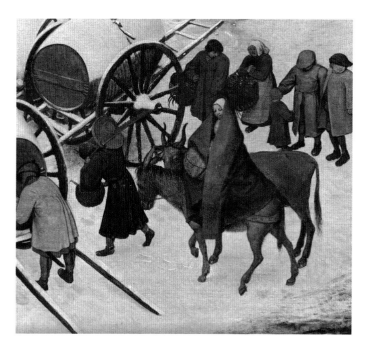

CHRISTMAS, EPIPHANY, AND ORDINARY TIME

Geertgen tot Sint Jans
The Nativity at Night
c. 1490

Oil on oak, 34 × 25.3 cm

The Nativity at Night by the early Netherlandish artist Geertgen tot Sint Jans (*c.* 1455/65–*c.* 1485/95) is not much larger than a sheet of A4 paper. Although St Joseph is depicted as quite a fine-looking man, and younger than in many fifteenth-century Nativity scenes, a modern viewer might not consider the faces of Mary, the angels, or the baby Jesus actually beautiful. Nevertheless, this is a truly delightful little work of art, probably made for private devotional use. One could, in fact, call the painting 'wonderful' in a literal sense. There must be few other Nativity paintings in which wonderment at the birth of Christ is so vividly conveyed.

This was one of the first paintings to depict the Nativity as a night scene, although many later depictions of the subject would adopt that same setting. It was also, like the *Portinari Altarpiece (see page 25)*, one of the earliest to make the main source of light the infant himself, an idea inspired by St Bridget of Sweden (1303–73), who recorded that in her visions the light of the newborn child was so bright 'that the sun was not comparable to it'. Indeed, the foreground of our painting has no other light source at all. But the brightness emanating from the baby in the manger illuminates the stable, and takes us in an upward diagonal from the angel in the bottom left-hand corner, via the central feature of the brightly lit head of Mary in its white headdress, to the face of Joseph on the more shadowy right edge of the painting.

The concentration on the faces of those three figures, directs us back to the subject of their look of awe: Jesus lying in the straw. There, beside the manger, barely visible between Mary and the group of angels, stand the ox and ass, which also stare wide-eyed at the newborn child, as do the other four angels. Three of the angels join their hands in prayer; a fourth leans forward slightly to see over the top of his fellow angel, who stands at the edge of the manger next to the ox. That fifth angel is surely one of the loveliest secondary figures in any religious painting. With his red hair sticking out on either side, he stands with his hands apart in amazement, looking in complete absorption and rapture at the wonder of God made man.

The curved back and head of Mary lead us, via the opening in the stable wall, to the annunciation to the shepherds at the top left. There, a group of five shepherds near the top of the slope are dimly seen by the light of their small fire. Three others, among their sheep slightly further down the slope, are more clearly illuminated by the light of the angel in the sky who brings news of Christ's birth. One of the two standing shepherds, wearing a red cloak, raises his hand to shield his eyes from the angel's brightness, as does the third who, nearest to the angel, has fallen to his knees, overcome by the sight of the angel and the message he brings.

The name Geertgen tot Sint Jans means 'Little Gerard of Saint John', apparently given because the artist lived with the Order of St John in Haarlem, as either a guest or a lay brother. The little that we know about him comes from a book by the Flemish artist and writer Karel van Mander of 1608, and a reference on a 1620 engraving by Jacob Matham. It seems Geertgen was born in Leiden some time between 1455 and 1465 and died when he was not yet thirty. Although Geertgen left only a small number of paintings, understandably given his short life, these demonstrate considerable originality. Probably his most important work was the triptych he painted for the church of the Order of St John with which he was associated. The one surviving shutter of this contains probably the first instance of a group portrait, a genre that was to become important in Dutch painting. However, whatever fame Geertgen might earn for that art-historical achievement, he surely deserves more for this little jewel of a painting, in which animals, angels, and humankind share in awe the miracle of the Incarnation. It is a truly inspirational work of art for a great feast day.

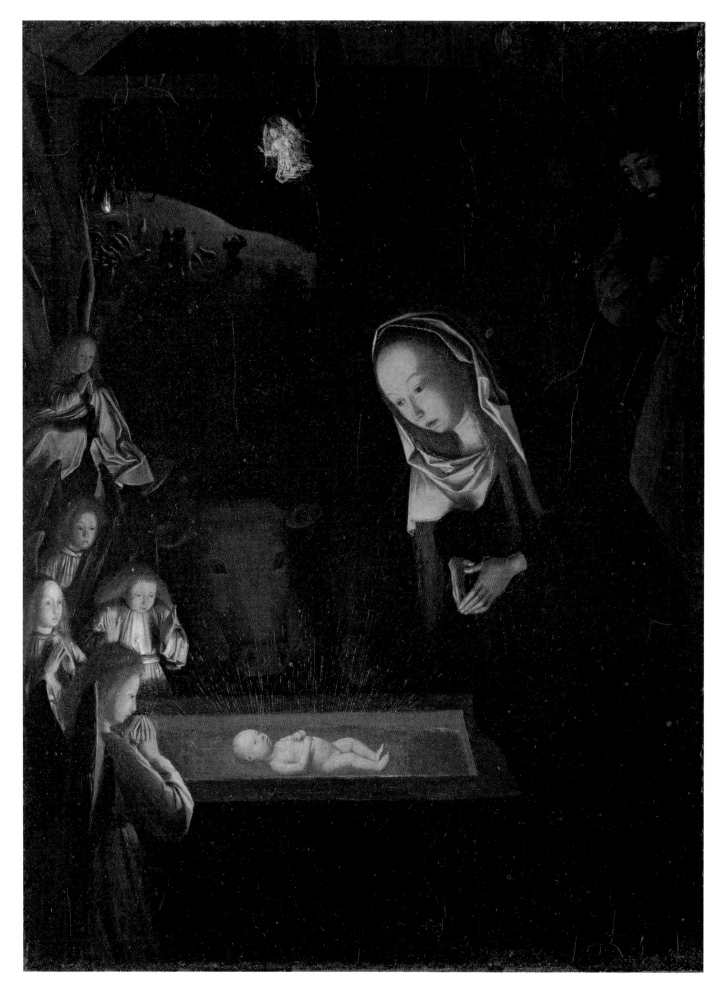

Zanobi Strozzi, *The Nativity*, fifteenth century, tempera and gold on wood, 38.7 × 29.2 cm, Metropolitan Museum of Art, New York

Piero della Francesca, *The Nativity*, 1470–5, oil on poplar, 124.4 × 122.6 cm, National Gallery, London

Puccio di Simone, *The Nativity*, c. 1350, tempera and gold on wood, 20 × 38.1 cm, Metropolitan Museum of Art, New York

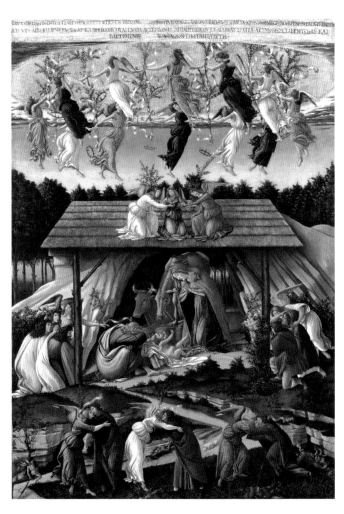

Sandro Botticelli, *The Nativity*, 1500, oil on canvas,
108.6 × 74.9 cm, National Gallery, London

Lorenzo Lotto, *The Nativity*, 1523, oil on panel, 46 × 35.9 cm,
National Gallery of Art, Washington, D.C.

Gerard David, *The Nativity with Donors and Saints Jerome
and Leonard*, c. 1510–15, oil on canvas, transferred from
wood, (centre) 90.2 × 71.1 cm, (wings) 90.2 × 31.4 cm,
Metropolitan Museum of Art, New York

Pupil of Rembrandt
The Adoration of the Shepherds
1646
Oil on canvas, 65.5 × 55 cm

The Adoration of the Shepherds continues the story of the birth of Jesus where we left it in the previous painting by Geertgen tot Sint Jans. The shepherds, having received the 'good tidings of great joy' from the angel of the Lord as they tended their flocks in fields nearby, have now come to the stable in Bethlehem to see the 'saviour who has been born' for them. It is another intensely moving depiction of an episode from the Christmas narrative. Instead of creating a set-piece tableau, like so many other versions of the subject, the artist offers an intimate, domestic scene that combines a high level of fidelity to the gospel story with a similar degree of naturalism and unobtrusive symbolism. There are no signs of the apocryphal midwives, who entered some Western Nativity scenes via the Eastern tradition. Nor do the ox and ass, which did not appear in the original Bible accounts, feature as participants, although one cowlike beast stands across the shadowy background on the left.

Just as St Luke wrote, however, the shepherds who come in response to the angel's message find Mary and Joseph with the baby, 'wrapped in swaddling clothes and lying in a manger'. The shepherd in the foreground with his back to us clasps his hands in prayer, as he kneels leaning forward towards the infant in the straw; his companion to the right, already down on one knee, holds up his hands in awe with the same expression as Geertgen's angel as he gazes on the child; while the elderly shepherd, standing behind with a lantern, makes with his right hand a gesture that is suggestive both of wonder and an instinctive protectiveness.

As well as the other shepherds pressing in behind, the artist has imagined that various family members have been brought along to witness such a momentous event. One of the shepherds' wives helps to lift up a small child to gaze at the baby over the back of a chair, while a slightly older boy, his face illuminated by the lantern, holds back the sheepdog they have brought with them.

The lantern provides a little illumination, but the main light in the painting comes from no normal source. Once again, as in Geertgen's Nativity scene, it is radiated from the Christ Child himself and is a key feature of the work. Most of the canvas is in deep shadow, and thereby it echoes the prophecy of Isaiah that 'on those who live in a land of deep shadow a light has shone'. The light illuminates not only the figures, however. By its glow we are able to see also the heavy wooden beams in the background, and the ladder leaning against the most prominent upright just behind St Joseph's shoulder. To anyone familiar with Western religious painting, these cannot help but suggest the beams of the cross at the Crucifixion and the ladder of the Deposition.

Joseph, standing there behind his wife, seems sunk in a wondering meditation as he absent-mindedly fingers his hat. St Luke tells us that, when the shepherds came to the stable and told the story of the angel of the Lord and his message to them, Mary 'treasured all these things and pondered them in her heart'. Here, sitting with hand on heart, she does indeed seem already engaged in that process.

Dutch artist Rembrandt Harmenszoon van Rijn (1606–69) painted episodes from the scriptures repeatedly throughout his life, and the Holy Family engaged and inspired him more than other biblical themes. Indeed, art historian Gary Schwartz, a leading authority on the artist, wrote that, 'Rembrandt could have been a relative if not a member of the Holy Family. In his imagination, he lived with Mary, Joseph, and Jesus all his life, from his first etchings to his final painting. His many depictions of the infancy and childhood of Christ evoke feelings not only about families, but also about the mystery of the incarnation.'

This painting was once thought to be a sketch by Rembrandt, but now it is believed to have been produced by a talented but unidentified pupil in his studio, probably

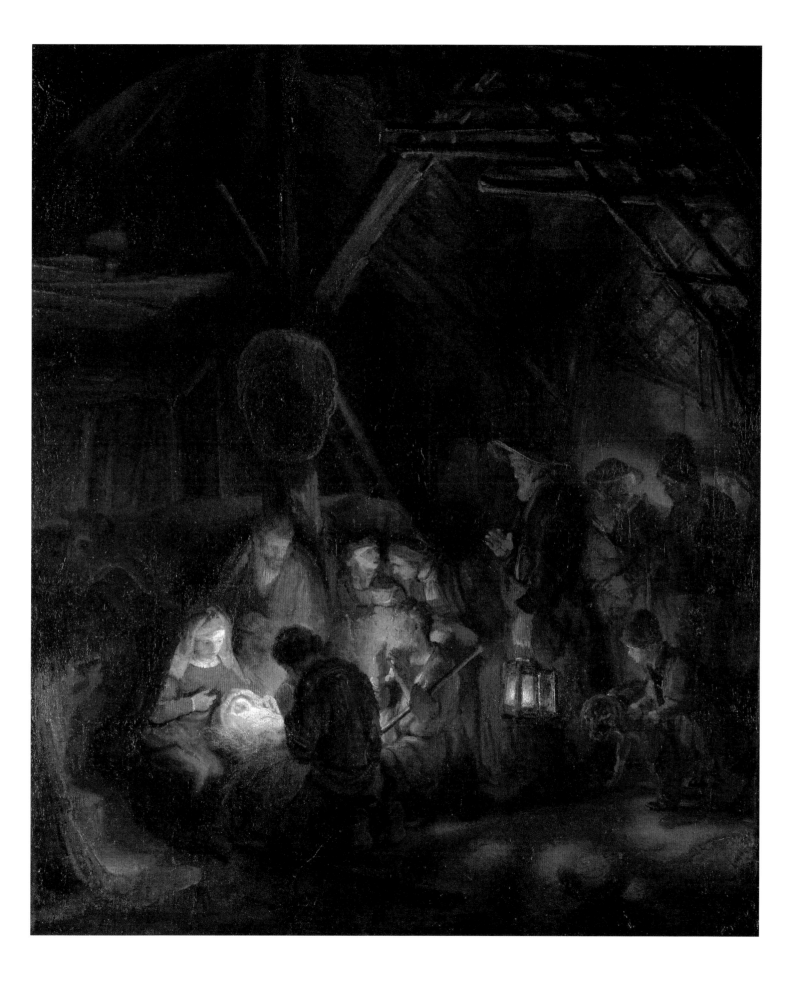

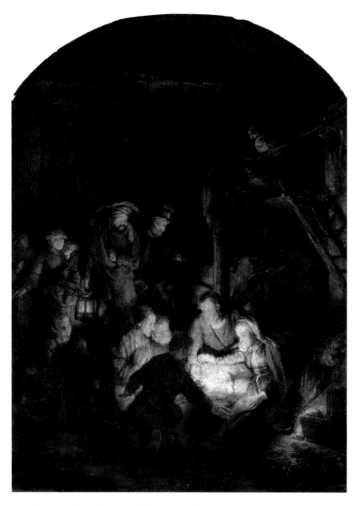

Rembrandt, *The Adoration of the Shepherds*, 1646, oil on canvas, 97 × 71.3 cm, Alte Pinakothek, Munich

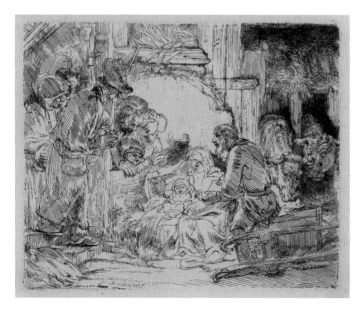

Rembrandt, *The Adoration of the Shepherds*, c. 1654, etching, 10.5 × 12.9 cm, Teylers Museum, Haarlem. In this later print version of the Nativity scene, Rembrandt returned to the motif of the shepherd in the foreground with hands clasped in prayer.

inspired by a work by the master while it was still in the workshop. It closely resembles a painting of the same subject and roughly the same date in the Alte Pinakothek in Munich that we know Rembrandt painted as part of a series of scenes from the life of Christ for the Stadholder of the Dutch Republic, Prince Frederik Hendrik of Orange. Copying works by the master was an important element in the training of the young apprentices in Rembrandt's studio. Sometimes it would involve producing exact copies; at other times, a pupil might paint an individual figure or a variant of the original. Our painting comes in that last category. The Munich picture is around one third larger than our painting and has the reverse composition, the Holy Family appearing on the right and the shepherds on the left. And while in our version, the shepherd in the foreground has his hands clasped in prayer, in the Munich painting Rembrandt had originally depicted him in that way but later chose to change his pose and show him with outstretched arms.

Whoever the artist may have been, he had clearly thought deeply about what the Christmas scene of Luke's gospel would have been like in reality. In this quite small painting, full of the evocative play of light and shadow, he encourages us to do the same and to share the wonder and emotions of Mary, Joseph, and their simple, temporary neighbours, faced with a mysterious event of momentous significance that would influence world history for millennia to come.

Bartolo di Fredi, *The Adoration of the Shepherds*, 1374, tempera on poplar, 175.6 × 114.6 cm, Metropolitan Museum of Art, New York

Domenico Ghirlandaio, *Nativity and Adoration of the Shepherds*, Sassetti Chapel altarpiece, 1485, tempera and oil on panel, 167 × 167 cm, Santa Trinità, Florence

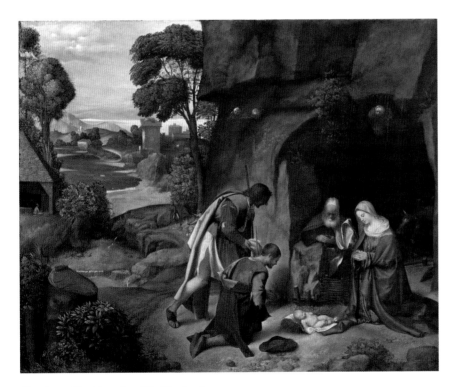

Giorgione, *The Adoration of the Shepherds*, c. 1505–10, oil on panel, 90.8 × 110.5 cm, National Gallery of Art, Washington, D.C.

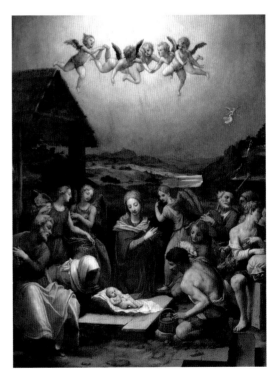

Agnolo Bronzino, *The Adoration of the Shepherds*, 1539–40, oil on wood, 65 × 47 cm, Szépmüvészeti Múzeum, Budapest

Workshop of Giovanni Bellini
The Circumcision
c. 1500

Oil on wood, 74.9 × 102.2 cm

Before the Second Vatican Council in the 1960s, 1 January was celebrated by most Christian denominations as the Feast of the Naming and Circumcision of Jesus. Roman Catholics now hold that day as the Solemnity of Mary, Mother of God, while other churches have maintained the celebration of the traditional feast day and its link with the formal giving of the Holy Name. All of the major denominations retain as the gospel reading for 1 January the same key passage from St Luke, chapter 2, verse 21: 'At that time, after eight days were accomplished, that the child should be circumcised, his name was called Jesus, which was called by the angel, before he was conceived in the womb.'

The Circumcision has been celebrated on this day since the sixth century or earlier. The thirteenth-century work *The Golden Legend* by Jacobus de Voragine, which had a major influence on religious art throughout the Renaissance period, gives four reasons why the feast was regarded as of particular importance. In the first place, it says, it marks the octave of Christ's nativity, the eighth day of Christmastide. In the Christian liturgy, an octave marked the eighth day – or *octava dies* – after a feast and thus fell on the same day of the week as the feast itself. The weekly celebration of the Resurrection itself takes place every 'eighth day', of course, and so that became an alternative name for Sunday. As Jewish circumcision was ritually performed on the eighth day after birth, the number eight later became associated also with baptism, and baptismal fonts have traditionally been octagonal for this reason. The second reason that *The Golden Legend* gives for the feast's significance is that it commemorates 'the imposition of a new and saving name' – that is, Jesus, which loosely means in Hebrew 'God saves' or 'God the saviour'. Thirdly, the feast commemorates the first shedding of Christ's blood and thus marks the beginning of human redemption. Finally, it marks his acceptance of a physical 'seal', related to his acceptance of humanity as

a Jewish child and his obedience to God's covenant with Abraham expressed in the terms of the Mosaic law.

It was almost certainly the third of these reasons that led to the Circumcision becoming established not just as an episode in artistic representations of Christ's life as a whole, but also as a frequent subject for individual paintings. Many of the lay religious fraternities – institutions of some power throughout Italy, but of particular importance in Venice when Giovanni Bellini (*c.* 1430–1516) was active there in the late fifteenth and early sixteenth centuries – had a focus on the blood of Christ and its redemptive power.

The connection between this first shedding of Jesus' blood, which confirms both his humanity and his name as 'Saviour', and the later blood of his passion and crucifixion, was almost certainly in Bellini's mind when he created this image. The composition, notable for its striking use of half-figures in a narrative painting, was inspired by the earlier work of Bellini's brother-in-law Andrea Mantegna, who created the first known example of the device with a picture of the Presentation in the Temple dating from the mid-1450s. Bellini and his workshop went on to develop the model into a highly successful and lucrative genre that would be imitated by generations of successors. While he produced such narrative paintings on many religious and devotional themes, the Presentation and the Circumcision were his favourite subjects, and the studio generated multiple versions. Many of these would have been created by assistants following a cartoon, sketch, or fully finished painting by the master. The workshop made so many copies in this way that it is impossible in most cases to identify Bellini's original or primary picture, if one existed, among the numerous replicas. Although our painting carries his signature in a central place at the base of the picture, it is attributed to his workshop. However, when the faces are so subtly portrayed, and the psychological atmosphere of the

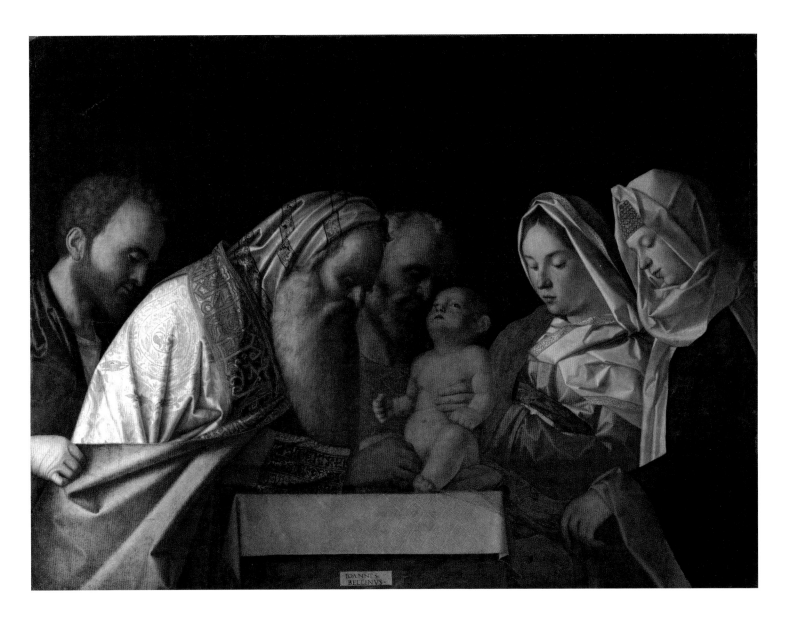

Maestro de la Sisla, *The Circumcision*, c. 1500, mixed media on board transferred to canvas, 213 × 102 cm, Museo del Prado, Madrid. Most Jewish boys in the time of Christ would have been circumcised at home, usually by their father or another male relative. Nonetheless, many Renaissance artists showed the operation performed by a priest in the Temple, often resembling a Christian church.

make us locate the scene in the Temple. Close behind the priest stands an attendant who, with a gloved hand, holds back the priest's outer robe to keep the weight off his arm. In doing this, he reveals the red of the robe's lining that forms, with the red garments of both Joseph and Mary, a broken arch of that colour. This helps to bind the group together into a single unit with Jesus at its centre. The strength of the red is also probably a reminder of the shedding of blood.

The whole atmosphere of this painting is remarkably intimate. Moreover, we are invited to share that intimacy. Many Circumcision paintings place the event at some distance from the viewer, often with quite a number of participants in a large architectural space. One such example is the work by Ludovico Mazzolino in the Palazzo Cini in Venice. Bellini, on the other hand, offers us a close-up view of the baby with five attendant figures. These are all so tightly bound together that each one overlaps with the next in a condensed group, and the depth of the illusionistic space could not be much more than three feet.

It is Mary who supports the child. We see her left hand holding the baby's left side, and can just glimpse the fingertips of her right hand between his right side and elbow. Joseph stands so close behind that either Mary's hand or the baby's shoulder could be supported by his chest. His expression is one of absorbed concentration as he follows the priest's delicately controlled hands. Mary's equal absorption appears to involve an element of anxiety. The female attendant behind her has her eyes modestly lowered. Her left hand, holding the thin band of gauze that covers the folded towel on which the baby is seated, unobtrusively balances the hand of the priest's attendant opposite. Bellini makes clear that this is a very real human baby undergoing a painful procedure. And yet he does not cry. In the effort not to do so, however, he looks upwards with back and neck stiffened and clenches his hands.

painting so intense, it is difficult to believe the master was not himself largely responsible for the painting.

Bellini adopts a remarkably simple composition for his treatment of the event. He provides no architectural details at all. Indeed almost a third of the picture surface is plain black, a highly original feature. However, the solid block of marble, covered by a rich cloth fringed with tassels, is clearly intended to suggest an altar. This, taken along with the priestly figure officiating in his formal robes, is enough to

An unseen light source illuminates the scene from the front and slightly to the left, on the same level as the priest's shoulder. This is both narratively consistent and artistically effective. On the one hand, it is completely appropriate that the light should be directed where it is, to provide the maximum help to the priest. On the other, in doing this it focuses attention not just on the baby and the priest's hands, which are on the central axis of the painting, but also on the faces, illuminated from below, particularly the faces of Mary and the female attendant.

In placing his figures so close to the picture plane, Bellini is here able to take advantage of a device several artists had made use of since the rediscovery of the laws of linear perspective by Filippo Brunelleschi some eighty years earlier. Bellini gives the impression that the edge of the altar is right against the picture plane; in other words, it is right on the line that divides the illusionistic space of the painting from the spectator's actual space. However, he then makes certain elements in the painting, such as the hands of the two attendants, the fold of the priest's robe, and the baby's foot, project beyond the edge of the altar, seeming to bring them into our space, and thereby to involve us, the spectators, in the scene in the Temple.

As we saw in the previous painting by Rembrandt, and as we shall see again with our next painting, also by Bellini, artists expected their spectators to be able to relate episodes from the childhood of Jesus to his later passion and death. So here, when the artist shows us an infant Christ as his blood is shed on a sacrificial altar, with back arched against the pain, he expects us to make the connection with the sacrificial shedding of blood by Christ's arched figure on the cross and the continuation of that sacrifice on the altar in the mass. He also goes out of his way to make us, the viewers, seem like participants in the scene. One in which a totally human Christ, the Messiah promised by the Old Testament,

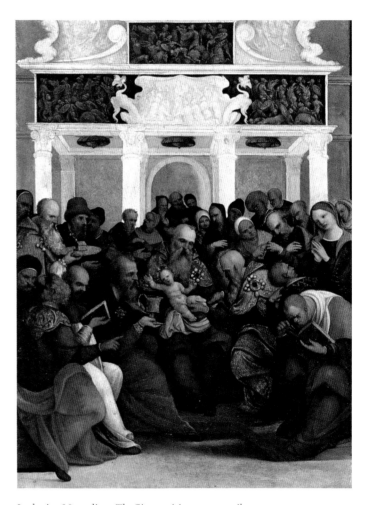

Ludovico Mazzolino, *The Circumcision*, *c.* 1500, oil on panel, 33 × 31 cm, Palazzo Cini, Venice

accepts the name of 'Saviour' as his blood is shed. How appropriate for Christians who, at so many levels, see themselves as both participants in, and beneficiaries of, that moment. How appropriate also that the naming of the one from whom Western civilization will be dated should be associated with New Year's Day.

Giovanni Bellini
Madonna of the Meadow
c. 1500

Oil and egg tempera on panel, 67.3 × 86.4 cm

When the Roman Catholic liturgical calendar was reorganized in the 1960s, this feast was introduced for 1 January. There are a great many depictions of the Madonna and Child that would be appropriate to consider here. One of the best loved is Giovanni Bellini's *Madonna of the Meadow*. Bellini came from Venice's most important family of artists. His father Jacopo and his half-brother Gentile were both accomplished and influential painters, while Andrea Mantegna (1431–1506), later the court artist in Mantua, became his brother-in-law after marrying Giovanni's sister. The relationship between the two men was to be one of mutual respect and reciprocal influence. Bellini revolutionized Venetian painting, developing a more sensuous colouristic style, aided by his use of slow-drying oil paints – a medium thought to have been introduced in Venice in the 1470s – and atmospheric landscapes that had a great effect on pupils such as Giorgione and Titian.

Images of the Virgin and Child are so common in Western art, and many are so familiar, that we often fail to appreciate certain aspects of a painting, and to realize which features would have appeared quite original when it was produced. In the thirteenth and fourteenth centuries, representations of the subject were usually iconic images, showing the Virgin Mary either standing, with Jesus supported on one arm, or seated on a throne with the baby on her knee, normally with a background of plain gold. Much less common were pictures depicting her seated directly on the ground, a form known as 'the Virgin of Humility'. An early example of this type is that by one of Bellini's Venetian predecessors, Lorenzo Veneziano (1336–79), the *Madonna of Humility with Saints Mark and John the Baptist*, from about 1366–70 (*see page 48*). This is a simple horizontal panel in three sections. In the central section, Mary is seated on a low green mound, suckling the swaddled Christ. In the panels on either side, the saints stand on a flat green surface looking in towards the Mother and Child, from whom they are divided by the vertical pillars of the frame.

The effects of the Renaissance in the early fifteenth century, along with the naturalism afforded by the rediscovery of perspective, brought a marked increase in demand for religious narrative painting. Some images that were essentially iconic in type were also given additional narrative elements. An interesting comparison with the paintings of Bellini and Lorenzo Veneziano in this respect is provided by the altarpiece *The Virgin and Child with Saints Jerome and Dominic*, painted by the Florentine artist Filippino Lippi (*c.* 1457–1504) in about 1485 (*see page 48*). Here the Virgin suckling the infant Jesus is again seated on the ground flanked by two saints. All the figures are placed together within a convincing if somewhat idealized landscape setting – although introducing the raptly praying St Jerome from the fourth century and the earnestly reading St Dominic from the thirteenth is clearly not designed to create any sense of narrative realism. In contrast, in Bellini's painting, there are no other foreground figures to distract our attention from the Virgin and Child. In fact, the triangle that encloses them occupies exactly half of the total canvas, thus dominating the picture. The setting is no ideal landscape of the imagination but is, with its plain stretching to the Alpine foothills, and a small walled town on a hill, typical of the Venetian mainland territory north of the city of Venice itself.

Several features strike one about this painting. First, the way in which the whole frame of the baby is within that of the mother, making them a single compositional unit, emphasizes the bond between the pair. That unity is also expressed by colour, as the flesh tones of the naked infant are the same as those of Mary's face and hands. Indeed, the triangular composition leads the eye immediately to Mary's face, from which that colour leads us, via the hands, to the infant Christ. The most unusual thing about him is that

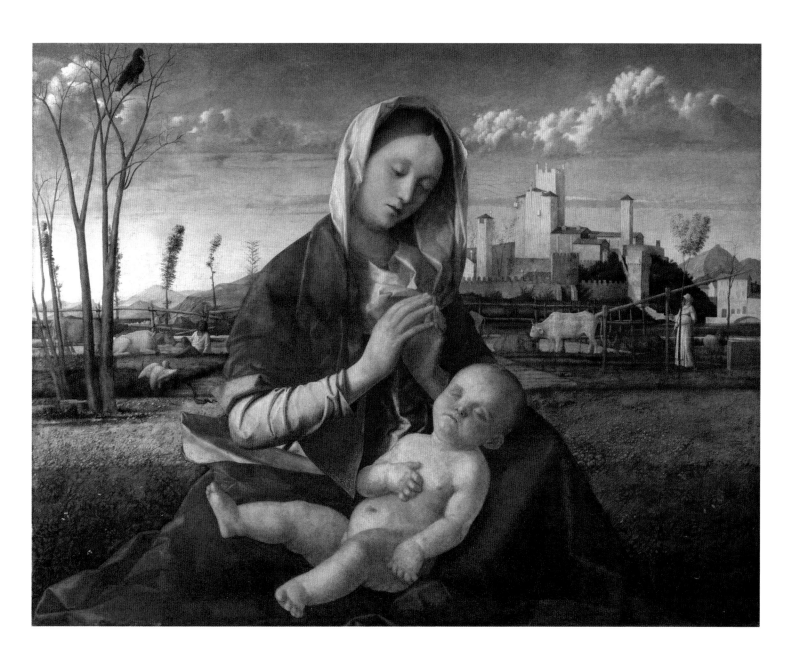

Lorenzo Veneziano, *Madonna of Humility with Saints Mark and John the Baptist*, c. 1366–70, egg tempera on poplar, 31.3 × 57.5 cm, National Gallery, London

Filippino Lippi, *The Virgin and Child with Saints Jerome and Dominic*, c. 1485, oil and tempera on poplar, 203.2 × 186.1 cm, National Gallery, London

he is asleep. Depictions of a sleeping baby Jesus were quite common in Nativity scenes. A popular representation of the theme was to show the newborn baby lying asleep on a cloth on the ground, in the open, with Mary kneeling next to him in prayer or adoration, sometimes, but not always, with Joseph alongside her. But a straightforward Madonna and Child with a sleeping infant was unusual. There is one example by Piero della Francesca (*right*) and another by Cosimo Tura (*see page 50*), both dating from the 1470s. These two works have the Madonna enthroned within an architectural setting, however, not presented as a Virgin of Humility.

Why did Bellini choose to represent the baby Jesus in this way? One possibility is that he did so to allude to some very different representations of Mary in an open space outside the walls of a town, with the pale figure of Jesus with closed eyes lying across her lap. One of the most famous of such *Pietà* images, as they are called, is Michelangelo's statue in St Peter's, Rome, from 1498–9. But the subject of Mary holding the dead body of her son had been well established in painting for many years before that time.

There are several reasons to suppose that Bellini wanted to make the specific association between his *Madonna of the Meadow* and the *Pietà* motif. This painting is dated to some time around 1500. In 1505, Bellini himself produced a wonderful *Pietà* painting now in the Accademia in Venice (*see page 51*). It is very similar in both size and composition to the *Madonna of the Meadow*. Moreover, Cosimo Tura's *Virgin and Child Enthroned*, which, as mentioned above, also has the Christ Child asleep, was originally the central panel of the *Roverella Altarpiece* and had directly above it a lunette with just such a *Pietà*, now in the Louvre. Clearly the association between a youthful Mary cradling the baby Jesus in her lap and her supporting his dead body in a similar position was already established in the public artistic consciousness. Bellini's painting also

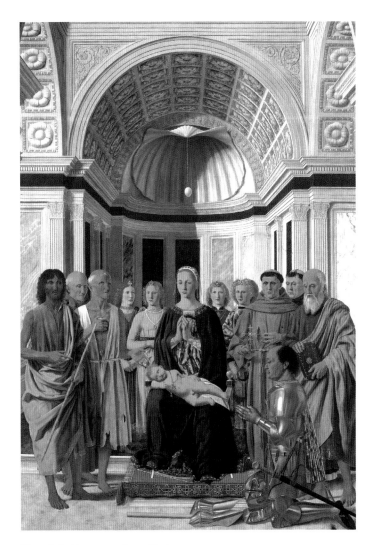

Piero della Francesca, *Brera Madonna*, 1472, tempera on panel, 248 × 150 cm, Pinacoteca di Brera, Milan

Cosimo Tura, *The Virgin and Child Enthroned*, mid-1470s, oil and egg on poplar, 239 × 101.6 cm, National Gallery, London. Photo World History Archive / Alamy Stock Photo.

provides some internal evidence. The strong upward diagonal band that encloses both the baby's head and Mary's hands leads us to the top left-hand corner of the canvas, where a dark bird stands out prominently against the blue sky. Some commentators call this 'a raven', others, 'a vulture'. There are ornithological objections to both identifications. What one can be sure of is that the bird is intended as a symbol of death, and the notion of 'death on a tree' has an obvious resonance in this context. That we are intended to think symbolically about the left-hand section of the painting is confirmed when we look to the bottom of the tree, where an egret is fighting with a serpent. The egret, a white-feathered member of the heron family, is one of the birds that, along with the stork and ibis, kills snakes. Because of the identification of Satan with the serpent in Genesis, the contest of the bird and serpent came to symbolize the struggle of good and evil, with the egret sometimes taken to represent Christ himself. Bellini has borrowed much of this imagery from his brother-in-law Mantegna's *Agony in the Garden* (*see page* 105). There we have the same bird in a tree, though with two egrets at the foot and no serpent.

To the right of the Madonna is a white ox that is sometimes misread as pulling a plough but is, in fact, not attached to anything except its own tail. Beyond it is a latticed fence. To the right of the ox, and slightly closer to the spectator, is a wooden mechanism. This consists of a tapering pole, with a cupped support in the middle and another on which the thicker, and heavier, end of the pole rests. From the thin end of the pole, a rope, which merges at the top with the edge of the white house, descends into the square stone well with its decorated panels. This is a common feature in an agricultural landscape, but here it is possibly also a reference to Christ's meeting by the well with the woman of Samaria, and his promise of 'living water'.

The *Madonna of the Meadow* has many other features of art-historical interest, including, for example, Bellini's wonderful and mysterious light, which clearly falls on Mary and Jesus from above front left, but does not seem to cast shadows. When one has finished considering the narrative and technical details, however, what one inevitably returns to is the face of the Virgin as she looks down on her sleeping baby. She has been told that he will be a light for the nations and a glory for Israel, but also that a sword will pierce her own heart. She loves, she prays, she wonders, yet she does not know, as Bellini and we do, in what circumstances she will hold that son of hers across her lap, in another field, in some thirty years' time.

Giovanni Bellini, *Pietà, c.* 1505, oil on panel, 65 × 87 cm, Gallerie dell'Accademia, Venice

Jan Gossaert
The Adoration of the Kings
1510–15
Oil on oak, 179.8 × 163.2 cm

The word 'epiphany' is derived from the Greek verb meaning 'to show forth'. It is St Matthew who gives us the story of the Epiphany, the 'showing forth' of the Messiah to the non-Jewish world, represented by the magi. In the second chapter of his gospel, he tells us that, after the birth of Jesus, wise men came to Jerusalem from the east. They asked where they would find the infant king of the Jews, as they had seen his star rise and had come to do him homage. King Herod asked the priests and scribes where the Christ was to be born, and they told him Bethlehem. Herod therefore sent the wise men on to Bethlehem saying: 'When you have found him let me know, so that I too may go and do him homage.' They continued until the star they had followed halted over the place where the child was. In great joy, they 'entered the house', saw the child with Mary his mother, and falling to their knees did him homage. Then, opening their treasures, they gave him gifts of gold, frankincense, and myrrh.

The fact that Matthew mentions these three gifts led to the assumption that there were three magi. And it was a later tradition, for which there was no real foundation, that turned the 'wise men' into 'kings', as most Epiphany paintings depict them. By the seventh century, the three 'kings' had been assigned a variety of names and given various characteristics. The most common version of the tradition in the Western Church takes them as representatives of the three known continents. It makes the oldest of the three kings Melchior, from Europe, who presents the gold. Then comes Balthasar, an African from Ethiopia, who gives frankincense. And the youngest is Caspar (or Gaspar), from Asia, who offers myrrh.

The Adoration of the Kings of Jan Gossaert is one of the best-known and best-loved of all Christmas paintings. It is one of those images that attracts the eye immediately by its large scale, composition, and the beauty of colours, even before one has become fully aware of its subject. Some

Epiphany paintings give so much attention to attendant people and circumstances that the principal event may got lost in the detail. Gentile da Fabriano's *Adoration of the Magi* in the Uffizi, for example, is a truly magnificent work, teeming with life and activity (*see page 54*). The dog, horses, and attendants in the right-hand section are presented with as much importance as the Holy Family on the left. But we might not notice the delightful moment of the baby placing his hand in welcome and blessing on the bald head of the kneeling king, for we are distracted by the apocryphal midwives behind Mary, opening with curiosity his not very impressive gift; we focus less on the second king than on the ox beside him; and our attention is diverted from the third royal visitor by his servant as he wisely removes his spurs for him, before he kneels to present the somewhat insignificant pot of myrrh.

Gossaert's composition, on the other hand, is designed to focus attention very specifically on the mother and child, the three kings, and their gifts. It rewards close examination. The very centre of the painting is on Mary's right cheek, and the face of the Child Jesus is placed on the central vertical axis. The open arch of the ruins, revealing beyond it a light sky between the two dark masses of the flanking walls, together with the positioning of the picture's vanishing point (established from the lines of the flooring tiles), just within that open arch on a level with the Virgin's head, automatically draws the eye to that area. There we find first the strong central triangle formed by the Virgin and Child and the kneeling king, Melchior. The beautiful strong blue of her robe makes us focus immediately on Mary and the baby that she is holding. Then the diagonal lines of the right-hand side of the triangle, created by Melchior's back and, in parallel, the left arms of both Melchior and Mary, lead the eye up towards the two angels above on the left, where those lines are picked up by the right wings of the green and white angels respectively.

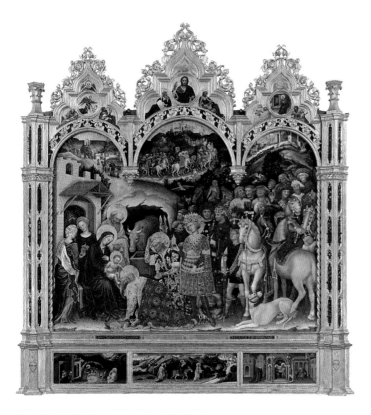

Gentile da Fabriano, *Adoration of the Magi*, 1423, tempera on panel, 203 × 282 cm, Galleria degli Uffizi, Florence

The strong verticals of the walls that frame the angels bring our eyes down to King Balthasar immediately below them on the left. From him, it is natural to move across to the balancing figure of Caspar on the right. But as we have noted, Gossaert does not make us focus just on the three magi themselves, but also on the gifts they bring. When one stands before the original, it is possible to see that the cup presented by Melchior, the lid of which he has placed on the tiles next to his crown-encircled hat and golden sceptre, is full of gold pieces. The gesture of the baby Jesus, as he puts out his hand to accept this chalice and its contents, is full of significance. It reminds us of the moment in the garden of Gethsemane when Jesus prays that, if possible his 'chalice' may pass from him, but says he will accept it if that is his Father's will (see Giovanni Bellini's *Agony in the Garden*, page 102).

The way in which the other two kings hold their treasures before them gives them far greater prominence than in most paintings of the magi. The gifts they brought have traditionally been seen to work on two levels. On the one hand, gold, frankincense, and myrrh have been taken to refer respectively to the kingship, priesthood, and death of Christ; on the other, the donation of those gifts has been seen as the offering to Christ of one's wealth, adoration, and self-sacrifice. However, an interesting and unusual extra dimension seems to be at work here, as Gossaert appears to be introducing a deliberate liturgical element into the painting. Not only has Melchior placed the lid of his gold container next to his crown and sceptre, thus associating his offering with those symbols of kingship, but also the container is, unusually, not a casket but a chalice. That, of course, makes reference not just to Gethsemane but also to the celebration of the mass. In fact, while the vessel held by Mary may at first suggest a chalice, when we see its cover on the ground, we realize that, with that lid in place, it would be more like a ciborium, the vessel that holds the hosts.

We have, therefore, associations with both the bread and wine of the Eucharist.

The gifts held by Balthasar and Caspar provide examples of the highly intricate and much-prized work of the goldsmiths of the fifteenth and sixteenth centuries. Specifically, they resemble very closely the forms of reliquaries, monstrances, and censers of that period, as well as that of many church buildings in the Low Countries, such as the one glimpsed through the arch. The association with elaborate gold reliquaries immediately takes us mentally inside one such church; the relation to monstrances and censers takes us to the liturgy within that church.

We note that, while Caspar holds his offering respectfully, he holds it in a single hand, with his eyes fixed on the infant Jesus. Balthasar, however, holds his in both hands, protected from the grip of his bare hands by a white silk shawl, and he gazes fixedly at it as the attendant behind lifts the bottom of his cloak. This is close to the image of a priest bearing the monstrance with the host, attended by an acolyte, which today would be associated, within the Catholic tradition, with the liturgical devotion of Benediction.

That devotion did not exist as such at the time that Gossaert was painting. However, exposition of, and processions with, the consecrated host had been common for well over a hundred years, often combined with devotions to the Virgin Mary. On these occasions, both the monstrance carrying the host and the censer bearing the incense would be very similar in form to these elaborate gold containers held by Balthasar and Caspar, and would surely be evoked by this imagery for Gossaert's original spectators. It is also noteworthy that, although difficult to decipher even when in front of the original, and impossible when dealing with a small reproduction, the opening of the prayer to the Virgin Mary, '*Salve Regina*' ('Hail Queen [of Mercy]'), is embroidered on the hem of the white shawl.

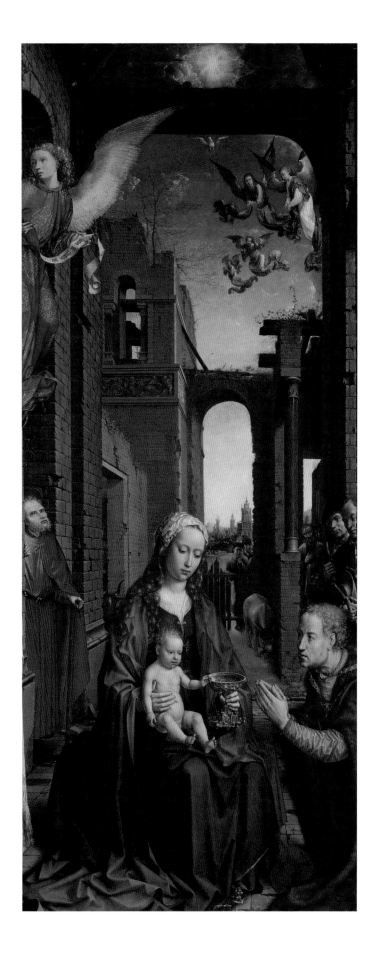

Some commentaries on this painting refer to the 'annunciation to the shepherds' in the background. While it is true that we can see a shepherd with a flock of sheep through the lower central arch, the four angels seen through the upper arch seem to be paying all their attention to the adoration of the kings in the foreground rather than to anyone tending animals. We can, however, on the extreme right of the painting, see a representation of the train of the kings coming down a hillside. Then, in the middle ground of the central area we have, already present, the shepherds who have also come to see the infant Jesus. Their simple clothes offer a contrast to the rich garments of the royal retinue, and their work is emphasized by the fact that the leading shepherd, half hidden by the pillar, has his hat in one hand and shears in the other. Their features, along with those of the visitors from the East, show the wonderful variety of human individuals. Also, partly hidden on the other side, is St Joseph, depicted in accordance with tradition if not probability as an old man with white hair, using a stick for support.

We saw earlier that Matthew tells us that the magi 'entered the house', meaning the family house that Mary and Joseph could have moved into from the animals' quarters when other kinsfolk had departed after the census, before the arrival of the magi. However, Gossaert's setting within classical ruins is one often employed in Nativity and Epiphany paintings, as it serves both a narrative and a symbolic purpose. On the one hand, such ruins would be a sensible place to stable the ox and ass, the apocryphal, if not unlikely, witnesses of the birth. We see these behind the Virgin's shoulders. On the other hand, the ruins symbolize the decline of the old Roman world, which the birth of Christ and rise of Christianity will bring about. Interestingly, in 1508 Gossaert was asked to accompany Philip of Burgundy to Rome, to make drawings of the Colosseum and other ruins.

Hieronymus Bosch, *The Adoration of the Magi*, c. 1475, oil and gold on oak, 71.1 × 56.5 cm, Metropolitan Museum of Art, New York. The artist has located the scene in a semi-ruined structure that doubles up as a dwelling-place for animals.

Workshop of Gerard David, *The Adoration of the Magi*, c. 1520, oil on wood, 70.5 × 73.3 cm, Metropolitan Museum of Art, New York. As in Gossaert's version, the classical setting here not only serves a symbolic function, it also reflects the spread of Renaissance ideals from Italy to northern Europe from the mid-fifteenth century.

Just below the top of the wider arch hovers the dove of the Holy Spirit, and immediately above, within the triangular shape that surmounts the arch, is a bright star. This provides a dual reference. At the level of the story, it refers to the star that, as St Matthew tells us, brought the wise men to the birthplace of Jesus. However, a star in that position, particularly when reinforced by a triangle, symbolic of the Trinity, also traditionally referred to God the Father. That this reading is intended here is reinforced by the fact that Gossaert, in a slightly earlier painting with a very similar structure, *The Holy Family with Angels*, now in Lisbon, shows the dove similarly placed above the Mother and Child, over which, in a similar aura of light, is an actual depiction of God the Father. Gossaert then, within his representation of the moment from the gospel narrative in which Jesus is revealed to the nations, establishes Christ's position within the Trinity. Furthermore, he infuses that representation with an awareness of Christ's passion and death. He evokes the continuation of that sacrifice in the mass, and of the other liturgical occasions through which the varied individuals who make up his Church continue their adoration.

The painting was probably produced as an altarpiece for the Lady Chapel of St Adrian's church in Grammont in East Flanders, south of Ghent and west of Brussels. How fitting that such a beautiful and richly significant picture should provide a backdrop for the rituals designed to give honour to the Virgin Mary, as well as glory and adoration to the Father, Son, and Holy Spirit.

Piero della Francesca
The Baptism of Christ
after 1437
Egg on poplar, 167 × 116 cm

The frequency with which St John the Baptist appears in painting from the early Renaissance onwards is an indication of the unique position he held within Christianity, and a reminder of the importance of Christ's baptism at his hands in the gospel story. As noted previously, all four gospels emphasize the coming of the Baptist in fulfilment of the prophecy of Isaiah. The three synoptic gospels of Matthew, Mark, and Luke describe John's baptizing of Jesus and the descent of the Holy Spirit in the form of a dove, accompanied by a voice from heaven. They all then follow this episode with the temptation of Christ after forty days in the wilderness, after which he began to preach in Galilee. The gospel of St John does not refer to Christ's baptism as such, but tells us that the Baptist declared that he had seen the Holy Spirit descending on Jesus in the form of a dove, as a voice from heaven had told him would happen to the Chosen One of God. St John's gospel follows this episode with the calling of the first disciples by Jesus. All four gospels, then, see the baptism by John as the beginning of Christ's public life and ministry.

Piero della Francesca's representation of this episode is quite enigmatic in several respects, although the formal elements of the painting are very much designed to concentrate attention on the figure of Christ and on the act of John's baptizing. Piero depicts the Jordan as a narrow and shallow stream. There appears to be a deeper pool in which the sky is reflected and, closer to the spectator, a shallow area that seems to be in shadow. Given that Christ appears to be illuminated from the upper front right, such a shadow on the water could not logically come from the overhanging tree depicted, although the representation of light and shadow within the painting is not wholly consistent. The paleness of Jesus' body and its central position, between the dark colour of John's camel-hair garment on one side and the strong dividing vertical of the tree on the other, ensure

that the gaze is immediately focused on the figure of Christ. The spectator's eye-level is set low down, roughly level with Christ's waist. The gaze then travels upwards to the darker element of his bearded face and head. The curve of the head is echoed immediately above in the curve of the bowl in the hand of the Baptist, and echoed again on a much larger scale by the curve of the painting itself.

The face of Jesus, on which Piero makes us concentrate, is notable for its intense, introspective seriousness. That this is a human being is emphasized by the pale vulnerable flesh and the broad feet firmly planted on the ground beneath the shallow water. However, the concentration on the face reminds us that this person is being asked to accept the reality of his divinity, and to embark on a public life that will lead to death on a tree like the one next to him. The dove of the Holy Spirit hovers protectively, its ambiguous shape making it almost merge with the surrounding clouds, while also suggesting the form of a cross.

Because of the profile view, one gets little impression of John the Baptist himself, apart from the sense of care and concentration in his action, expressed by the tension in his left arm, the gentleness of the pouring with his right hand, and the intentness of his gaze on the face of Jesus, his cousin.

Possibly the most unusual aspect is that provided by the three remarkably human angels. Many fifteenth-century paintings of angels emphasize their ethereal nature. These three have some of the usual attributes: wings, a coronet of roses, and a half coronet of olive leaves. However, Piero seems to go out of his way to give them a strong physical presence. The feet of the white-robed central angel are planted on the ground with the same firm solidity as those of Christ. As he looks with seeming amazement and concern at Jesus, his left hand clasps the left hand of his blue-robed counterpart. That angel also looks on with concern, and his right hand lies heavily on his companion's shoulder.

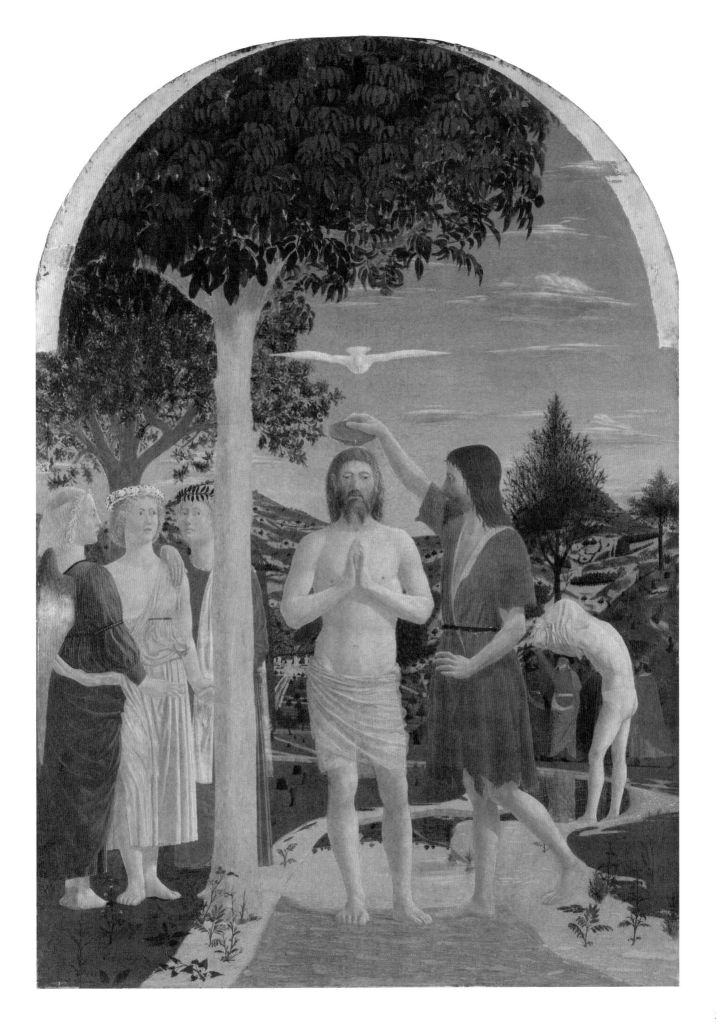

'Can it really be', they seem to wonder, 'that God will allow his only son to suffer and die as a man?'

Another slightly enigmatic note is struck on the right-hand side of the painting. There a group of four figures, seemingly in the robes of priests, scribes, or Pharisees, are partially hidden by the male figure who is removing his garments prior to being baptized. The second figure from the left has turned and points up towards the dove, but the others look in different directions. Both Matthew and John refer to the Pharisees who came to John the Baptist, and Matthew makes the Baptist's use of the phrase 'brood of vipers' refer specifically to them. While the four figures themselves are almost camouflaged in the landscape, the reflection of the lower half of their garments stands out brightly in the water.

Although Piero della Francesca enjoyed a considerable reputation in his own lifetime, he rather sank into obscurity after his death, and it was really only in the twentieth century that his importance in the development of Italian painting became acknowledged. The *Baptism* was the central panel of a polyptych, almost certainly painted for a chapel dedicated to St John the Baptist in Piero's home town of Borgo Sansepolcro in Tuscany. It is richly symbolic. John the Baptist is a New Testament figure and a Christian saint. He was, however, often thought of as the last of the line of prophets in the Old Testament. One notes, for example, that Fra Angelico, in his painting of *Christ Glorified in the Court of Heaven*, includes John with such Old Testament figures as Moses and David (*see page 187*). John has told his disciples that, although he baptizes with water, the greater one to come after him will baptize with the Holy Spirit. The pouring of water on the head of Jesus in the presence of the Holy Spirit can, then, be seen as John's passing on of his rite of baptism to Jesus. Here is the moment at which the law and prophecy of Judaism and the Old Testament are being fulfilled, and superseded. The voice from heaven, which claims Jesus as the Son, again in the presence of the Holy Spirit, declares the Trinitarian nature of the one true God, just as the angel's annunciation to Mary had also done.

After the Resurrection, Jesus gave his final instructions to the apostles, telling them to go and make disciples of all nations, and to 'baptize them in the name of the Father, and of the Son, and of the Holy Spirit'. It is at the moment of baptism that the individual believer actually becomes a Christian. That term would first be used to designate the followers of Jesus some ten years after the event depicted by Piero. One could, however, say that what the artist succeeds in showing us here is, in a very real sense, the birth of Christianity, and the introduction to the world of a 'new testament'.

Andrea del Verrocchio, *The Baptism of Christ*, 1472–5, oil on wood, 177 × 151 cm, Galleria degli Uffizi, Florence. This painting was produced in Verrocchio's workshop in Florence and is thought to show evidence of the hands of several of his pupils as well as that of the master. A young Leonardo da Vinci is recorded as having painted the angel on the left, but some modern commentators believe that he also painted parts of the landscape in the background and the figure of Christ.

Gerard David, *Baptism of Christ*, 1502–8, oil on panel, 182 × 132.2 cm, Groeningemuseum, Bruges. This baptism scene also contains an image of the Trinity, with God the Father and the Holy Spirit in the form of a dove appearing above Christ. The background depicts scenes from the life of John the Baptist. The side panels show the donors and their children. On the left is Jan de Trompes, treasurer of Bruges, who is presented by John the Evangelist, while his deceased first wife Elisabeth is also presented by her name saint, John the Baptist's mother saint Elizabeth.

Master of the Life of the Virgin
The Presentation in the Temple
c. 1465–70
Oil on oak, 83.8 × 108.6 cm

The feast of the Presentation of the Lord, on 2 February, has replaced the one previously called the Purification (or Candlemas), although both really celebrate the same moment in the biblical story, and the gospel reading for each is largely the same. That passage, from the second chapter of St Luke, stresses the unity of the two events: 'And when the day came for them to be purified as laid down by the Law of Moses, they took him up to Jerusalem to present him to the Lord – observing what stands written in the Law of the Lord.' The opening reference to the 'Law of Moses' concerns the requirement established in Chapter 3 of Leviticus. This stated that a woman who has given birth to a son must have him circumcised after eight days. Then, after a further thirty-three days she must go to the Temple to be purified. On that occasion, she must bring to the priest a lamb for a holocaust, and a young pigeon or turtledove as a sacrifice for sin. If she cannot afford a lamb, she can substitute another young pigeon or turtledove. The second reference to the 'Law of the Lord' is to the command of Moses in Exodus 13, that all firstborn males should be consecrated to God, in recognition for the deliverance of the Israelites from Egypt, after the firstborn of the Egyptians were destroyed. It would be natural that both these requirements of the Mosaic law should be fulfilled at the same time.

Luke tells us that when Mary and Joseph took Jesus into the Temple they were met by the holy man Simeon, to whom the Holy Spirit had revealed that he would not die until he had seen the Messiah. Simeon took Jesus in his arms and said:

Now, Master, you can let your servant go in peace,
just as you promised;
because my eyes have seen the salvation
which you have prepared for all the nations to see,
a light to enlighten the pagans
and the glory of your people Israel.

There was also in the Temple the elderly prophetess Anna, who came up, praised God, and 'spoke of the child to all who looked forward to the deliverance of Jerusalem'.

This painting shows the moment at which Simeon takes the baby Jesus in his arms. The gospel does not actually state that Simeon was a priest, but that is how he is always depicted. Because very little was known in the fifteenth century about either the interior of the Temple or the vestments of a Jewish priest, both are depicted as in a contemporary Christian context. So Simeon, vested in alb and cope, stands on the lowest of the three altar steps, in front of a typically constructed altar, which has candlesticks at either side and a sculpted stone altarpiece behind. Just as a typical fifteenth-century altar might have as an altarpiece a triptych with three narrative scenes from the New Testament, this one has three scenes from the Old Testament: the stories of Abel, Isaac, and Noah, all taken to have special reference to the life and death of Christ. The panel on the left shows, in the background, Abel and Cain offering sacrifice and, in the foreground, Abel being killed by Cain. The central panel shows the angel holding back the sword with which Abraham is about to sacrifice Isaac. The right-hand scene shows the drunken Noah, lying beside his spilled wine. The youngest son, Ham, mocks Noah's nakedness, while the two elder sons approach with a cloak with which to cover their father. These episodes were interpreted as having particular relevance to the passion of Christ and hence to the mass.

The offerings made to God by Cain and Abel provide the first examples of sacrifice referred to in the Bible. Abel, a good man and a shepherd, who is killed out of jealousy, offers God a lamb. Jesus called himself the 'Good Shepherd', and in the sacrifice of the mass is referred to as 'the lamb of God', the title given to him by John the Baptist in St John's gospel. For all fifteenth-century Christians, the sacrifice of

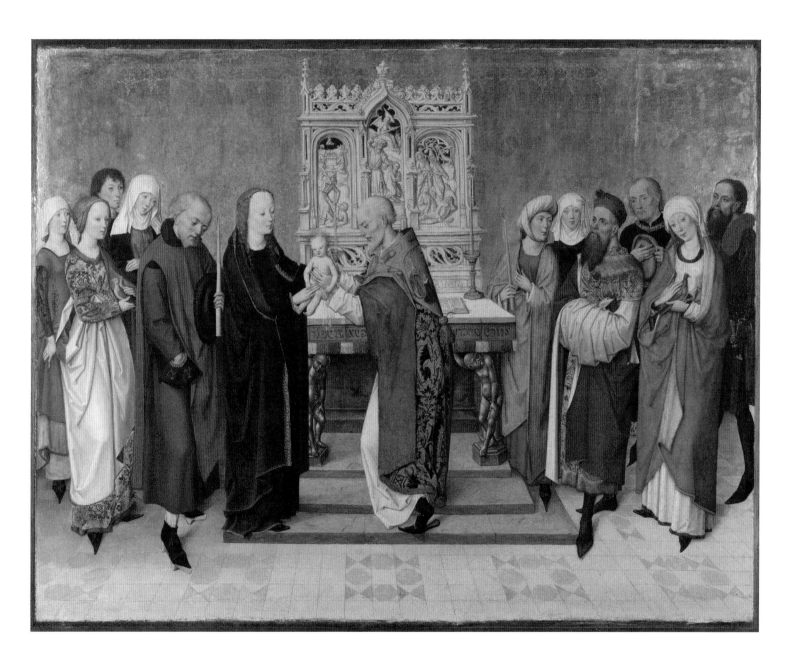

the mass was identified with Christ's offering of himself in sacrifice on the cross. Abraham's willingness to sacrifice his son was seen as a reflection of God the Father's allowing his son to be sacrificed; while Isaac's carrying of the wood for that sacrifice was thought to prefigure Christ's carrying of the cross to Calvary. For his part, Noah was credited with being the first person to produce wine, with its obvious associations with the Eucharist; and the mockery of him by Ham was seen as prefiguring the mockery of Christ in his passion. One notes that the priestly alb referred to earlier, is traditionally taken to allude both to the garment of mockery put on Christ by Herod and, in its whiteness, to the eternal purity and joy of those redeemed by Christ's blood.

St Joseph, whose fine face is one of the many delights of this painting, stands just behind the Virgin Mary. He is putting his right hand into his purse. This is because, as the gospel states, Mary and Joseph, as good orthodox Jews, were 'observing what stands written in the Law of the Lord'. And what stands written (in Chapter 18 of Numbers), is, that when the firstborn son has been presented to God, he is to be redeemed at a price of five shekels. As Joseph reaches for the five shekels with his right hand, he holds in his left hand a rod, from the tip of which a new shoot has grown. This attribute of Joseph is a reference to the legend that Mary's suitors were all presented with a rod, and when Joseph's sprouted that was taken as a sign that he was chosen by God to be Mary's husband.

In the attendant group of relatives and friends, the young woman immediately behind Joseph holds the two doves that Mary, as a person of little wealth, is about to offer. On the other side, the woman nearest to the altar can be identified as Anna because she wears a turban, which is traditionally associated with a sibyl or prophetess. Indeed, although it may be difficult to make out in a reproduction, in the original one can see that the picture embroidered on the

top of Simeon's cope is of 'the vision of Augustus'. According to legend, when the Roman senate wanted to declare the Emperor Augustus a god in his own lifetime, Augustus consulted the Tiburtine Sibyl as to whether he should accept this honour or not. The Sibyl revealed to Augustus in a vision that a child would shortly be born who would be greater than all earthly rulers, thus causing Augustus to reject the senate's proposal. The Sibyl depicted on the cope wears a very similar turban to that of Anna.

With regard to the group on the right of the painting, to whom Anna is speaking about the baby, the suggestion made by some commentators that the man at the front is probably Anna's husband is definitely wrong, as the gospel states clearly that she was a widow. It seems, indeed, far more probable that he is intended to be the husband of the young woman next to him, although their business in the Temple is unclear. The man, in spite of the fact that his hands are hidden in his sleeves, is grasping a paper of some sort. The woman carries a single dove. They have no child with them, and there does not seem to be any obviously relevant case within the Mosaic law that requires the offering of a single dove.

While the Virgin Mary has the typical disc-shaped halo, the infant Jesus has rays of light emanating from his head. He is also positioned in front of one of the lighted candles on the altar. Both of these details seem to be a deliberate reference to the words of Simeon that the child is 'a light to enlighten the pagans'. They also link to the custom of the procession with, and blessing of, candles on this 'Candlemas Day', as does Anna's holding of a lighted candle similar to the ones on the altar. We may also observe that the candle held by Anna, in shape and approximate size, balances the rod held by Joseph.

This painting is one of the eight panels showing scenes from the life of the Virgin Mary that originally formed an

 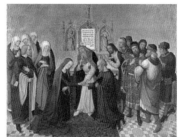

 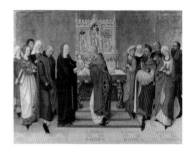 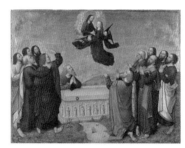

Master of the Life of the Virgin, the eight panels for the *Life of the Virgin* altarpiece, *c.* 1460, for St Ursula's Church, Cologne, all panels oil on oak, 83.8 × 108.6 cm: (top row, from left) *Joachim and Anna Meeting at the Golden Gate*; *Nativity of Mary*; *Presentation of Mary in the Temple*; *Marriage of the Virgin*; (bottom row, from left) *Annunciation*; *The Visitation*; *The Presentation of Jesus in the Temple*; *Assumption of the Virgin*

altarpiece in St Ursula's Church in Cologne. Because almost nothing is known of the anonymous artist, he is always referred to simply as 'Master of the Life of the Virgin'. Whoever he was, he certainly needs to be acknowledged for this lovely work. It was produced at a time of transition in the history of art. The developments of the Renaissance spreading from Italy and other innovations from the Netherlands were, in this period, influencing painters in the rest of Europe, including Germany, but were not yet familiar everywhere, and even where known, they were not always adopted. So, although this artist creates a more believable illusion of three-dimensional space than would have been possible sixty years earlier, he does not actually follow the rules of single-vanishing-point linear perspective, leaving the impression that the floor and steps of the Temple have a definite slope. He still uses a traditional gold background, and he does not provide the effects of a consistent light source nor anatomically accurate proportions for the baby's head and body.

What he does give us, however, is real recognizable human beings with genuine human feelings. One of the most touching details is that of the aged Simeon who, in his haste to grasp the saviour he has waited so long to see, is about to lose his left shoe – an instance of true humanity.

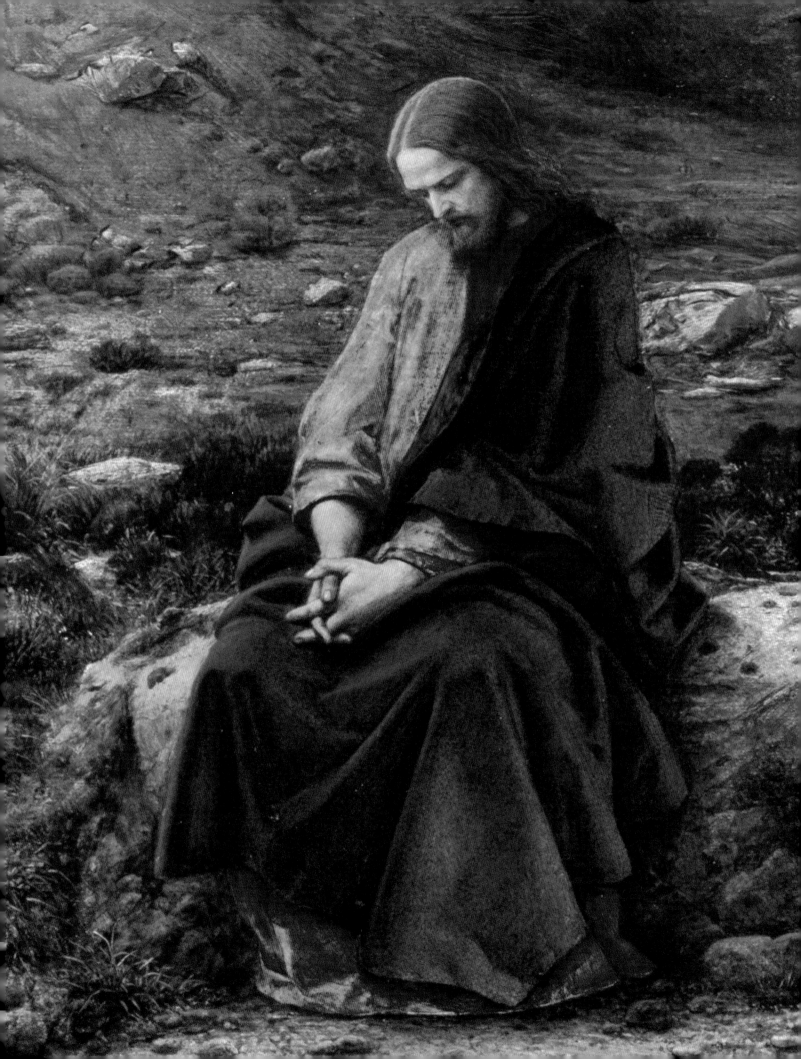

LENT

William Dyce
Man of Sorrows
c. 1860

Oil on millboard, 34.3 × 49.5 cm

Although Christ's fast of forty days in the wilderness, and his temptation there, is treated in several major painting cycles on his life, it is an unusual subject for an individual easel picture. This work, by the Scottish artist William Dyce, is one of great interest, particularly in the context of its time. Dyce was born in Aberdeen in 1806. He spent two periods as a young man in Rome, where he came under the influence of the group of German painters known as the Nazarenes, who worked there principally on religious subjects. Then, after a brief period in Edinburgh as a portrait-painter, he spent most of his career in London, where he died in 1864. He was not formally involved with his younger contemporaries the Pre-Raphaelites, but he influenced them and gave them support, and was in return impressed by their ideas and techniques.

Dyce was a leading member of the Royal Academy in London, declining its presidency in 1850. He was also influential in the development of what became the Royal College of Art, and was the first Professor of the Theory of the Fine Arts at King's College, London. He reintroduced the art of fresco painting to Britain and worked very successfully in stained glass. He also had considerable skills and interest in music, as both a scholar and composer. A very committed High Church Anglican, Dyce devoted most of his musical efforts to religious purposes. Although his painting oeuvre was by no means exclusively religious, including, for example, mythological works, much of it was explicitly Christian. There was also often a religious or spiritual background to works that were not overtly religious.

The middle of the nineteenth century was a time of religious turmoil in Britain. The publication of *The Principles of Geology* by the Scottish geologist Charles Lyell in 1830–3 had led to a radical change of view concerning the age of the universe. Up to the end of the previous century, most of western Europe had accepted a calculation based on the

Book of Genesis that made the universe a few thousand years old. When evidence from fossils and rock strata made it necessary to think in terms of many millions of years, and to see the human race as a comparatively recent arrival in that timeline, parts of the Old Testament could no longer be seen as historical fact. Within the next thirty years, not only had biblical scholars shown that the origins of the sacred texts were far more complex than had been believed, but also the work of Charles Darwin and Alfred Russel Wallace on evolution by natural selection had demonstrated that many phenomena, previously regarded by theologians as firm proof of 'design' by a supreme intelligence, were the result of a continuum of minute changes over the aeons. Such developments caused many Christians to question their beliefs. Some simply denied the relevant evidence. Others who accepted the science could be divided into two groups: those who turned, or drifted, to either atheism or agnosticism; and those who succeeded in reconciling the advances in scientific knowledge with their Christian faith. While Darwin and eventually Lyell belonged to the former group, Dyce was an important figure in the latter.

Man of Sorrows was painted around 1860. The relevant episode is described in all three synoptic gospels, and acts as the prelude to Jesus's public ministry after his baptism by John. Mark gives only a brief reference to the forty-day fast and temptation. The other two versions are almost identical, although Matthew's order of the second and third temptations is reversed by Luke, who tells us that, after being led into the desert by the Spirit and not eating for forty days, Jesus was hungry. The devil said to him, 'If you are the Son of God, tell this stone to turn into bread.' Jesus replied, 'Scripture says a human being does not live by bread alone.' The devil then showed him all the kingdoms of the world in a single moment and said, 'All this power and splendour will be yours ... if you will adore me.' But Jesus responded,

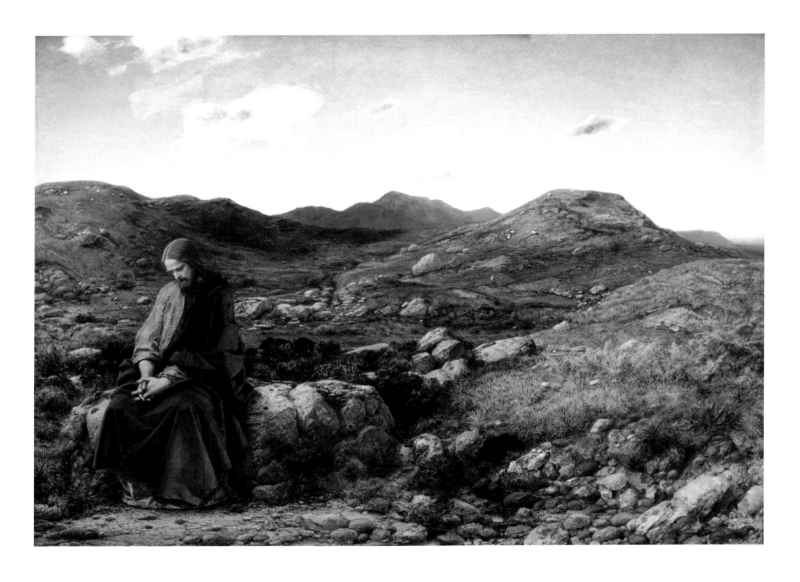

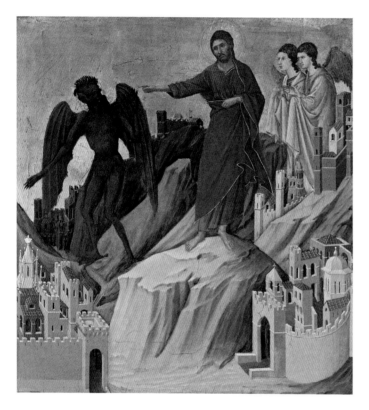

Duccio di Buoninsegna, *The Temptation of Christ
on the Mountain*, 1308–11, egg tempera on wood,
43.2 × 46 cm, Frick Collection, New York. This panel is
from the Passion cycle on the reverse side of Duccio's
Maestà produced for Siena Cathedral (*see page 83*).

'Scripture says, "You must adore the Lord your God and
serve him alone."' The devil then set Jesus on the pinnacle
of the Temple in Jerusalem and said: 'If you are the Son of
God, throw yourself down from here, for Scripture says,
"He has given his angels orders about you, and they will
carry you in their hands so that you do not hurt your foot
against a stone."' But Jesus replied, 'It is said, "You shall not
test the Lord your God."'

One deduces that this account was based on what
Jesus had told his disciples, and one assumes from the
second temptation in the narrative that Jesus, conscious
of exceptional gifts, rejected the devil's suggestion to use
those powers to acquire worldly might and become the type
of Messiah that the Jews were expecting. However, the key
phrase that forms part of the other two temptations is:
'If you are the Son of God.' The 'hypostatic union', the
concept that the person Jesus Christ had both a human and
a divine nature, is a mystery of faith. But to be fully human,
Jesus would necessarily share the basic uncertainty that is
fundamental to the human situation; indeed, he would
experience it in an extreme form. While the rest of us may
have to wrestle with doubts about the existence of God,
which is ultimately a matter of faith, Jesus here has to
wrestle with doubt as to whether he actually is God in
human form. Again, as a human being, his only weapon is
faith, supported by prayer and scripture. The temptation
here is to try to do something to prove his own divinity to
himself, but he remembers the statement from scripture
that one must not attempt to test God. Faith must suffice.

Probably the two most influential representations
of Christ's temptation in the desert are those in Duccio's
Maestà and in Botticelli's frescoes in the Sistine Chapel. The
former depicts Satan very much as the fallen angel, totally
black with featherless ribbed wings, like those of a dragon,
and clawed feet. Botticelli emphasizes the ability of the devil

Sandro Botticelli, *Temptations of Christ*, 1480–2, fresco,
345.5 × 555 cm, Sistine Chapel, Vatican, Rome

to deceive by presenting what is evil as what is good. His
Satan is disguised as a holy man, but with his dark wings and
scaly claws visible, in spite of the religious habit he wears.

In Dyce's painting, the artist does not resort to any
such medieval representation of the devil as a strange evil
creature. In fact, he does not depict Satan at all. His emphasis
is on the fact that Jesus is alone, and that his struggle is an
internal one. Dyce does, however, follow the advice given to
Christians by preachers in the fourteenth and fifteenth
centuries, and followed also by both the Nazarenes and
Pre-Raphaelites. Their suggestion was to try to imagine the
gospel scenes as taking place within one's own familiar
surroundings. Dyce does not, therefore, offer us a bare, stony
Palestinian waste, but a Scottish moorland landscape remote
from habitation. While the stones in the foreground clearly
relate to the temptation to 'turn these stones into bread',

Félix Joseph Barrias, *The Temptation of Christ by the Devil*, 1860, oil on canvas, 58.4 × 47 cm, Philbrook Museum of Art, Tulsa. Like Duccio four and half centuries earlier, this French nineteenth-century artist has chosen to represent Satan as a demonic figure sent to tempt Christ in the desert.

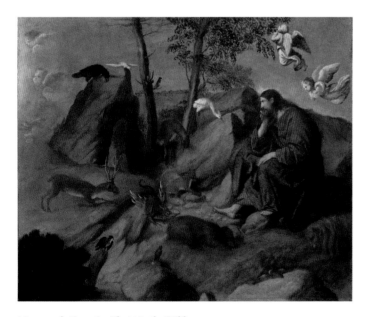

Moretto da Brescia, *Christ in the Wilderness*, c. 1515–20, oil on canvas, 45.7 × 55.2 cm, Metropolitan Museum of Art, New York. Here Jesus seems to be at peace with the creatures that surround him despite the inner turmoils he must contend with.

the prominent larger rocks together with the more distant mountains, both produced by many millennia of geological forces, speak to the preoccupations and doubts of Dyce's own time. Although Jesus went without food for forty days in the wilderness, he would obviously have needed water to survive. The artist, therefore, provides a spring on the hillside. The water from this is seen most clearly to our right of Jesus's left upper arm. From there, it seems to flow diagonally down the slope and bend round the back of the rock on which Jesus is sitting, to reappear a couple of metres to his left a little below a line from his feet, and disappear a little closer to the centre of the painting at the bottom edge of the picture plane. Although a spring of running water makes narrative sense, it also has other immediate associations for a Christian. On the one hand, it suggests the inner strength given by the Holy Spirit on which all Christians must rely when facing a time of spiritual darkness and struggle, as Jesus is here. On the other, it links with the reference to the 'living water' that Jesus tells the woman of Samaria he can offer when, with this present struggle won, he is able to begin his public ministry.

Undoubtedly the most unusual element in this painting, from a compositional point of view, is the placing and posture of Jesus. The painting is about him. He is the only person, indeed the only non-natural element, in the landscape. Yet he is placed well away from the centre of the work and occupies only approximately ten per cent of its surface area. Moreover, with his ascetic, fasting face bent down and his powerful, sensitive hands clasped, probably in prayer, Jesus does not look out at us or attempt to engage with us as spectators in any way. Why has Dyce chosen this presentation? In the first place, Jesus is resisting the temptation to pursue worldly power and glory. He later tells his disciples that they must not follow the example of the Pharisees, who love to be the centre of attention and

Ivan Kramskoi, *Christ in the Desert*, 1872, oil on canvas, 180 × 210 cm, Tretyakov Gallery, Moscow. In a composition that closely resembles Dyce's picture, Jesus is shown deep in contemplation amid a rocky, barren landscape, a figure not of action but of mental anguish.

Carl Spitzweg, *Ash Wednesday*, 1860, oil on canvas, 21 × 14 cm, Staatsgalerie, Stuttgart This allegorical painting by the German artist Spitzweg shows an isolated figure reflecting, as did Jesus, on his fate. The imprisoned Harlequin-like character is perhaps regretting a night of excess during the Mardi Gras carnival that precedes the start of Lent.

who win social approval and status by a mere outward show of religious observance. Rather, they must follow his example of humility, mercy, acceptance of the will of God, and service to others. So Jesus sits away from the natural focal point, head bent in submission to the will of the father. And then the decision not to allow any eye contact between Jesus and the spectator emphasizes that he is completely alone with his own thoughts, temptations, and inward struggles. He has no human contact for support.

However, the way that Dyce's composition works in practice is itself of considerable symbolic interest. When we instinctively look to the centre of the picture for its main significance, the downward diagonal slope of the hills from the right automatically takes us to the bottom left-hand section, to which we are simultaneously attracted by the one area of bright colour there. Moreover, every time we look away from that part of the picture, those elements work to bring our attention back. In other words, when we move away from Jesus, he draws us back to himself. When we seek him, we find him, as he told us we should. When we find him, we see his example, and we are reminded that he shared all our human trials: hunger, poverty, homelessness, hatred, betrayal, torture, death – and doubt. He confronted them with our same weapons: faith, prayer, the scriptures, and the living water of the Holy Spirit. He was thus able to preserve the greatest human gift, love. Love for God and love for his neighbour. Love not just for those grieving for him at the foot of the cross, but for the strangers who crucified him in ignorance. And as he said, we shall find him in our own surroundings: in the poor, the sick, the persecuted and suffering, as well as the lonely and those struggling for faith amidst doubts.

Zanobi Strozzi
The Annunciation
c. 1440–5
Egg tempera on wood, 104.5 × 142 cm

In his seminal book *Lives of the Artists* of 1568, the Italian painter and biographer Giorgio Vasari provides an account of the life and work of the saintly Dominican master Fra Angelico (*c.* 1400–55). In listing the artist friar's paintings, he says: 'In San Francesco outside the San Miniato gate, there is an Annunciation by his hand.' In that church in Florence, now known as San Salvatore al Monte, there is a chapel endowed by the Lanfredini, an old Florentine family closely allied in the fifteenth century to the ruling Medici. The circular symbol on the capitals of the two columns in this painting has been identified as the insignia of the Lanfredini, which has led to its being identified as the one referred to in the *Lives*. Vasari's attributions are by no means always reliable, however, and scholars have realized for many years that this painting was not in fact by the hand of Fra Angelico, although from the same period as his work and in very much the same style. More recent scholarship has allowed the work to be attributed with confidence to Zanobi Strozzi (1412–68), one of the four pupils of Fra Angelico mentioned specifically by Vasari. Attribution to Strozzi was hard to question when the name 'Zanobi' was discovered concealed in the embroidery on the hem of Mary's robe.

One can immediately see reasons why the painting might, on a casual examination, be thought to be by Fra Angelico; and why, on a more detailed consideration, even without the aid of modern technology, it would be seen not to be. On the one hand, the basic composition of Strozzi's painting is very similar to that of three of Fra Angelico's most famous representations of the Annunciation: those in San Marco in Florence, the Diocesan Museum in Cortona, and the Museo del Prado in Madrid. In all those paintings, we have the Virgin seated in an open loggia, separated by a central column from the Archangel Gabriel, who bows towards her, with left foot forward and left knee bent, very much as here in Strozzi's painting. However, in

all of Fra Angelico's Annunciation scenes set in a loggia, he shows some of the side columns on the left, as well as those across the front, neither of which appear here. Moreover, although the painting of necks may not have been Fra Angelico's principal strength, in none of his works does the head of the Virgin sit on the neck quite so awkwardly as it does here; nor do any of his Gabriels have quite such a pointed nose as Strozzi's. That is not to deny that this is a work of considerable charm and interest.

There is, however, another reason that would make one doubt that this could be by Fra Angelico. The art historian Michael Baxandall has shown that there are five types of Annunciation painting, corresponding to the five emotional states that, according to fifteenth-century preachers, the Blessed Virgin passed through in the course of this event, as narrated by St Luke. These were, according to the preachers: disquiet; reflection; inquiry; submission; and merit. If we look at the four paintings reproduced on the following pages – those by Sandro Botticelli, Filippo Lippi, Leonardo da Vinci, and Carlo Crivelli – we can see that they represent four different specific moments in the gospel narrative. Luke tells us that, at the angel's greeting, Mary 'was deeply disturbed' by his words. Botticelli's painting (*see pages 2–3 and 76*) represents this moment of 'disquiet'. Mary's perturbation is registered by the backward movement of her body and the protective gesture with both hands. In fact, the hand positions and gestures in Annunciation pictures are, as Baxandall indicated, highly significant and accord with generally accepted conventions of their period. So, when an artist is representing Mary's moments of reflection, as she 'asked herself what this greeting could mean', she is shown, with one hand, palm inwards across her breast, as in the version by Filippo Lippi (*see page 76*). When, in response to Gabriel's next words, she inquires, 'How can

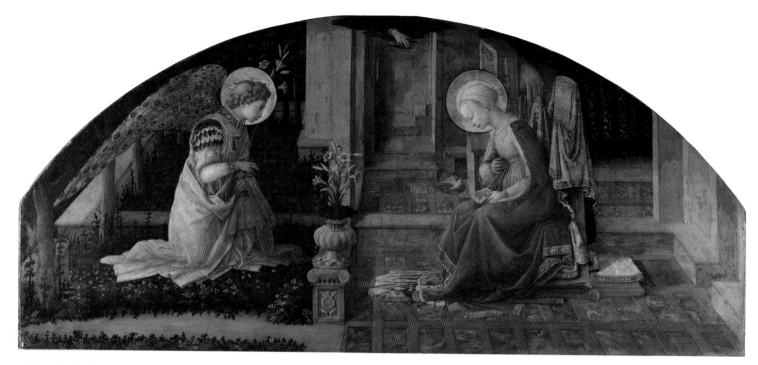

Filippo Lippi, *The Annunciation*, *c.* 1450–3, egg tempera
on wood, 68.6 × 152.7 cm, National Gallery, London

this come about as I am a virgin?', she is shown making what
was, at the time, an accepted interrogative gesture, with one
open-palmed hand slightly raised and partially outstretched,
as in the painting by Leonardo da Vinci. After Gabriel's
explanation, Mary shows her submission to the divine will
with her arms crossed over her breast, as she says that she
is 'the handmaid of the Lord'. This moment is the one shown
by Carlo Crivelli in his interesting and unusual *Annunciation*.
Depictions of the state of 'merit' show the Blessed Virgin
in meditation after the departure of the angel. This last
type of presentation is far less common than the others
and would often, instead of an 'Annunciation', be referred
to as 'The Virgin Annunciate'.

Fra Angelico, in his numerous Annunciation paintings,
always depicts the Virgin's moment of *acceptance*, her hands
crossed over her breast, as in his best-known depiction of
the event in the Convent of San Marco in Florence. Strozzi,
however, has the Virgin with just one hand, palm inward
over her breast, in the gesture of *reflection*, as she 'pondered
what this greeting might mean'.

Many Annunciation paintings show Gabriel carrying
a lily as a symbol of Mary's purity, or include a vase of lilies in

Sandro Botticelli, *Cestello Annunciation*, 1489, tempera
on panel, 150 × 156 cm, Galleria degli Uffizi, Florence.
Photo Peter Barritt / Alamy Stock Photo.

Carlo Crivelli, *The Annunciation, with Saint Emidius*, 1486, egg and oil on canvas, 207 × 146.7 cm, National Gallery, London

Fra Angelico, *The Annunciation*, 1437–46, fresco, 230 × 297 cm, Convent of San Marco, Florence

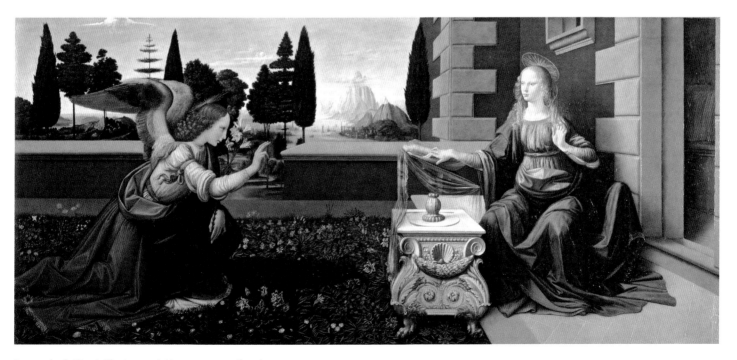

Leonardo da Vinci, *The Annunciation*, *c.* 1472–5, oil and tempera on panel, 98 × 217 cm, Galleria degli Uffizi, Florence

the Virgin Mary, because of the mention of a 'well of living waters' in the Song of Solomon, just as the reference to the enclosed garden three verses earlier was also taken to refer to her.

When Mary asks Gabriel how she can give birth to a son, since she is a virgin, the angel replies: 'The Holy Spirit will come upon you, and the power of the Most High will overshadow you.' So, we see here the Holy Spirit, represented in the form of a dove, as he appeared at Christ's baptism. The dove reminds us, then, not only of the angel's words. Through his position above the fontlike well, he also brings to mind both Christ's own baptism and the continuation of the sacrament of baptism within the Church. There is also the association with Christ's speech on 'living water' to the woman of Samaria, which took place beside Jacob's Well.

Water itself has several liturgical associations. Within the Eucharistic celebration, the mixing of the water and wine, at an immediate level, represents the water and blood that flowed from Christ's side at the Crucifixion, but has also been seen as symbolic of the union of Christ's divine and human natures. Strozzi clearly want us here to be reminded of the sacrifice of Jesus on the cross. We see, through the left-hand arch, the stark upright of a tall tree flanked by smaller trees on either side, alluding to the crucifixion of Jesus between two thieves. The connection is reinforced by the setting of the trees against a high hill. This, with a path leading up to the walled city, is suggestive both of Christ's entry into Jerusalem and his road to Calvary.

The fruit of the trees on the left of Strozzi's painting offers another well-recognized religious symbol, but again one that is unusual in an Annunciation painting. The pomegranate has two established meanings in Christian art. On the one hand, it represents the Church, through

the room with her. Strozzi instead has lilies outside the loggia, in the enclosed garden, which is itself often used as a symbol of Mary's virginity. Also prominently shown in the garden is a well. This is a less-common feature in Annunciation paintings. But as we noted in our discussion of Velázquez's *Immaculate Conception* (*see page 21*), a well or fountain is often employed symbolically in connection with

the concept of many being united in one; on the other, it represents the Resurrection, a meaning it acquired via the pagan myth of Proserpina and her return each year as the spring.

There are two rather unusual features in the central section of the painting, between the angel and the column. Through the top right-hand part of the left arch is a distant view. However, the almost schematic pyramidal blue hills, with their hilltop towns, set on a white ground and what appears to be the beginning of a white hillside almost up against the arch itself, seem stylistically at odds with the rest of the background. Moreover, the foreground in front of that same arch is just a blur of different colours, an almost modernist display of abstraction. There appears to be no reference to the painting's being either damaged or unfinished, and bearing in mind it was almost certainly commissioned for, and placed in, an important Florentine church, that section seems out of keeping with the meticulous painting of the rest of the work.

Whatever the explanation, those elements scarcely detract from the interest of this work. We are shown the moment of Mary's 'reflection' on Gabriel's message. Her positive response will lead to the Incarnation of the Son of God. But Strozzi is able, through his imagery and within a coherent narrative scene, to produce a great many relevant resonances. He relates the moment depicted to the baptism of Jesus, to the 'living waters' of his message to humanity, to his death on the cross and to his resurrection; while we are also reminded of the Church he established and the sacraments it administers, particularly the Eucharist, when water is mixed with the wine, as it was with Christ's blood on Calvary. We could, in fact, say that Strozzi, in one and a half square metres, offers a synopsis of much of St Luke's gospel and a little of his Acts of the Apostles as well.

Duccio di Buoninsegna
The Entry into Jerusalem
c. 1310

Egg tempera on panel, 101 × 56 cm

Palm Sunday is the final Sunday of Lent and marks the beginning of Holy Week leading up to Easter. Its name relates to the reception that Christ was given on his entry into Jerusalem just before his crucifixion. The accounts of his entry are almost identical in the three synoptic gospels, and John also provides the same principal points. When Jesus was in sight of Jerusalem, his disciples put their garments on a borrowed donkey as a saddle for him to sit on. As he rode into the city, he was accompanied by a great throng of people. Some spread their garments on the road in front of him; others cut palm fronds and strewed these in his path, as they sang, 'Blessed is he who comes in the name of the Lord. Hosanna in the highest.'

Palm Sunday is also known as Passion Sunday. The two names are significant and are reflected in the two parts of the liturgy of the day, as celebrated by all the main Christian denominations. Its origins can be traced back at least as far as the fourth century. The first part of the service involves the reading of one of the gospel accounts of Christ's entry into Jerusalem, along with hymns and a procession of the faithful carrying palm fronds, which are often formed into a cross. In some Mediterranean countries, such as Italy, the palm leaves are often replaced with olive branches. Then the main part of the liturgy includes a reading of the whole of one gospel account of the Passion of Jesus, including the Last Supper, the betrayal by Judas, the Agony in the Garden, and Christ's arrest, trial, mockery, death on the cross, and burial.

There are countless images of individual events from Christ's passion. But undoubtedly one of the finest series of paintings, covering both the entry into Jerusalem and the whole story of the Passion, is that by Duccio di Buoninsegna (*c.* 1255–1318/19), for the main altarpiece of Siena Cathedral. This great work has seen many vicissitudes, and continues to present a problem that exercises art historians to this day.

The altarpiece was completed in 1311, and on the day of its installation, which had been declared a public holiday in Siena, it was carried through the streets of the city in joyful procession to its position on the high altar of the cathedral. It was a massive, double-sided work. The city of Siena was dedicated to the Virgin Mary, and the front of the altarpiece, facing the congregation, had an enormous central panel representing the Virgin and Child enthroned in majesty, surrounded by angels and saints. From this image, the altarpiece as a whole was known as the *Maestà*. Around the edge of the painting, the artist had written in Latin: 'Holy mother of God, be thou a cause of peace to Siena and life to Duccio because he painted thee thus.' The predella immediately below this panel showed seven events from Christ's childhood, interspersed with paintings of Old Testament prophets, while above were images of the apostles. The pinnacle panels had apocryphal scenes relating to the death of the Virgin. The back of the altarpiece, which during services would be visible only to the clergy sitting in the choir area, contained the story of Christ's passion and resurrection, on the four central rows of panels. The predella on this side contained scenes from the earlier parts of the gospels, and the pinnacles depicted gospel episodes that followed the Resurrection.

At some point in the sixteenth century, the altarpiece was taken down and dismantled because it was thought too old fashioned. The front and back were separated, and the individual scenes from the predella and pinnacles were sawn apart. These eventually ended up in art galleries around the world, including Washington, New York, Philadelphia, Fort Worth, London, Madrid, and Brussels. The principal sections of both front and back remained in Siena, however.

The problem referred to earlier concerns the order in which the artist intended the four rows of panels telling the story of Christ's passion to be read. At least four different

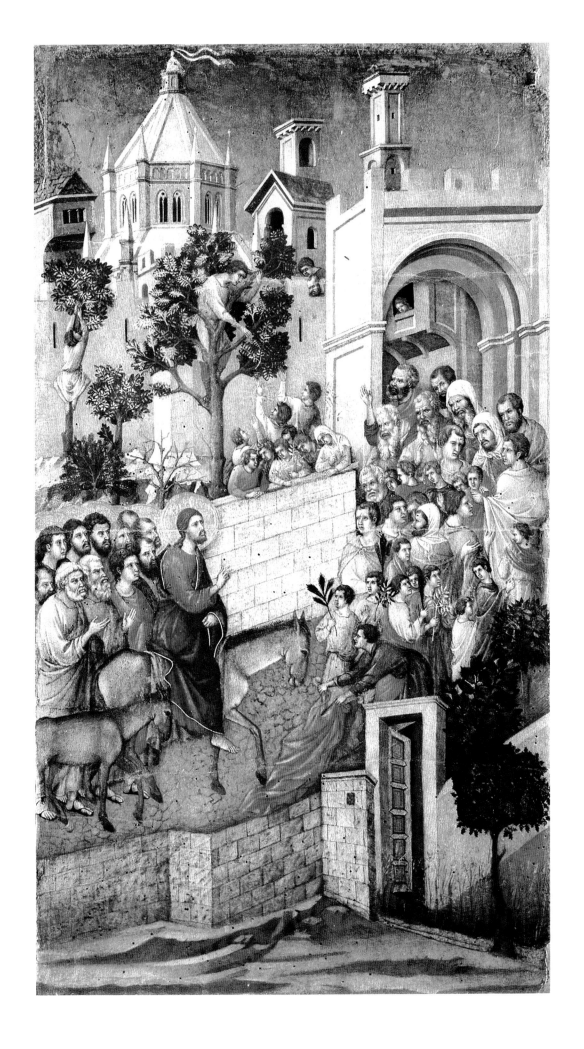

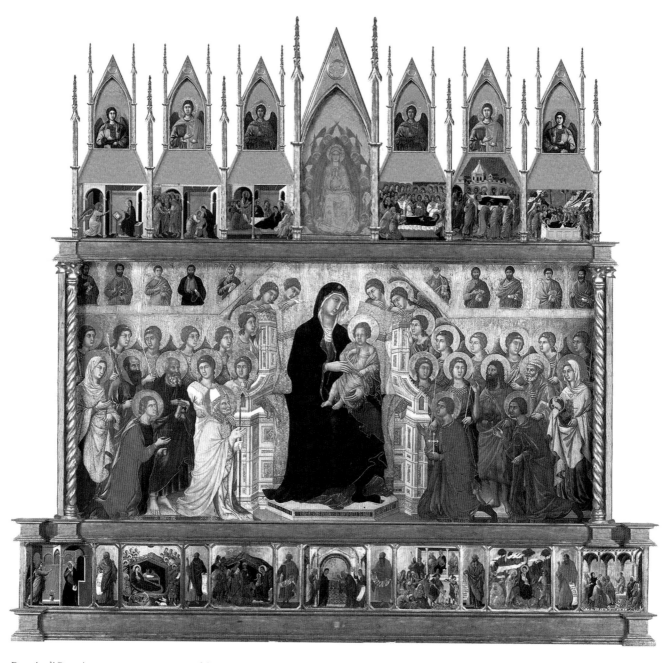

Duccio di Buoninsegna, reconstruction of the *Maestà*,
altarpiece (front), 1308–11, tempera and gold on panel,
213 × 396 cm, Museo dell'Opera del Duomo, Siena

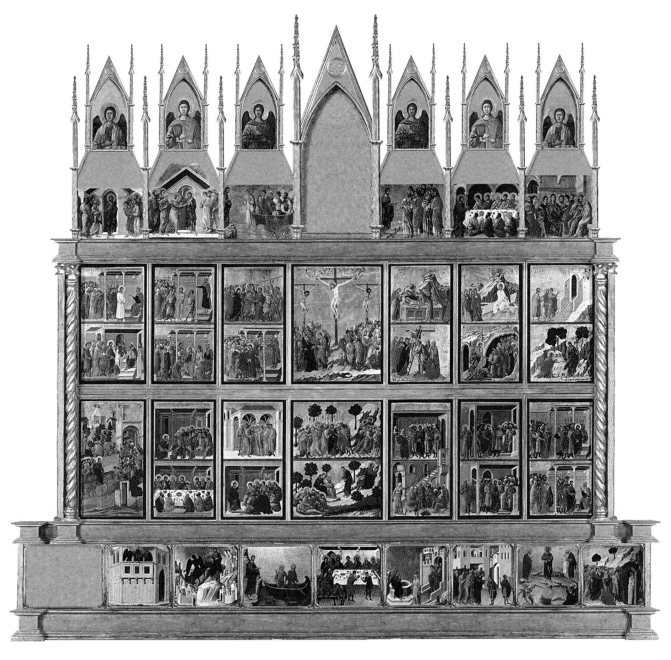

Duccio di Buoninsegna, reconstruction of the *Maestà*,
altarpiece (back), 1308–11, tempera and gold on panel,
213 × 396 cm, Museo dell'Opera del Duomo, Siena

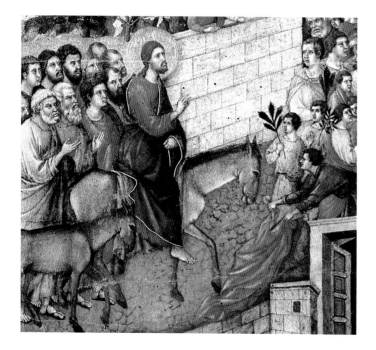

orders have been suggested by art historians. Everyone agrees that the images are intended to be read from left to right, and that the bottom two rows come before the top two. Luciano Bellosi, the author of the most authoritative book on the *Maestà*, then takes each panel on a lower row to be read in turn ahead of the one immediately above it. The problem with this reading, however, which is acknowledged by Bellosi, is that it places the crowning with thorns before the scourging at the pillar, although in all four gospels the scourging comes first. However, the other, more complex suggested readings, all proposed to solve that problem, create yet further complication of their own in terms of the gospel narrative. Aside from these, there are also strong artistic reasons for adopting Bellosi's approach.

The opening panel of *The Entry into Jerusalem*, at the lower left, not only covers both of the lower two tiers, but has very strong upward diagonal lines from left to right. This immediately establishes the idea of taking two rows together and reading them upwards as one moves from left to right. That strong upward diagonal is reinforced by the slope of the hillside in six subsequent scenes: the Agony, Arrest, Crucifixion, Entombment, Resurrection, and appearance to Mary Magdalene; it is also emphasized by the staircase of the First Denial, by the door of hell in the Descent into Limbo, by the tomb lid in the Resurrection, and finally by

the entrance to Emmaus. We shall see later X-ray evidence revealing Duccio's consciousness of such strong lines, and where they lead the eye, when we consider two predella panels for the Feast of the Transfiguration (*see pages 169 and 171*). We shall also return shortly to it in relation to our main Palm Sunday panel of *The Entry into Jerusalem*, at which we must now look more closely

Within the *Maestà* as a whole, Duccio combines details from all the different gospel accounts. This panel is no exception. John tells us that Jesus entered Jerusalem riding a 'young donkey' (*onarion* in Greek, *asellum* in Latin), although, in the swiftly following quotation from Zachariah, he uses the Greek phrase *polos onou*, which the Vulgate translates with the Latin *pullus asinae*, both phrases meaning 'foal of a donkey'. Luke and Mark, with similar usage, both speak of Jesus borrowing 'a foal that no one has yet ridden'. Matthew, however, speaks of two animals: a female donkey and her foal, and uses the same terminology when he too quotes Zachariah. We see that Duccio has followed Matthew here, as Jesus is clearly riding an older animal, while a foal follows close behind. We also note the green cloak on which Jesus sits, in place of a saddle. Matthew, Mark, and Luke all mention the people strewing their garments in front of Jesus, so Duccio allows plenty of space to give a good view of the young man laying his large red cloak in Christ's path. Next to

him, we see three children with their palm fronds ready. The indication seems to be that these have been passed along a chain from the two young men in the field, who have climbed trees to cut off branches and drop these down to others. Both Matthew and Mark speak of the people cutting foliage. However, John is the one who refers specifically to 'palm branches', and Judea was apparently well known for its palm trees. While the other evangelists emphasize the people who accompanied Jesus, both in front and behind, it is John who also speaks about the people coming out from Jerusalem with great enthusiasm to welcome him when they heard he was coming. Matthew also mentions the great excitement and the tumult of curiosity generated by his arrival.

Duccio, therefore, shows us this heightened atmosphere. Some of his people line the side of the road behind the wall on the left; others are clearly walking towards the city entrance in front of Jesus, but meeting a crowd coming out of the city towards him; and curious citizens or visitors look down from the walls and windows. As the three synoptists all speak of Jesus entering the Temple as soon as he is inside the city, Duccio shows us, at the top left of the panel, the large hexagonal, sunlit dome, which he clearly intends to be the Temple.

For Palm Sunday, then, this one panel gives us a concise, but very full account of the event that Christians celebrate on this day in the first part of the liturgy. Then, when we remember the other name, Passion Sunday, and the second part of the liturgy, we have in the totality of Duccio's narrative a similar concise, full, and inspiring account of Christ's suffering and death. Naturally as we enter Holy Week, we are already beginning to look beyond Good Friday to the climax of the liturgical year in the greatest of all Christian feasts, Easter.

Let us go back to what we said about Duccio's consciousness of the directional lines he creates. One of the most wonderful things about this magnificent Passion series is the strength of that upward diagonal line established in the opening panel. A straight edge placed along the neck of the donkey that carries Jesus, leads across Calvary, across the centre of the cross and Christ's dead body in the Deposition, straight up the line of the lid of the open tomb, and through the open gates of Emmaus. Christ, riding into Jerusalem, is heading not only to his ignominious death on Calvary, but to his glorious resurrection, and to the celebration of the very first Holy Communion after that with the two disciples in Emmaus. What a magnificent source of meditation and inspiration for the priests of Siena, about to commemorate that death and resurrection in their own celebration of the Eucharist, at the altar on which this great work was standing.

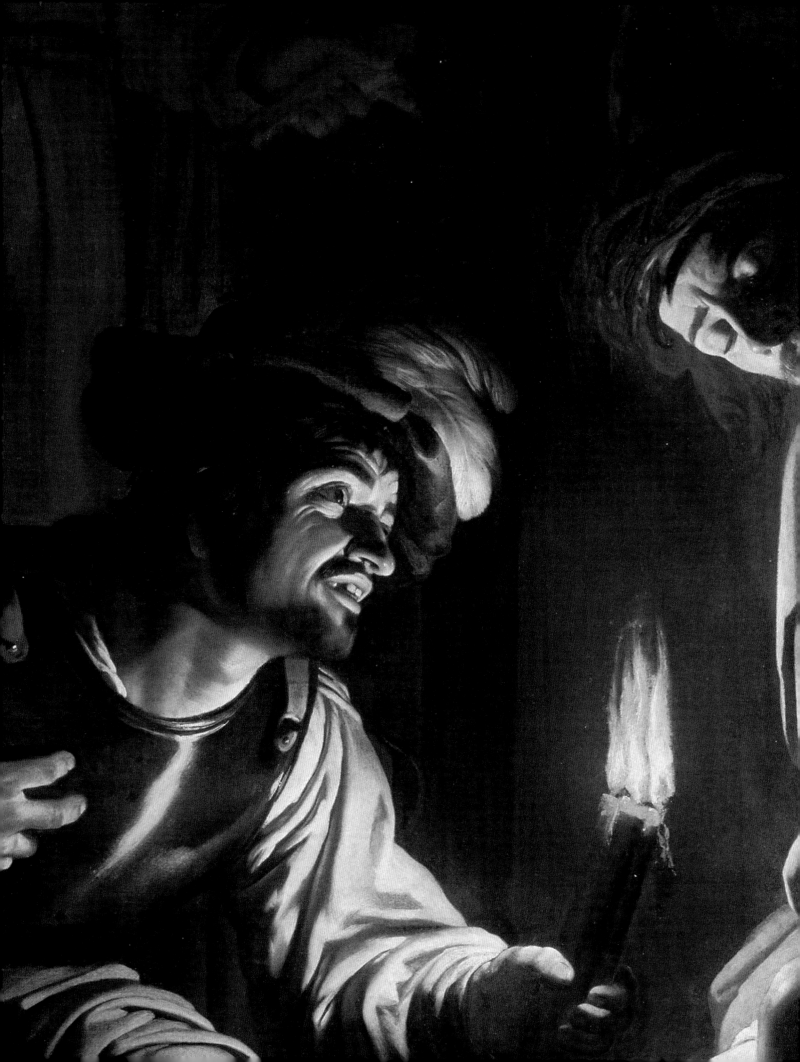

HOLY WEEK
AND EASTERTIDE

Tintoretto
Christ Washing his Disciples' Feet
c. 1575–80
Oil on canvas, 204.5 × 410.2 cm

The fifth day of Holy Week, Holy Thursday is the last Thursday before Easter. In Western denominations, the date is always between 19 March and 22 April. The feast marks the beginning of the Easter Triduum, the three-day period commemorating the passion, death, and resurrection of Christ that ends on the evening of Easter Sunday. Some Christians call the day Maundy Thursday, named for the Maundy – that is, the washing of the apostles' feet that Jesus performed immediately before they sat down for the Last Supper. The name comes from the Latin *mandatum*, meaning 'command', and is taken from the Vulgate translation of John's gospel account of Jesus' instruction to his disciples as he washed their feet: '*Mandatum novum do vobis ut diligatis invicem sicut dilexi vos*' ('I give you a new commandment, That ye love one another as I have loved you'). For all the main denominations, the liturgy of Holy Thursday commemorates the Last Supper, with some churches practising ritual washing of congregants' feet as part of the service.

Jesus and his disciples had come up to Jerusalem to celebrate the Passover (or Pasch), the great Jewish feast of Pesach. This celebration commemorated the Israelites' liberation from slavery in ancient Egypt. In the Old Testament story of the Exodus, God helps the Children of Israel flee their enslavement by visiting ten plagues upon the Egyptians, the last and worst of which was the slaying of the firstborn in each household. God instructed the Israelites to mark the doorposts of their homes with the blood of a slaughtered lamb so that the spirit of the Lord would know to 'pass over' these homes. After the Israelites were thus spared, the Pharaoh allowed them to leave Egypt.

When the apostles asked Jesus where they should make preparations to celebrate the Passover, he told two of them to follow a man they would meet and speak to the owner of the house he entered. They would be shown an upper room already set out, and should prepare the meal there. John begins his account of the actual supper with Christ's washing of the apostles' feet. When they were at table, Jesus told the apostles how he had longed to be able to celebrate this Paschal meal with them before his suffering and death. John then concludes his narrative with three brief chapters of Christ's farewell discourse to the apostles, and another with his final prayer for them before setting off for the Mount of Olives.

As we shall see in the next chapter, the Last Supper itself was a popular subject for painters from at least the early fourteenth century. So too was the washing of the feet that preceded it. It was a favourite theme of Venetian artist Jacopo Robusti (1518–94), also known as Tintoretto, and there are at least six extant works by him on the subject. One of these was commissioned for the Fraternity of the Blessed Sacrament based in the church of San Trovaso in Venice. In the fifteenth and sixteenth centuries, lay fraternities played a major role in religious, social, and cultural life in Venice, as they did in many other Italian cities. These fraternities were voluntary organizations of laymen that crossed the barriers of social class. The members came together because of their devotion to a particular saint, or to Jesus or the Virgin Mary under a particular title or aspect. They met regularly to pray, as well as to plan and carry out works of charity in their community. They also helped each other in times of need and provided assistance to the widows and children of deceased members. Such fraternities were normally based in a particular church or an associated building. They were also patrons of local artists, frequently commissioning works for their places of worship.

The size and shape of *Christ Washing his Disciples' Feet* help us to identify it as a *laterale*, that is, one of the paintings for the side wall of a comparatively narrow chapel. The subject was quite a common one for a chapel of the Blessed

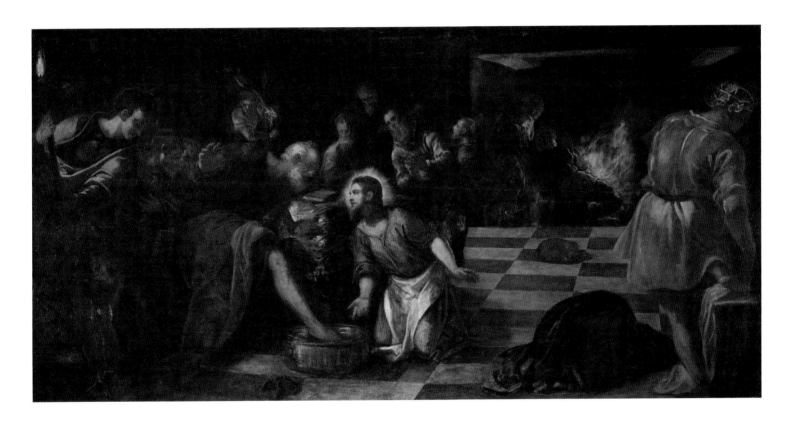

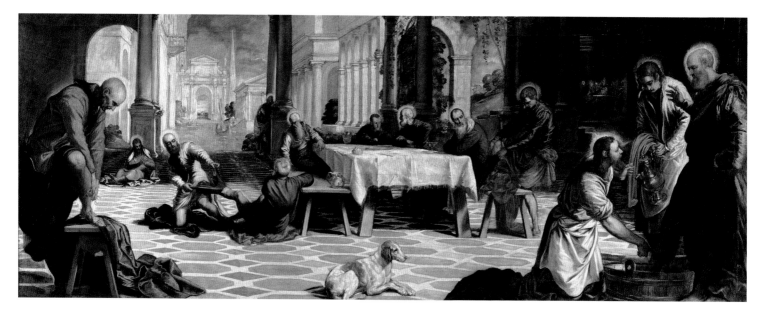

Tintoretto, *Christ Washing the Disciples' Feet*, 1548/9, oil on panel, 228 × 533 cm, Museo del Prado, Madrid. The painting was created as a companion piece to Tintoretto's *Last Supper*, which still hangs on the left side of the altar at San Marcuola in Venice.

Sacrament. It was often matched on the opposite wall by a separate representation of the Last Supper, as was the case in San Trovaso. Tintoretto was responsible not only for this other work, which we will consider in the next chapter (*see page 94*), but also for similar pairings of the two subjects in at least two other Venetian churches (*above*).

Because the lines of the tiles on the floor in our painting lead upwards to the right, to a vanishing point at the top of the fire, one might initially assume that the painting would have been for the left-hand wall of the chapel. However, research has shown that it was almost certainly for the other wall on the right and, as experience of both viewing angles will show, this makes far more sense. In fact, in contrast to the direction of the flooring, a strong upward right-to-left diagonal is established by the figures in the painting, particularly by those near the fire and by Jesus Christ and St Peter. This dynamic, combined with Tintoretto's use of colour and lighting, focuses our attention immediately and firmly on these two central characters in the episode that is represented.

We remember the details of the incident from John's gospel: how, at the Last Supper, Jesus got up from the table,

wrapped a towel round his waist, filled a bowl with water and began to wash the feet of his disciples. Peter demurred, but Christ said, 'If I do not wash you, you can have no part with me.' Peter answered: 'Not my feet only, Lord, but my hands and head as well.' Jesus responded that someone who has bathed has no further need of cleansing but would be clean all over. He then added, 'And you are clean, though not all of you.' St John observes that this last phrase is a reference to the treachery of Judas. One may note that the word he uses for clean is *catharos* in the original Greek, which can mean both 'clean' and 'pure'. It may well be that the apostles had actually bathed earlier, in preparation for the Passover feast, but that their feet would still have been dusty, from walking through the streets to the upper room. Peter would indeed have probably worn partially open sandals, little different from the sixteenth-century type we see he has just discarded by the bowl.

Tintoretto was a master of narrative painting. He brought a very vivid imagination and deep spiritual insight to bear on the gospel scenes he created, envisaging a range of possible scenarios for his different versions of the same event. Here his powerful visualization captures the moment

at which Peter, having been swayed by Jesus' response to his own initial reluctance, is on the point of putting his newly bared foot into the water. Peter's outstretched arm conveys the request he has just made for further cleansing. Christ's gesture indicates that a washing of the feet is all that is required.

The great power of the painting lies in the psychological strength with which Tintoretto has established the relationship between the master and disciple. Jesus makes clear in the gospel that his action here is to give the apostles a lesson on service and humility. It is with the intentness of the teacher that Christ gazes deep into Peter's eyes; and it is with

the love of the devoted follower that Peter responds, leaning forward with his open-hearted gesture of acceptance, and willingness to learn and follow.

The dramatic quality of the chiaroscuro (the strong contrast of light and dark within the work) and the flames of the fire in the background contribute to the emotional dynamism of the painting. The fire also serves as a secondary light source. However, Christ's shadow shows us that the principal light comes from the torch held by the youthful St John on the extreme left of the canvas. As indicated earlier, this lighting directs our gaze to Christ and Peter. It brings out the orange, red, and white in this most colourful passage of

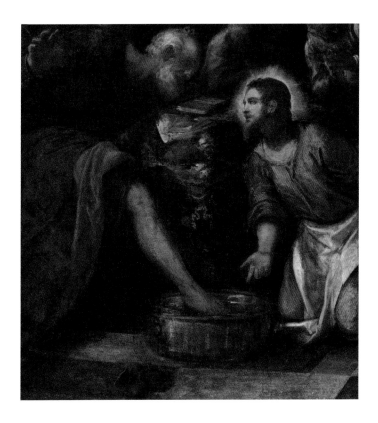

the work, but most importantly it acts with the diagonals of Peter's right leg and Christ's left arm to make us concentrate on the intensity of that exchange of looks between the two men.

In an essay on Tintoretto's technique, the art historian Jill Dunkerton makes two interesting points about this figure of St John. When Tintoretto knew that a particular part of a painting would be positioned in a dark place, he often left any dark passages in that area of canvas without any surface paint, just the underpainting, as he has done here. This tends to create a greater sense of deep shadow than a fuller application of oil paints on the surface. Tintoretto also, in painting figures, liked to paint them in unclothed outline first, and then establish the light and shade of the drapery as he 'clothed' them. With a strong light on the lower left-hand corner of this painting, we can still see the white outline of St John's legs from the knee down, which Tintoretto, in this instance, has not thought it necessary to clothe.

Tintoretto makes his scene a very lively informal one. The figure of St John on the left is balanced by that of the disciple on the right. He, with his back towards us, appears to be completing the drying of his newly washed feet, which, according to the gospel, Christ would already have wiped with his towel. Next to that disciple, Jesus' discarded blue outer garment is draped over a chest. A cat sleeps within reach of the warmth of the fire where two of the disciples are warming themselves. The others in small subgroups talk and watch Christ's actions.

What are we to make of the figure coming through the doorway in the upper left background? With just a casual glance at the painting, we might assume this to be a serving man entering the supper room. However, only a slightly more careful examination of the painting makes us aware of several relevant points. Although this figure is also quite youthful, he has no tray, apron, or other accoutrement of a servant. He is positioned immediately above St Peter, and the line of Christ's left arm, taking us to the faces of Jesus and Peter, leads straight on to his face, which is also illuminated by the light of St John's torch. We then count the disciples and find there are only eleven, and realize that this must be the twelfth, Judas, imagined by Tintoretto as entering late, hastily and guiltily, after arranging the betrayal of Jesus. The twisted lines of the curtain that Judas is holding aside as he peers into the room symbolize the traitor's emotional turmoil. St John actually begins his passage in the gospel on the washing of the feet by saying that the devil had put it into the mind of Judas to betray Christ. Then, as noted, Christ in our painting is on the point of telling Peter that not all the apostles are clean or pure.

Unlike his great Venetian contemporary Paolo Veronese, who liked to show Christ and his companions in rich and luxurious settings, Tintoretto was often anxious to depict them as homely people, simply and even roughly dressed, as he does here. Moreover, we see Jesus teaching his disciples the lesson of humble service to others, shortly before he institutes the Blessed Sacrament of the Eucharist at this, his last supper before his death on the cross. It is that lesson that the members of the Fraternity of the Blessed Sacrament wished to absorb for themselves, and to put into practice alongside their devotion to Christ's Eucharistic sacrifice. How fortunate were they to have an artist like Tintoretto to give their wish such visual reality with this magnificently human and dramatic representation.

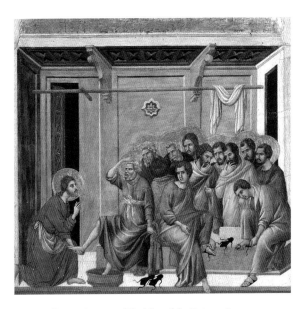

Benvenuto Tisi called Il Garofalo, *Christ Washing the Disciples' Feet*, c. 1520/5, oil on panel, 35.9 × 52.1 cm, National Gallery of Art, Washington, D.C. Garofalo shows the same moment in John's gospel as Tintoretto, with Christ on the point of telling St Peter that not all of the apostles were clean and pure. The figure on the extreme left in the foreground, turning his body away from the scene, is likely to be Judas, who, according to John, has already been prompted by the devil to betray Jesus.

Duccio di Buoninsegna, *Washing of the Feet*, 1308–11, egg tempera on wood, 50 × 53 cm, Museo dell'Opera del Duomo, Siena. This is one of the twenty-six narrative scenes from the Passion cycle on the reverse side of the *Maestà*. It appears on the bottom row on the left side above the Last Supper (*see page 83*).

Ford Madox Brown, *Jesus Washing Peter's Feet*, 1852–6, oil on canvas, 116.8 × 133.3 cm, Tate Britain, London. Brown was an associate, though not a member, of the Pre-Raphaelite Brotherhood, several members of which modelled for the disciples in this picture. Originally, Jesus was depicted semi-clothed. Critics complained that the painting was 'coarse', and it caused an outcry when it was first exhibited and remained unsold for many years.

Tintoretto
The Last Supper
c. 1563–4
Oil on canvas, 221 × 413 cm

The companion painting to Tintoretto's *Christ Washing his Disciples' Feet* in the church of San Trovaso, which we saw in the previous chapter, was the artist's *The Last Supper*, similarly commissioned by the Fraternity of the Blessed Sacrament to hang on the opposite wall of the same chapel. Tintoretto was one of many painters from the beginning of the fourteenth century onwards to have tackled this key episode in the Easter story: Jesus' final meal with his disciples before the start of his passion that evening and crucifixion the following day.

The gospel narratives of the Last Supper contain several important moments. All four of the evangelists tell us of the distress caused to the apostles when Jesus announced that one of those present would betray him. Likewise, all of the gospels include Christ's prophesy that before the cock crows Peter will deny any knowledge of him. The three synoptic gospels give accounts of the institution of the Eucharist, all essentially the same, with minor variations in wording. Matthew says: 'When they had eaten, Jesus took bread, blessed it and broke it and giving it to the disciples said, "Take and eat. This is my body." And taking a chalice and giving thanks, he gave it to them saying, "Drink from this all of you; for this is my blood of the new covenant, poured out for the many for the forgiveness of sins."' Mark and Luke both recount an almost identical scene, with Luke giving the additional words used in the consecration, 'Do this in memory of me.'

The many artists who have given us paintings of the subject vary as to the particular episode that they wish to emphasize. In the early 1300s, Duccio, in the *Maestà*, offers three pictures from the occasion: the washing of the feet (*see page 93*); the announcement of the betrayal; and the discourse to the apostles. Giotto, in the Scrovegni frescoes, gives us the first two of these moments (*see page 96*). In the seventeenth century, the emphasis was generally on the Eucharist, as in Matteo Rosselli's 1634 fresco in the Servite Convent of Montesenario in Tuscany (*see page 97*), and Nicolas Poussin's huge canvas from six years later, now in the Louvre. But from the mid-fourteenth century to the middle of the sixteenth, scenes of the announcement of the betrayal were by far the most common. When Jesus says one of the twelve will betray him, they each in turn reply, 'Surely not I, Lord?' Matthew tells us that to Judas, Jesus answers, 'You say so.'

The most famous depiction of the announcement of the betrayal is that by Leonardo da Vinci, painted for the refectory of the Dominican friars of Santa Maria delle Grazie in Milan (*see page 97*). It was, in fact, because of the popularity of such scenes as frescoes for the end wall of refectories in monasteries and friaries that so many were produced, particularly in Italy, over the two-hundred-year period mentioned. Indeed, within the city of Florence alone, at least twenty-five major Last Supper frescoes were painted for the refectories of religious houses between 1345 and 1582. All of these have the same basic format, with Christ flanked by apostles, facing the spectator across a long rectangular table. The one significant difference from the familiar arrangement of Leonardo is that, in most examples, Judas is placed alone on the opposite side of the table from all the other disciples, emphasizing his position as an outsider, as in Domenico Ghirlandaio's *c.* 1486 version in the San Marco convent in Florence (*see page 97*).

Tintoretto's *Last Supper* from San Trovaso similarly concerns the announcement that a traitor is present among them. It is useful to remind ourselves of the relevant gospel passages. John tells us that at the supper, 'the disciple Jesus loved' (John himself) was reclining with his head against the chest of Jesus. Some artists have tried to do justice to this description with a slightly awkward arrangement of the figures seated upright.

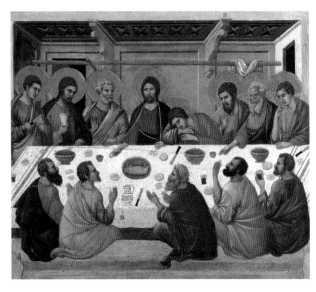

Duccio di Buoninsegna, *The Last Supper*, 1308–11, egg tempera on wood, 50 × 53 cm, Museo dell'Opera del Duomo, Siena

Giotto di Bondone, *Scenes from the Life of Christ*, 1304–6, fresco, 200 × 185 cm, Scrovegni Chapel, Padua

This reflects a misunderstanding of the conventions for such occasions at the time of Jesus. A formal meal such as the Passover would normally be served on a low table, around which the guests would recline on couches. However, as this fact was not generally known by the artists depicting the scene, most paintings have the participants sitting upright on benches, chairs, or stools at tables of a corresponding height. Other artists solved the apparent problem by showing John as apparently dozing with his head on the table, as Tintoretto does here. This latter approach, although just about acceptable in the context of the synoptic gospels, rather conflicts with John's account, where Peter tells him to ask whom Jesus means. Of course, the passage makes more sense when we realize that both Jesus and the apostles would have been reclining on couches. John, by leaning slightly back, could put his head against Christ's chest; Peter by doing the same would have his head close to John's to speak to him *sotto voce*.

When John asks, as Peter has requested, who the traitor is, Jesus replies: 'It is the one for whom I shall dip a morsel and pass it to him.' St John then continues by writing that, having dipped a morsel, Jesus gives it to Judas Iscariot. St Luke's gospel quotes Jesus as saying simply, 'the hand of the one betraying me is with me at the table'; Matthew has, 'The one who has dipped his hand in the dish with me, he will betray me'; and the sense of Mark is virtually the same. If, then, we consider again some of the paintings mentioned earlier, we will note that Duccio shows Jesus passing the morsel to Judas; Ghirlandaio has Judas about to eat the morsel he has just received, with Peter looking daggers at him; and Giotto shows Judas dipping his hand in the dish at the same moment as Jesus.

When we first look at Tintoretto's painting, we may have difficulty in identifying which of the apostles is Judas. This is quite appropriate. All the other disciples are also wondering which one of them is the betrayer, while seeking

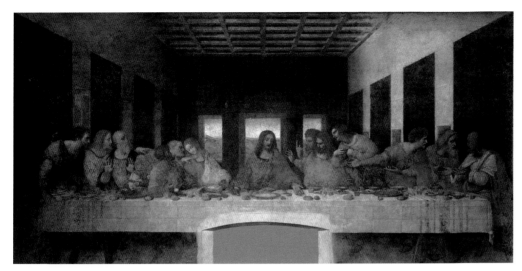

Leonardo da Vinci, *The Last Supper*, 1495–8, fresco, 460 × 880 cm, Santa Maria delle Grazie, Milan

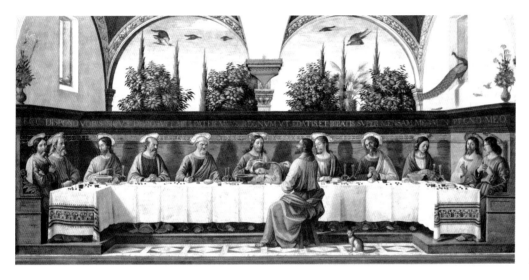

Domenico Ghirlandaio, *The Last Supper*, *c.* 1486, fresco, 200 × 185 cm, Convent of San Marco, Florence. Photo Adam Eastland / Alamy Stock Photo.

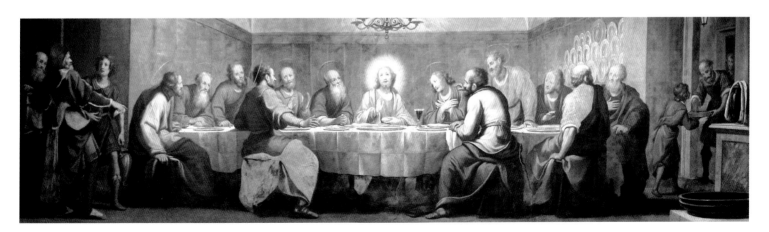

Matteo Rosselli, *Last Supper*, 1634, fresco, dimensions unknown, Servite Convent of Montesenario, Vaglia, Tuscany

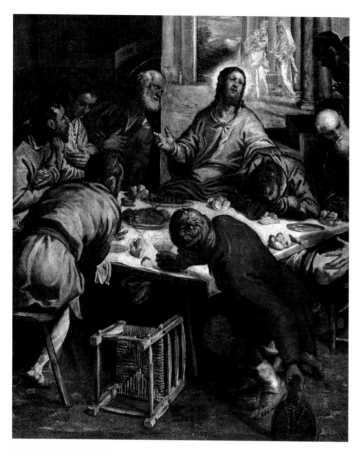

reassurance from Jesus about themselves. However, with closer examination we become aware that some of the apostles have a halo in the form of a very thin gold circle. With diligence, we can see that at least the trace of a golden ring can be found above everyone except the figure on the extreme right with the red leggings. We note then not only that the bright red against the light blue makes this figure contrast with his more soberly coloured companions, but also that he is sitting somewhat away from the others in the darkest corner. Finally we observe that Tintoretto has included two dishes in his scene: one is in the bottom left-hand area where the pink-robed apostle is about to remove its lid; the other is resting on the knees of the red-legged figure, whom we now realize is Judas, as he is just dipping his hand into it. Presumably Tintoretto envisages the dish as being passed round from Jesus in the centre of the gathering, and having now reached Judas in his well-shaded corner.

The whole movement of the painting is diagonally upwards from left to right. This is emphasized particularly by the staircase with its handrails on the left; the line of apostles on the left-hand side of the table; and the foreground apostle leaning forward over the table. While these last two diagonals lead us to the figure of Christ (as does the extended arm of the apostle reaching for the wine flask), the very strong perspective lines of the chair legs in the foreground and the right edge of the table point towards the figure of Judas.

Although *The Last Supper* was painted as the companion piece for *Christ Washing his Disciples' Feet*, there is no attempt to offer us the same setting in the two pictures. Tintoretto tended to rethink the location of a subject each time he treated it. Characteristics that the works do share are a sense of movement and drama and a pervading atmosphere of informality in spite of the ritual nature of the occasion. In our present painting, those elements are emphasized by

the postures, gestures, and expressions of the twelve, as well as by the knocked-over chair, the dish on the floor with the cat next to it, the arm reaching for the wine, the garments thrown casually over the handrails of the staircase and the disorderly pile of baggage in the right foreground corner. It may be that the white bag on the floor, quite close to Judas, is intended to be the purse of communal money of which he had charge.

One of the most unusual features of the painting is the spatial setting. The gospels of both Mark and Luke speak very specifically of the Last Supper as taking place in 'a large upper room'. Luke also suggests in the Acts of the Apostles that this is a room in which the apostles continued to stay after Jesus' resurrection. But the space in this painting scarcely seems to be a room. We can see that the table here is not a solid piece of furniture. The knocked-over chair reveals that it is a temporary construction consisting of trestles supporting a thin board or, given what seems to be a slight change in height in the middle, more likely two boards, with a very makeshift covering. To the left, we have a staircase going up with a door at the top, but there is no door shown for the main space, which seems to open behind Jesus into a very spacious and architecturally imposing area. Moreover, behind Judas we do not have a solid wall but seemingly a wooden screen.

Tintoretto again seems to want to emphasize Jesus's humility, in contrast to the scribes and Pharisees who looked to be treated with special importance. He appears to suggest that part of a communal space has been adapted to provide a temporary dining area for Jesus and his twelve companions. This might also explain the figure, sitting at the top of the stairs with what appears to be a spindle. Possibly she is to be construed as a servant who would normally work in this area, but has now been displaced, perhaps with an added duty of carrying the dining pots and utensils up and down the stairs. The other subsidiary figures are also of interest. It has been

suggested, with quite a high degree of probability, that the child carrying food in the extreme left foreground is Tintoretto's beloved daughter Marietta. She apparently accompanied her father everywhere, dressed as a boy. Having been born in 1554, she would have been ten years old at the time the work is most likely to have been painted.

What are we to make of the somewhat ghostly figures in the very churchlike, background area behind Jesus? It is difficult to be sure. In one of his other Last Supper paintings, in the church of San Giorgio Maggiore in Venice, Tintoretto seems to fill the whole area above the table with spirit forms (*see overleaf*). In two other large-scale works, *The Baptism of*

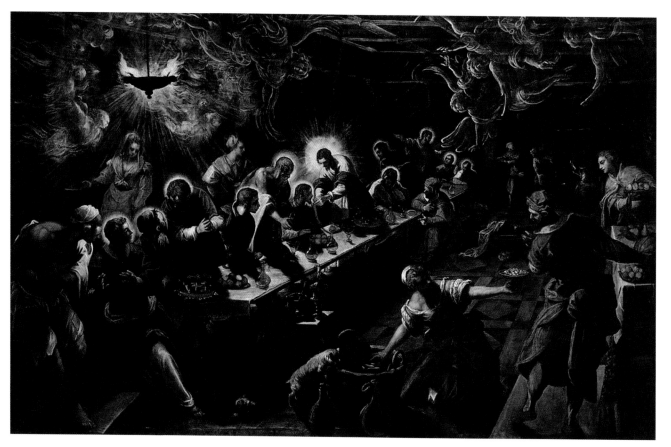

Tintoretto, *The Last Supper*, 1592–4, oil on canvas, 365 × 568 cm,
Basilica di San Giorgio Maggiore, Venice

Christ in the Scuola Grande di San Rocco and *The Theft of the Body of St Mark* in the Accademia, both also in Venice, he has numerous figures that seem on the cusp between the physical and the supernatural. In the former of these, the weight seems towards human reality; in the latter, the opposite. What Tintoretto seems to want to indicate in all of these works is that in moments of great religious significance there are powerful spiritual forces at play.

However, after considering some of the secondary issues relating to the painting, we must return to the central image. It is one of a close-knit group of friends, having a celebratory meal together in a relaxed, informal atmosphere, and being told by their leader that one of them has betrayed him to his death. That image of restrained conviviality, among a group of people from different backgrounds, united under the leadership of Jesus and anxious to follow his example, was surely the one that the Fraternity of the Blessed

Sacrament was looking for, to inspire them in their efforts to love their neighbours as themselves.

The traitor here has already put himself outside the circle of the group, and Jesus is about to tell him that he should now go quickly to carry out his intentions. But when Judas has left, as we learn from St John, Jesus will give the most beautiful discourse on selfless love. He has already said that he is about to lay down his own life for his companions and for the whole human race. Now he will give them the commandment to 'love one another as I have loved you', saying, 'no one has greater love than this, that he lays down his life for his friends ... In this way will everyone know that you are my disciples, that you have love for one another.' He adds that he will send the Holy Spirit to strengthen their faith and give them the courage to continue in the face of persecution. That promise will be fulfilled on another great Jewish feast, that of Pentecost.

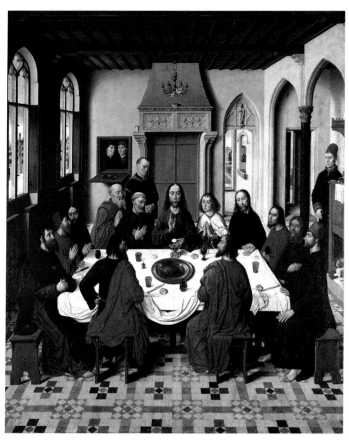

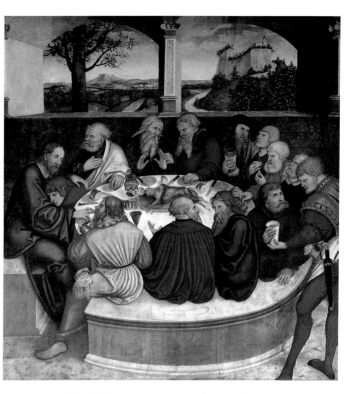

Dirk Bouts, *The Last Supper*, 1464–7, oil on panel, 180 × 150 cm, St Peter's Church, Leuven. Paintings of the Last Supper appeared later in northern Europe than in Italy. This version, which emphasizes the institution of the Eucharist, is the earliest Flemish work on the subject.

Lucas Cranach the Elder, *Last Supper*, 1547, oil on panel, dimensions unknown, City Church of St Mary, Wittenberg, Germany. Although large-scale religious painting largely disappeared in the north after the Reformation, the subject of the Last Supper was an exception. Cranach was a close friend of Martin Luther, who is shown seated among the apostles in this picture, which was painted as the central panel of the artist's most celebrated work, the *Wittenberg Altarpiece*.

William Blake, *The Last Supper*, 1799, tempera on canvas, 30.5 × 48.2 cm, National Gallery of Art, Washington, D.C. In typical fashion, visionary British artist Blake produced a singular interpretation of the Last Supper, with Christ radiating light at the head of pyramid formed by the assembled apostles.

Giovanni Bellini
The Agony in the Garden
c. 1465
Egg on wood, 81.3 × 127 cm

When considering Giovanni Bellini's *Madonna of the Meadow* (*see page 47*), we referred to *The Agony in the Garden* by Andrea Mantegna, Bellini's brother-in-law. There are many reciprocal influences between the two painters, and Bellini's depiction of Christ's agony in the garden of Gethsemane, from around 1465, is clearly influenced by Mantegna's version of the scene (*see page 105*), painted some five years earlier. Bellini's painting illustrates the union of two strong, but slightly conflicting traditions within Italian religious painting. The first is to try to include within paintings of the gospel narrative all details reasonably possible that can be derived from the text. The second, which came through the advice of many influential preachers, was to try to make the gospel as alive as possible by imagining the episodes as taking place within one's own familiar surroundings.

Matthew, Mark, and Luke all mention, in their description of Christ's preparation for the entry into Jerusalem, that when Christ had come to the Mount of Olives, he said to two of the disciples: 'Go into the village facing you.' Here, then, Bellini ensures that in his depiction of the mount there is a prominent hill village to be seen opposite, in the upper left-hand corner of the painting. Moreover, because both Mark and Matthew link that episode to Christ's cursing of the barren fig tree – the miracle in which a hungry Jesus cursed a fig tree that was without fruit by exclaiming 'May you never bear fruit again!' and the next day it was found withered – we are shown the leafless tree towards the central left edge of the painting, in contrast to the olive tree with all its leaves and spring flowers, in the bottom right-hand corner. Close to that tree is the slightly rickety open gate in the rustic fence, referring to the enclosed 'garden' mentioned by St John, where presumably the other apostles remain. Also visible, on the other side of the painting is the brook, Kedron, over which, as St John says, Christ would have to pass to reach that garden on the Mount of Olives. One might mention in passing that modern translations that refer to an 'olive grove' instead of a 'garden', and to the Kedron 'valley' instead of 'brook', are far less accurate than the traditional translations. The normal meaning of the original Greek *kepos* is 'garden', and though it can mean a 'plantation', it cannot of itself mean an olive plantation. And the original Greek *cheimarros* means very specifically a *stream* that flows in winter, and could never mean simply a 'valley'. Bellini, however, and any religious adviser working with him, would have been using the Latin Vulgate, where *hortus* (garden) and *torrens* (stream) are completely unambiguous.

Christ is shown facing the walled city of Jerusalem, and since one of the few topographical details available from the gospels comes from the reference in Christ's temptation in the desert to the 'pinnacle of the Temple', Bellini provides us with a very clear, minaret-like pinnacle as an easily recognizable method of identification. We can see in the centre of the painting Judas leading the soldiers. Among their weapons there is at least one sword and one club, as referred to in the gospel, although a number of shields and lances make the military nature of the band of small figures more easily identifiable. We also notice that in his agony, Christ's eyes are fixed on the craggy hill in the upper right section of the painting, which is flanked by the road winding up towards Jerusalem. Bellini almost certainly intends this to be Calvary, 'the place of the Skull', the scene of Christ's crucifixion. St John tells us that this was close to the city and passed by many. The artist ensures that the white lines on the dark rock serve to bring out the slight resemblance of the hill to a human skull.

Bellini, then, tries to be as accurate to the gospel as he can be. He was, however, clearly not able to draw on first-hand experience of the Holy Land, and the overall landscape with its low hills, walled town, and hill village is typical of the

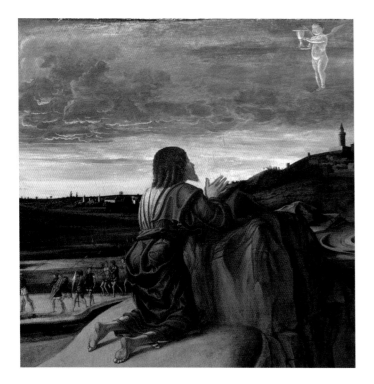

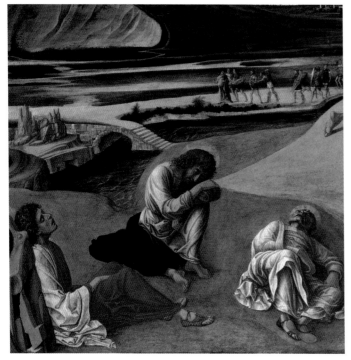

and his companions have only just come from supper. It will be after Christ has been led back into Jerusalem and examined before the High Priest that Peter will be mortified for his denials at the sound of the cock crowing to announce the dawn. And then, as all the gospels make clear, it is early in the morning that Jesus is taken to Pilate. In fact, as regards the time of the agony in the garden, St John mentions in addition to swords and clubs, that the band led by Judas carried 'torches and lanterns'. It would, however, have been virtually impossible for Bellini to paint an event that demands a landscape background as a night scene. And so what he gives us is a moment just before sunset. The rays of the dying sun, coming from the upper left of the picture, illuminate the village on the hill and the right shoulders of saints Peter and James. They fall also on the slope on which Jesus kneels, shining on his back and casting the shadow of his legs onto the slope and that of his body onto the rock in front of him. The sunset light is, of course, particularly appropriate for Christ's last few minutes with his disciples before his trial and death.

Surprisingly, Bellini does not offer us a clear view of the face of Jesus, and it is only with close attention to the painting that we can see, on his right cheek, a slightly red area denoting the sweat of blood mentioned by St Luke. What we are shown, with great clarity, are his vulnerable bare-soled feet, soon to be nailed to the cross.

The rather podgy cherub floating above Christ is perhaps not an immediately attractive image for the modern spectator. However, the chalice he holds reminds us not only of Jesus' prayer in that moment that the chalice of suffering might pass from him, but also of the Eucharist, instituted just a few hours previously at the Last Supper. At least one commentator refers to the clearly visible covering of the chalice as a paten, the small plate that contains the host to be consecrated during mass. It is, however, almost invariably

northern edge of the Venetian plain. A delightful detail is the small stone bridge across the brook, with its steps, very reminiscent of several bridges in Venice itself.

Some commentators have written about Bellini's noteworthy treatment of the 'dawn light'. There can be no argument about the effectiveness of the light in the picture, but it is certainly not that of 'dawn', nor yet of sunrise. Christ

round. What Bellini seems to show here is, a corporal, the folded square of starched linen that is placed on top of the chalice and paten when the priest carries these to the altar, and on which he later places the host. In either case, Bellini obviously intends that covering to reinforce the reference to the Eucharist.

Although the slope of the rock on which Jesus kneels draws our eyes diagonally from the sleeping apostles to the figure of Christ, and on to the angel with the chalice, it is to those sleeping apostles that we tend to return. They are easily identifiable: Peter with his grey beard and hair on the right; the young beardless John on the left; and John's elder brother James in the centre. All are shown deep in slumber, with their arms lying relaxed and heavy, and no immediate signs of distress on their faces.

What Bellini seems to emphasize is just how alone and isolated Christ is at this moment of supreme agony, even with his three closest friends nearby. Moreover, because those companions are in the foreground, close to the picture plane, it is with them that we, as spectators tend to identify, rather than with Christ himself. Bellini seems to want to remind us of the extent to which we remain spiritually asleep, oblivious to Christ's sacrifice, and to the power of the Eucharist, and allowing the forces of evil to come upon us undetected, even in our own familiar surroundings. We could also generalize to say how often we remain oblivious to the sufferings of others, both those close to us and those more distant. All these messages are surely as relevant today as they were some five hundred years ago.

As implied earlier, the distant pinnacle of the Temple reminds us of Christ's temptation. So when we return to Christ in his mental torture, we may remember the closing statement of Luke's version of that episode: 'The devil left him until the time.' In Matthew's gospel, Jesus, sending his disciples to prepare for the Passover, tells them to say

Andrea Mantegna, *The Agony in the Garden*, c. 1458–60, egg tempera on wood, 62.9 × 80 cm, National Gallery, London

to the householder: 'The teacher says, "My time is near."' Mark tells us that in the agony in the garden, Jesus prays, 'If it be possible, let this hour pass', and both Matthew and Mark, at the conclusion of the agony, give Jesus' words 'the hour has come'. This is the moment when, facing the terrible death of crucifixion, Christ, alone again in his agonies of fear and doubt, has to rely on faith and prayer.

Matthew, at the end of his description of the temptation, says that the devil left Jesus and angels ministered to him. Bellini, here following Luke, shows through the presence of the angel that the prayer of Jesus for help in his final agonizing mental struggle is indeed answered. He will now be able to face the dreadful suffering and death that is to come, with the calmness of faith in his resurrection and in the love of his true Father.

Gerrit van Honthorst
Christ before the High Priest
c. 1617

Oil on canvas, 272 × 183 cm

Gerrit van Honthorst (1592–1656) was born and died in Utrecht in the Netherlands and was, along with Hendrick ter Bruggen, a leader of the group of painters in the city known as the 'Utrecht Caravaggisti' – in other words, stylistic followers of the Italian Baroque painter Caravaggio. In fact, Honthorst fell under the spell of Caravaggio when he arrived in Rome in 1610, just a few months after the Italian's death. Honthorst stayed in Rome for ten years. Ter Bruggen was also in the city during this period. While there, van Honthorst's adoption of Caravaggio's use of very strong chiaroscuro – that is, the juxtaposition of intense light and dark to produce dramatic effects – led his fellow artists in Italy to give him the nickname Gherardo delle Notti, 'Gerard of the night scenes', as it was by concentrating on such scenes that he was able to use this aspect of Caravaggio's style most effectively. When Honthorst and ter Bruggen returned to Utrecht, many of the younger painters there immediately also came, through their example, under the influence of the art of Caravaggio.

Christ before the High Priest is not merely one of the best examples of van Honthorst's style in his 'night scenes', it is one of the most fascinating and unusual of Passiontide paintings. The four evangelists give us slightly varying accounts of the events immediately following Christ's arrest after his agony in the garden of Gethsemane. Matthew and Mark both say that Jesus was taken off to the house of the High Priest, Caiaphas, where he was questioned before the whole assembly of scribes and elders, the Sanhedrin, the supreme Jewish council and highest court of justice in ancient Jerusalem. Then, after being condemned, he was beaten and mocked by the guards and taken to Pontius Pilate the following morning. Luke speaks of Christ's being beaten and mocked by the guards after his arrest, and then being brought before the Sanhedrin in the morning.

It is, however, an episode in John's version that appears to have interested van Honthorst. He wrote that Jesus, after his arrest, was first taken to the former high priest, Annas, the father-in-law of Caiaphas. There Jesus was questioned by Annas, struck by one of the guards on the pretext of having answered the High Priest disrespectfully, and sent off 'bound' to Caiaphas. Matthew and Mark speak only of Jesus' being 'bound' when he is taken to Pilate. Luke is silent on that detail.

The subject of Christ's appearance before the High Priest is not at all a common one. It is particularly rare as a major individual painting, although there are a number of representations of the scene, in medieval and early Renaissance paintings, within cycles of paintings of Christ's life or his passion. Two of these occur in closely contemporary, and exceptionally influential, works of the early fourteenth century: Giotto's cycle of the life of Christ in the Scrovegni Chapel in Padua (*see pages 96 and 145*), and Duccio's cycle of his passion on the reverse of the great *Maestà* altarpiece, painted for Siena Cathedral (*see page 83*). Duccio, in separate panels, shows the scenes of Jesus before both Annas and Caiaphas. Giotto depicts only the appearance before Caiaphas. These works, which adopt quite a formal setting, with the High Priest sitting on a thronelike chair in a room crowded with the elders and guards, established the norm for representations of the event. Moreover, because the appearance before Caiaphas involved the dramatic moment of the High Priest tearing his garments, as reported by Matthew and Mark, that was the obvious choice for a single representation.

The idea that van Honthorst, in his far less formal and surprisingly intimate scene, had in mind the preliminary interview with Annas is supported not only by the depiction of the High Priest as quite advanced in age and the bound hands of Jesus, but most of all by the seeming absence of other senior members of the Sanhedrin. One also notes the

attire of the soldiers behind Jesus. Matthew and Mark both speak of men armed with clubs and swords sent by the Jewish leaders to arrest Jesus. Luke speaks of the Temple Guard, who had the chief priests and elders with them. John, however, indicates that it was a combined Jewish and Roman force that came to apprehend Christ. He says: 'The cohort and its tribune and the Jewish guards seized Jesus and bound him. They took him first to Annas.' Surely the soldiers behind Jesus, who wear breastplates and carry (rather un-Roman) pikes, are actually intended to be Roman.

The most fascinating thing about this painting is that, although the lighting effect is extremely dramatic, the scene itself is in no way histrionic. Rather it is one of psychological intensity. There is no rending of garments or giving of blows. The drama is one not of action but of looks and, to some degree, of hands. The drama has two principals, two actors with minor roles, and four others with walk-on parts, who suggest greater numbers behind them. Christ and the High Priest look each other in the eye, at the distance of a metre and a half. One of the High Priest's attendants looks hard at Jesus' face with intense interest; the other looks, seemingly with pity, at his beautiful, bound hands. The foremost soldier and the one on the extreme right, behind Jesus, stare at the High Priest and at his brightly illuminated hand with the finger pointing upward. The other two stare at the face of Jesus. All have expressions of great concentration.

By his composition and the lighting, which is wholly dependent on the candle flame at the centre of the picture, van Honthorst concentrates our attention on a broad diagonal band in the painting, rising only slightly from left to right. This takes in the High Priest's right hand on the chair, his book of scriptural law, his robes, his head, and his left arm and hand, with its outstretched finger, and leads us to the hands and head of Christ, and the white alblike garment of this priest-victim.

What is the intended significance of Annas's outstretched finger pointing upward? Is he indicating that there is only one God, and that this all-seeing God will judge blasphemy; or is he simply telling Jesus that the Mosaic law demands death for the blasphemer? One cannot be certain. There is, however, no sense in this painting of the manipulation of the spectator's emotions in any propagandist manner. We are not made to consider Annas as obviously evil, hypocritical, or vindictive. We see him as an old man, possibly roused from sleep, with his priestly robes over his nightshirt in the manner of a dressing gown. There does not appear to be major tension in his right hand holding the arm of the chair, and his general expression seems to be one of interrogation and warning, as he looks straight into the eyes of Jesus.

The face of Jesus, as his steady eyes return the searching look of the High Priest, is remarkable. He seems to be looking at the very soul of Annas and, very possibly, seeing potential for true holiness corrupted by the power and status that his robes represent. Those lovely bound hands of Jesus are relaxed. It is less than an hour since, in agony, he prayed that the chalice might pass from him. Now his whole demeanour, conveyed by his steady look and relaxed hands, is one of complete calm acceptance.

The composition emphasizes the gap and opposition between the old order and the new. But, for Jesus, now is not the time to engage with this representative of that old order in an analytical discussion of either the scriptures or his own teaching, and he is about to say so. Annas, at a loss to know how to deal with this impressive, dignified figure, who does not appear either to fear death or to want to justify himself, is about to take the only course he can, and pass the buck. He will send Jesus off to let Caiaphas and the Sanhedrin handle the problem in the way that both he and Jesus know they will do.

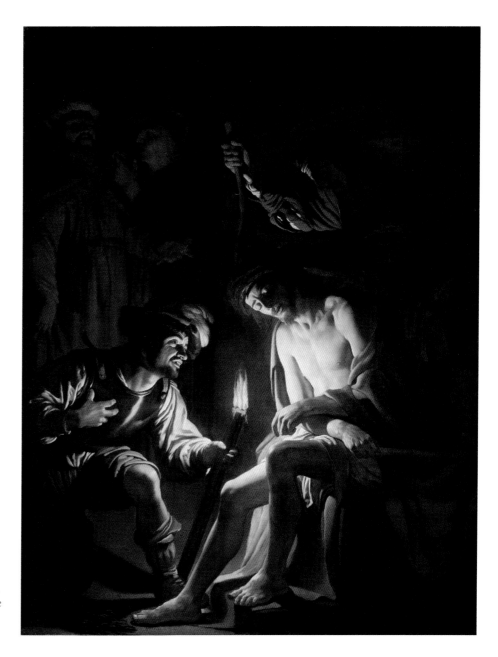

Gerrit van Honthorst, *Christ Crowned with Thorns*, *c*. 1620, oil on canvas, 222.3 × 173.4 cm, J. Paul Getty Museum, Los Angeles. In this recently rediscovered painting, van Honthorst painted a later episode in Christ's passion. Here he is mocked by one soldier and crowned with thorns by another. In the shadows on the left, two figures discuss his fate, which is, of course, to begin the journey to his death on Calvary.

However, we suspect that this thoughtful Annas whom van Honthorst has created is one who would have many lingering doubts about the actions that the Sanhedrin will, inevitably, take. We would also guess that this candlelit confrontation will remain for a considerable time in the memories of these soldiers and attendants who regard it so intently. They will long ponder about this powerfully intense moment from Christ's passion which is, of course, what van Honthorst makes us do too.

Sandro Botticelli, *Christ Carrying the Cross*, c. 1490,
tempera on canvas, 132.5 × 106.7 cm, Beaverbrook Art
Gallery, Fredericton, New Brunswick

El Greco, *Christ Carrying the Cross*, c. 1577–87, oil on canvas,
105 × 79 cm, Metropolitan Museum of Art, New York

Titian, *Christ Carrying the Cross*, c. 1565, oil on canvas,
67 × 77 cm, Museo del Prado, Madrid

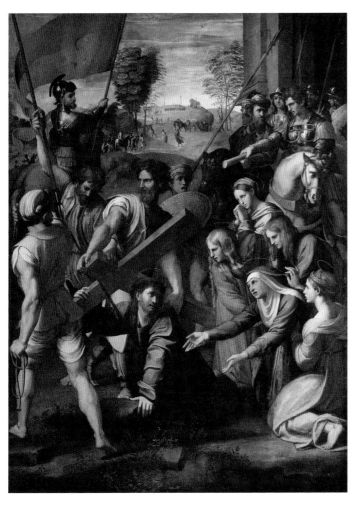

Raphael, *Christ Falling on the Way to Calvary*, 1514–16, oil on panel transferred to canvas, 318 × 229 cm, Museo del Prado, Madrid

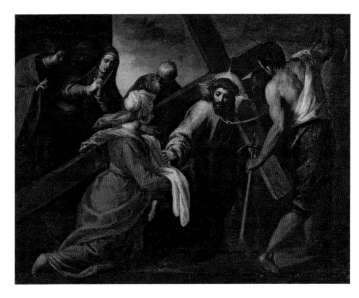

Jacopo Palma, called Palma Giovane, *Christ on the Road to Calvary*, late sixteenth century, oil on canvas, 151.1 × 193 cm, whereabouts unknown

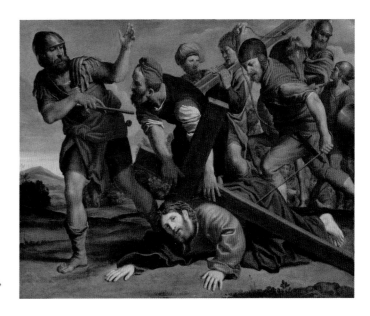

Domenico Zampieri, known as Domenichino, *The Way to Calvary*, c. 1610, oil on copper, 55.2 × 67.6 cm, J. Paul Getty Museum, Los Angeles

Raphael
The Mond Crucifixion
c. 1502–3
Oil on poplar, 283.3 × 167.3 cm

Crucifixion paintings can normally be divided into two categories: the narrative and the iconic. A work by the Italian Renaissance painter Raffaello Sanzio da Urbino (1483–1520), known in English as Raphael, and one by the nineteenth-century French artist Eugène Delacroix (1798–1863) show the distinction between these two types very clearly.

While Raphael's work is immediately identifiable as a Crucifixion painting, there is no suggestion of an attempt to represent Christ's death on the cross as it is actually described in the gospels. Certainly Christ's mother and St John stand at the foot of the cross, but they do so in very formal poses, with no show of emotion. One of the other people named in the gospels as a witness of the actual crucifixion, Mary Magdalene, kneels and looks up at the cross with a rather more intense expression. However, she is separate from the Virgin Mary and John and balanced by the other kneeling figure. He, holding a stone in his right hand with which to beat his exposed breast, is recognizable by those attributes as the fifth-century saint and doctor of the Church St Jerome. It was, in fact, for a side altar dedicated to Jerome in the church of San Domenico, in the Umbrian town of Cittá di Castello, that Raphael painted the picture.

Raphael offers no suggestion of the outskirts of Jerusalem in his background landscape, which is, indeed, reminiscent of areas close both to Cittá di Castello and to Raphael's own native town of Urbino, some thirty miles to the north-east. Christ is not shown in physical agony on the cross. His eyes are closed, but he appears almost as if in a state of relaxed contemplation rather than death. Pilate's inscription *Jesus Nazarenus Rex Iudaeorum* appears, not in full, but in the abbreviated form of the acronym we are accustomed to see on the average crucifix: INRI. The absence of any attempt at narrative realism within the painting is most apparent in the depiction of the two angels. With their balletic poses, each on tiptoe on a convenient

strip of flat cloud, they catch the blood from Christ's hands and side in three chalices, which provide a clear reference to the Eucharist. The sashes of their robes are arranged with an almost calligraphic effect, as is the trailing end of Christ's loincloth.

However, the fact that Raphael is not attempting to make us relive the experience of Christ's death on the cross in a narrative way does not mean that his work is without significant religious purpose. The whole point of such an iconic representation is that it encourages us to do what Mary Magdalene and St Jerome are depicted as doing here: they gaze at a representation of Christ on the cross, and meditate upon its significance. Mary Magdalene is traditionally seen as the archetypal repentant sinner, and it is also as a sinner doing penance that Jerome is, as he often is, represented here. They see Christ as dying for their sins, and the redemption of his precious blood as available to us through the Holy Communion, and invite us, as repentant sinners, to share in their meditation on this great mystery.

Delacroix, on the other hand, offers us a very personal depiction of an actual historical moment from the gospel (*see page* 114). We are told that the Roman soldier, coming to Jesus to break his legs and finding that he had already died, pierced his side with a lance and blood and water came out. Delacroix offers us the scene just after this incident. The soldier on his horse, from which he would have been able to reach Christ's side with his lance, has backed away a little from the top of Mount Calvary. Christ's blessed mother has fainted on witnessing the moment of his agonized death, and has to be supported to prevent her from falling to the ground. Mary Magdalene clasps her hands tightly at arm's length as she strains her head to look up at her beloved saviour. Jesus' closest friend, St John, has to turn away and holds his head in despairing disbelief that what he has just witnessed could have happened. Delacroix asks us to share the completely

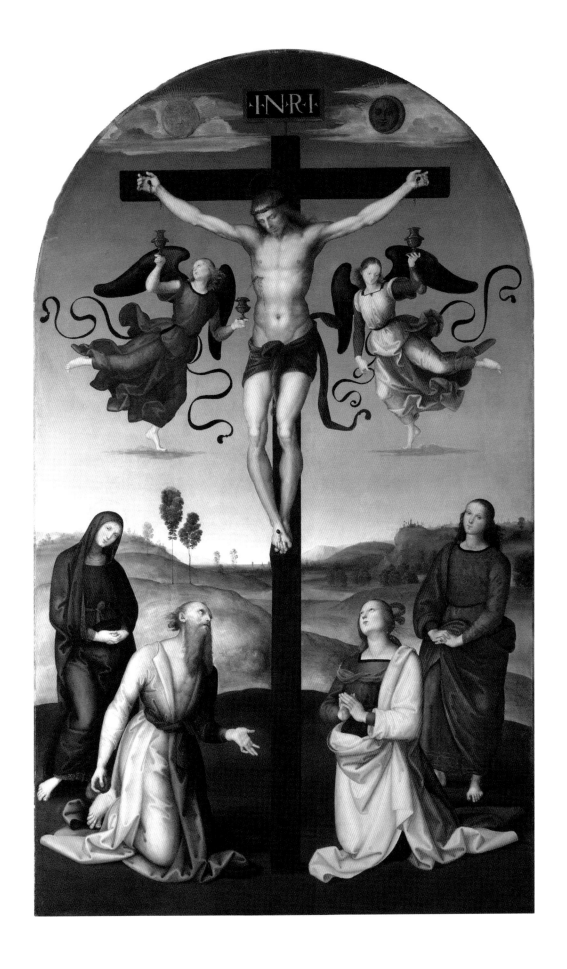

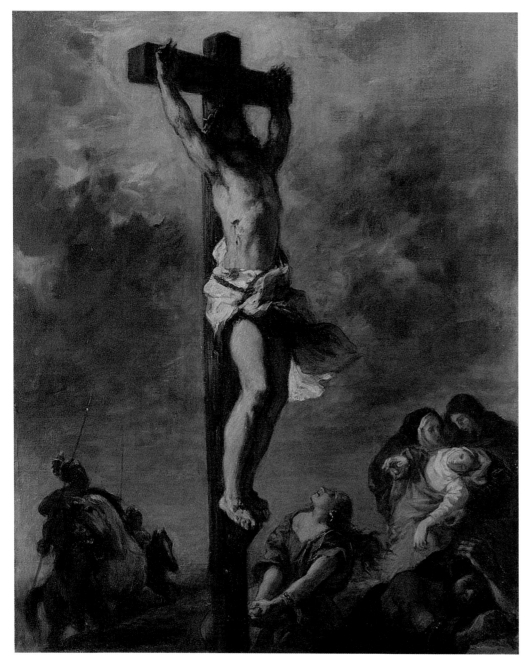

Eugène Delacroix, *Christ on the Cross*, 1853, oil on canvas,
73.5 × 59.7 cm, National Gallery, London

overpowering emotion of these three people who loved Jesus above all else, and who have now seen him not triumphant as they had expected, but dying in agony as a common criminal.

The Mond Crucifixion is an early work by Raphael, painted when he was still very much under the influence of his master, Pietro Perugino. In his later paintings, Raphael's saints are much more genuine human beings with strong

personal identities. Here, however, they have the bland, overly sweet, faces typical of Perugino. Delacroix makes very little effort with his faces. Rather, he conveys the agony of Christ's death, and the anguish of his mother and best friends who witness it, through their bodies and gestures. He reinforces the effects of these by his background. Raphael offers us quite a clear blue sky. Delacroix, by contrast, has a dark, tempestuous atmosphere. Not only does this fit the gospel narrative, in which we are told that at the moment of Christ's death darkness fell upon the Earth, but it also reflects the emotional tumult of the spectators.

Of course, these two paintings demonstrate not only the difference between iconic and narrative images, but also the contrast between classicism and romanticism. Delacroix was, along with Théodore Géricault, the most important figure in French romanticism. When we contrast their work with classicism, we are normally thinking of the neoclassicism of figures like Jacques-Louis David (1748–1825) and Jean-Auguste-Dominique Ingres (1780–1867). However, the contrast is equally clear here with the high Renaissance classicism of Raphael.

Classicism, looking back to Greek and Roman models, emphasizes form, formal regularity, and patterning, and favours the use of a very linear style. It tends to aim for the ideal, particularly in the representation of the human body, and makes its principal appeal to the intellect. Romanticism, on the other hand, tends to adopt a far freer approach, and a much more 'painterly' style, with forms partially suggested by splashes of colour rather than being delineated precisely in draughtsman-like fashion. It usually makes its primary appeal to the emotions rather than the intellect, eschews idealization, and frequently depicts nature in its wilder aspects.

Here, then, Raphael organizes his painting through the very balanced form of the crucifix. The upright of the cross is on the precise central axis of the painting. Christ's body naturally takes the same form. We then have an angel, a standing figure, and a kneeling figure on either side. Above the horizontal beam, Pilate's inscription is no irregular, hastily scrawled placard, but is framed and mounted on a short, precisely centralized, post. On one side, a cloud contains the sun, with a face; on the other, a cloud with a similarly featured moon appears. The landscape background on either side rises level with the head of the standing figure. Apart from the wound in the side, Christ's body has much in common with the idealized classical representations of Apollo or Hermes, and the garments and features of all participants are clearly delineated.

In Delacroix's painting, the cross is placed at an angle to the picture plane, and set slightly left of centre. In compositional terms, there is a balance between Christ's companions on the right and the Roman horsemen on the left, but nothing approaching the regularity of Raphael's composition. Christ's body is painted to convey the reality of his suffering, not the beauty of the human form, and none of Delacroix's faces are clearly delineated. Nor are the clouds in the tumultuous sky.

Both works, however, have much to tell us. Raphael, with his centralized cross between the sun and moon, reminds us of the centrality of Christ's crucifixion within the whole context of the created universe. He also emphasizes its centrality to the gospels that Jerome translated and, through both the gospels and the mass, to the church of which Jerome was one of the doctors. Delacroix invites us actually to be with, and share the anguish of, Christ's mother and companions at the moment of his death on the cross. But he also asks us to hear the voice of the centurion who, having seen the manner of Christ's death, and having opened his side with a lance, sees the reaction of the elements and says: 'Truly this was the son of God!'

Master of the Starck Triptych, *The Raising of the Cross*,
c. 1480/90, oil on panel, (left) 65.6 × 24 × 3 cm, (centre)
65.3 × 48.3 × 3 cm, (right) 65.4 × 24 × 3 cm, National
Gallery of Art, Washington, D.C.

Andrea Vanni, *Scenes from the Passion of Christ: The Agony in
the Garden, the Crucifixion, and the Descent into Limbo*, 1380s,
tempera on panel, 56.9 × 116.4 × 3.4 cm, National Gallery of
Art, Washington, D.C.

Matthias Grünewald, *The Small Crucifixion*, c. 1511/20, oil on panel,
61.3 × 46 cm, National Gallery of Art, Washington, D.C.

Peter Paul Rubens
The Deposition of Christ from the Cross
1611–14

Oil on panel, 420.5 × 320 cm

Flemish artist Sir Peter Paul Rubens (1577–1640) was one of the most influential European painters of the first half of the seventeenth century. His parents had been forced to flee their home in Antwerp at the height of religious conflict there, so Rubens was born in Westphalia in Germany. After the death of his father in 1587, his mother took the family back to Antwerp, where Peter Paul was admitted to the Guild of Painters in 1598. From 1600, he worked in Italy as court painter to the Duke of Mantua, but returned to Antwerp in 1608, when his mother contracted a serious illness from which she subsequently died. Between 1625 and 1633, Rubens was engaged in a series of major diplomatic missions and was ennobled for his efforts by both Charles I of England and Philip IV of Spain. Both before and after this activity on the European political stage, he was firmly established in Antwerp, and it was as the central panel of an altarpiece for that city's cathedral church of Our Lady that our present work was painted between 1611 and 1614.

The Deposition of Christ from the Cross was clearly a subject of great interest to Rubens, for he returned to it several times in his long career. Among the first things that strikes one about this particular version is the imaginative power that lies behind it. While the component elements are taken from the gospel accounts, the detailed way in which these are employed is entirely down to Rubens' skills and imagination, and gives witness to deep meditation on the event depicted.

Some of the details of Christ's passion and death appear in all four gospels, but others are absent in some, or present but with minor variation. However, a knowledge of all four versions enables one to see which details Rubens has taken or chosen to emphasize. All the gospels agree that it was Joseph of Arimathea who went to Pilate to beg for the body of Jesus. He is variously referred to as 'a rich man', 'good and just', 'a member of the Council',

and 'a secret disciple' of Jesus. It is Matthew's word 'rich' that helps us identify him as the older, finely dressed figure with the velvet cap, on the left of Christ's figure. Opposite him, but slightly less finely dressed, is Nicodemus, another member of the Council who had also become a secret disciple of Jesus. He is mentioned only by St John.

The two workmanlike figures at the top of the painting are obviously servants, although not mentioned in the gospels. Possibly both Joseph and Nicodemus are seen as having each brought one servant. More probably, Rubens envisages both as having been brought by Joseph to assist him. The young man in red is obviously intended to be St John, the only apostle said (by John himself) to have been present at the foot of the cross as Jesus died. Artists often represent John as beardless to indicate his youth. Rubens does give him a slight beard, but a very youthful, downy one.

The three women are easily identified. Mary, the mother of Jesus, stands, stretching out her left hand to touch and then grasp the right arm of her dead son. Below her, Mary, the mother of James and Joset, kneels behind the also kneeling Mary Magdalene. The latter can be known both by her long hair and the more leading role she plays as, holding the left leg of Jesus and with his foot on her shoulder, she begins to take some of the weight.

All three synoptic gospels say the body of Jesus was 'wrapped in a shroud' after being removed from the cross. It is Mark who says that Joseph of Arimathea 'bought' the shroud specifically, after being granted the body by Pilate. Rubens sees the shroud as playing a major role in the deposition itself. In the bottom right-hand corner of the painting lies the metal dish that contains a little of Christ's blood as well as the crown of thorns and the three nails with which he has been crucified. The dish rests on the notice that Pilate had written and had affixed to the cross. All the gospels mention the notice and its inscription,

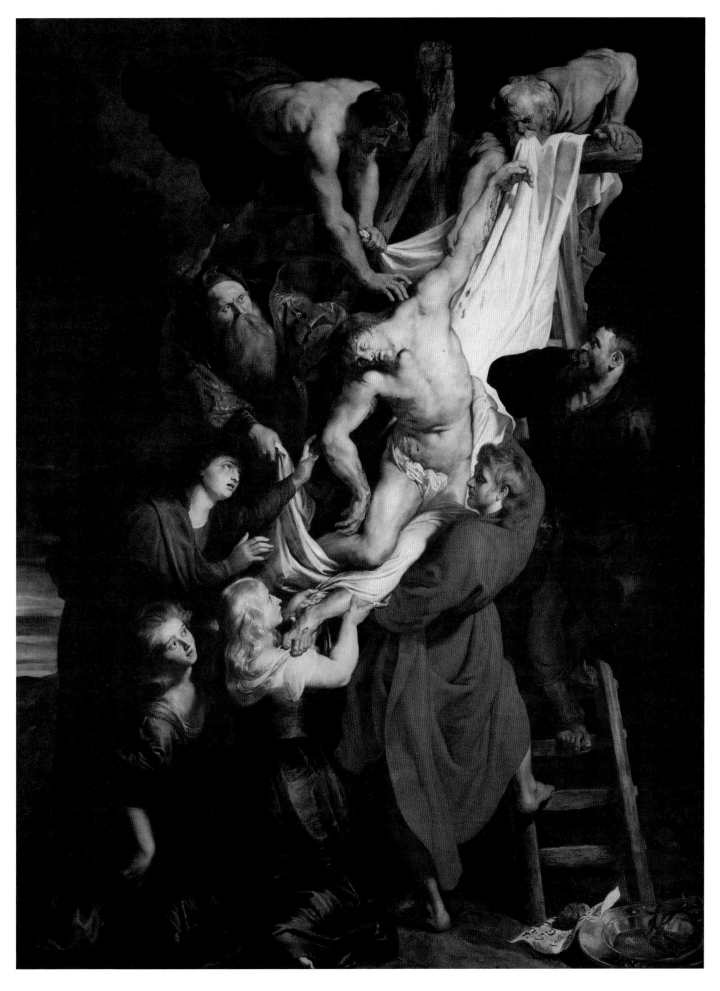

but only John says that it was written in Hebrew, Greek, and Latin. Rubens shows, beneath the Hebrew writing, the full name of 'Jesus' in Greek.

None of the gospels gives any account of the details of the deposition, but Rubens seems to have thought through a likely sequence of events. He imagines that four ladders have been brought. Two have been placed behind the cross, one on either side. From near the tops of these, the servants lean across. Given the height of the crucifix that Rubens has depicted, Christ's feet would have been near enough to the ground for the nail through these to be removed by someone standing at the foot of the cross. After this has been done, it would seem that the body has been eased forward, with St John, standing on the ground, able to take the weight of the lower body as the shroud is passed up behind it until each of the servants can take a corner.

After the crown of thorns and notice have been passed down, the servant on the left has removed the nail from Christ's right hand and supported the upper body on that side, slightly forward from the upright. Another ladder has then been leant against the upright, on which Joseph of Arimathea has ascended. He helps guide and take the weight of the body on that side, partly directly with his hand and partly via the shroud. The other servant has then removed the nail from Christ's left hand and has succeeded in holding on to his left arm with his own strong right one. He has also held on to the shroud with his teeth as the final ladder has been squeezed up against the left crosspiece to enable Nicodemus to ascend. John braces his foot against the ladder.

The precise moment then that Rubens gives us is that at which Nicodemus is about to turn inwards to pass one corner of the shroud to the younger servant on the left, already stretching to receive it. The two servants will then be able to take part of the weight on the shroud from above, while both Nicodemus and Joseph of Arimathea can join

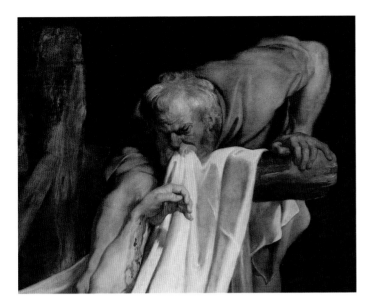

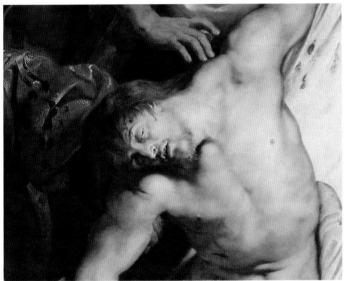

John to take the principal weight and lower the body to the ground. The realistic sense of a dead weight being lowered that Rubens creates is quite remarkable. It is indicated by the limpness both of Christ's neck, as his head droops onto his shoulder, and of his right hand and lower arm, partly held up by Nicodemus. It is also emphasized by the composition of the painting with its strong downward diagonal from top right to bottom left, reinforced by the white shroud and by the illumination that comes from an unseen source at the upper front right. The effect created is almost that of the dead Christ sliding down a stream of light.

The composition is beautifully balanced without any sense of artificiality. Rubens positions one figure on either side at the top leaning forward over the crucifix; one on either side of the cross in the centre, standing on the ladders, their heads in line with that of Christ; one standing on either side at ground level, wearing the brightest colours in the painting; and finally the two Marys kneeling on the ground in such a way that their flesh tones continue the slight curve at the bottom of the central illuminated area. The shroud serves to bind the whole group together. All the figures are in direct physical contact with this shroud, except 'the other Mary', but she forms a single compositional unit with Mary Magdalene.

The angle of the light offers direct illumination of all nine faces. Their beautifully nuanced expressions make a major contribution to the psychological intensity that Rubens generates. So often in everyday life, the death of a person close to us produces internal conflict, with the need to take practical actions at a time of great emotional turmoil. Rubens, in these faces, suggests that conflict within all his participants, but also, by their positioning, shows the extent to which the emotional predominates. Here, then, the servants at the top of the cross, whom one would expect to have the least personal emotional investment, do show both

tenderness and compassion. However, they are very much concentrating on the practical, physical aspects of the task in which they are engaged. The most powerful compositional elements in the diagonal that Rubens creates are the arms of Christ. These lead upwards from Christ's head to the face of the servant, and downwards via the left arm of Mary to her face, which has room for nothing but grief. Her hand is stretched upwards, not to aid in the deposition, but simply to touch and hold her beloved son.

The ones who accompany Mary at the foot of the cross are those with the strongest emotional ties. The one least involved in the actual deposition is 'the other Mary'. She has no task to distract her from her emotions and is the only one shown with actual tears on her face. John is the member of this lowest group who is most heavily engaged in the work in hand. His face seems to suggest that he is working in an emotional numbness, as he stares across at Mary, whom Jesus has just committed to his care. Mary Magdalene supports the leg of Jesus with her right hand and grasps the shroud with her left, but her eyes are firmly directed at the face of Jesus, as if trying to understand whether he can really be dead or whether the eyes may reopen.

Between the servants at the top of the ladders and the close companions of Jesus on the ground, we have the two members of the Sanhedrin, Joseph of Arimathea and Nicodemus. These are both firm believers in Jesus, as indeed their actions here after his death indicate. They did not, however, have the same type of emotional relationship with him as those positioned below them. They are members of a social and academic elite. When Nicodemus had first come to Jesus by night (as told in Chapter 3 of John), Jesus had referred to him as 'the teacher of Israel'. Moreover, and particularly interesting in the present context, it was to Nicodemus that Jesus first foretold the type of death he would face, saying that he would be 'lifted up' as the bronze serpent had been by Moses in the desert. Joseph and Nicodemus have, then, at least subconsciously, intellectual issues to trouble them as well as practical and emotional ones. At the instant that Rubens offers us, Nicodemus is looking up at the servant to whom he is passing his side of the shroud. However, Joseph is looking across at this wise 'teacher of Israel', doubtless wondering how he is reacting to the death of Jesus, in the context of Jewish expectations relating to their Messiah.

Of course, the actual centre of the painting in every sense is the body of Jesus. In compositional terms, this lies across both the vertical and horizontal axes of the painting, and is given maximum illumination. Rubens establishes a very high viewpoint for the spectator, so that we are actually looking down on the head of Jesus. We have already noted the sense of dead weight that Rubens creates. In fact, few paintings offer such a strong portrayal of a lifeless human being. The whole painting gives the message that Jesus is dead, and shows the struggle of his followers to come to terms with the finality of this consummation of his ministry.

However, the Christian knows that it is, in fact, not the end. One of the most interesting details in the painting is towards the bottom left. The rest of the area around the illuminated central section is clothed in darkness, but here is a patch of red-tinged sky, with a black band across the middle of it. At one level, this makes complete narrative sense. The gospels tell us that over the three hours before Jesus died, a premature darkness descended over all the land. They also emphasize that haste was needed for Jesus to be buried before the Sabbath, which would begin at sunset on Good Friday. It would be unsurprising, therefore,

for Rubens to remind us both of the darkness that descended and the onset of evening.

There are, however, two related points. The first is that the curve we have mentioned at the bottom of the illuminated diagonal that follows the lines of Christ's body leads us directly to that patch of light. It seems clear that Rubens is reminding us that the darkness of the death of Jesus will actually lead to the light of his resurrection. But it may be the case that he is being still more specific. How do we explain the very marked black band across the middle of that patch of sky? Should we perhaps take it in conjunction with the dark grey band at the top of the patch? If we think of that in terms of the present Good Friday evening, are we not being offered a sequence of day-night-day? If we note that the curve from Christ's knee via the faces of the two Marys, actually takes us to the lower patch of light, we may decide that Rubens is directing us very specifically from the darkness and grief of Good Friday to the light and joy of Easter Sunday, when Jesus will rise again, as he foretold, on the third day. This pictorial unification of both the death and resurrection of Jesus takes us to the very heart of the Christian faith. It is a great painting for the greatest week in the Christian year.

Jacopo di Cione
The Resurrection

1370–1

Egg tempera on wood, 95.3 × 49 cm

The Coronation of the Virgin by early Italian Renaissance painter Jacopo di Cione (1325–90) is one of the most impressive paintings in London's National Gallery. His painting of the Resurrection forms part of this enormous work, which was painted as the main altarpiece for the church of San Pier Maggiore (Greater St Peter's) in Florence (*see page 143*). The panels of the predella depicted the life of St Peter, and these have been dispersed among various collections around the world. The three panels of the lower main tier, immediately above the predella, and the nine panels of the two upper tiers, are all in the National Gallery. As one would expect from the title, the central panel of the main tier shows Christ crowning his mother as Queen of Heaven. The panels on either side of this show crowds of identifiable saints, with St Peter himself, prominent on the left, holding a model of the church of San Pier Maggiore. Above each of these three major panels are two smaller ones. Those on the left depict the Nativity and the Adoration of the Magi respectively; those in the centre show the Resurrection and the three Marys at the tomb; those on the right have images of the Ascension (*see page 141*) and Pentecost. The central panel of the top tier shows the Trinity, in the form of a kinglike God the Father, supporting the cross of a crucified Christ, above which hovers the Holy Spirit in the form of a dove. The side pinnacles have angels, looking inwards to the Trinity.

Within the physical structure of the altarpiece itself, therefore, the scene of the Resurrection has a subsidiary part. It is, however, symbolically situated at the centre of the Redemption narrative, which the altarpiece in its entirety depicts as God's plan, a plan that the Church, founded on St Peter, continues to implement. What is also interesting, from an art-historical point of view, is the extent to which this particular image has helped to found a tradition for the representation of the Resurrection. The precise moment of Jesus' rising from the dead is not actually described in the

gospels. As a result, the early series of paintings tracing the gospel story, such as those by Duccio in Siena and Giotto in Padua, instead of the Resurrection itself, tended to show either the Marys at the sepulchre or the meeting of Mary Magdalene with the risen Christ, the latter normally known by the Latin version of Christ's instruction, *Noli me tangere*.

However, representations of the actual moment of the Resurrection did gradually begin to appear. One of the earliest is by the Sienese painter Ugolino di Nerio (1280–1349) and precedes our present painting by almost fifty years. This was also a small, subsidiary predella panel at the base of a large altarpiece. It depicts a very static figure of Christ, with only the top half visible, as he stands upright, still in a sarcophagus but with one foot on the edge, holding the flag of victory and surrounded by sleeping soldiers (*see page 126*). Another example painted just over a century later in 1457–9 and now in the Musée des Beaux-Arts in Tours, France is that by Andrea Mantegna (*see page 126*). Here a strong-looking Christ figure can be seeing stepping onto the edge of the open sarcophagus, bearing the flag, surrounded by hosts of angels, and radiating beams of intense light all around. The terrified soldiers keeping guard have just been awoken from their slumber at the entrance to the tomb. A third work is by an unknown follower of Mantegna, painting a decade later. His *Resurrection* offers an upward view of a Christ, standing on a still-closed sarcophagus, and backed by a huge dark rock, again holding the flag in his left hand as he blesses the world with his right (*see page 128*). Unlike the precedent created by Mantegna himself, his follower's version has the tomb once more surrounded by sleeping soldiers unaware of the wondrous act taking place above them. Working more than half a century later, the northern Italian artist Gaudenzio Ferrari (1471–1546) painted a Resurrection between 1530 and 1546 that formed a larger, central panel from an altarpiece (*see page 127*). This shows Christ about to step out of the

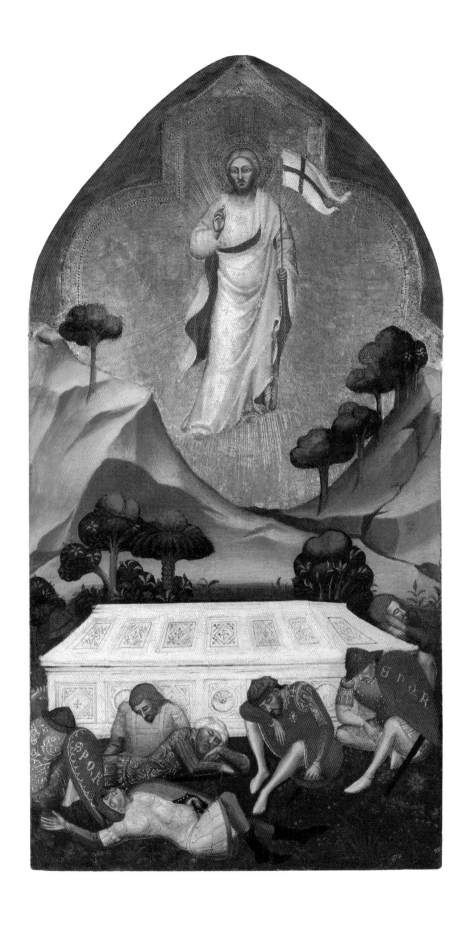

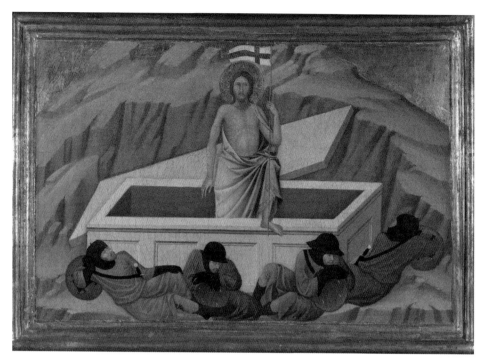

Ugolino di Nerio, *The Resurrection*, possibly 1325–8,
egg tempera on wood, 41.5 × 58.1 cm, National Gallery,
London

Andrea Mantegna, *The Resurrection*, 1457–9, oil on canvas,
71.1 × 94 cm, Musée des Beaux-Arts, Tours

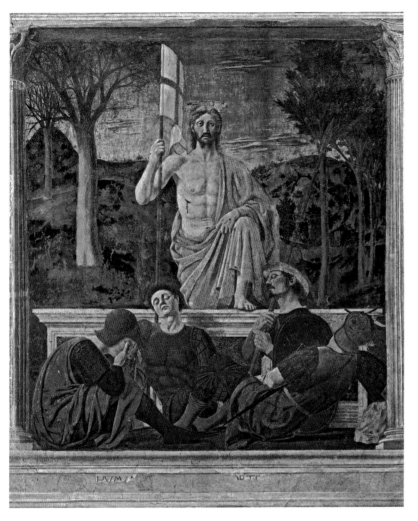

Piero della Francesca, *The Resurrection*, c. 1460s, fresco, 225 × 200 cm, Museo Civico, Sansepolcro

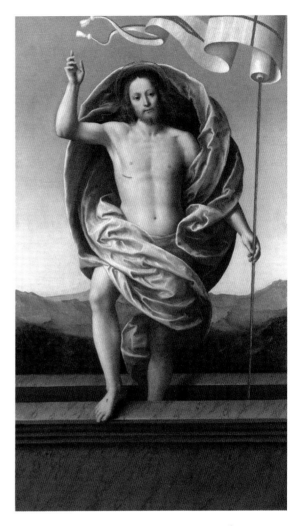

Gaudenzio Ferrari, *The Resurrection*, 1530–46, oil on poplar, 152.4 × 84.5 cm, National Gallery, London

sarcophagus, against a landscape background. He again holds the flag and raises his right hand in blessing, but there are no soldiers or other figures present. One of the most famous Resurrection paintings, that by Piero della Francesca in his birthplace, the Tuscan town of Sansepolcro, was painted around 1460, roughly half way between those of Ugolino di Nerio and Gaudenzio Ferrari, and it shares major features with them. It again has Christ standing in the sarcophagus, but with one foot on the edge, holding the flag, with sleeping soldiers and a landscape background.

We can see, therefore, from these few examples, the emergence of two separate traditions of Resurrection paintings. Those by Ugolino di Nerio, Piero della Francesca, Mantegna, and Gaudenzio Ferrari illustrate a type of static, largely iconic image of Christ before he has fully stepped out of the newly opened tomb. The painting by Jacopo di Cione has a far more dynamic narrative content. The miraculous nature of the event, and the fact that Christ's body is now in a glorified state, is emphasized by its emergence from an unopened tomb. (Jacopo is clearly thinking that the tomb

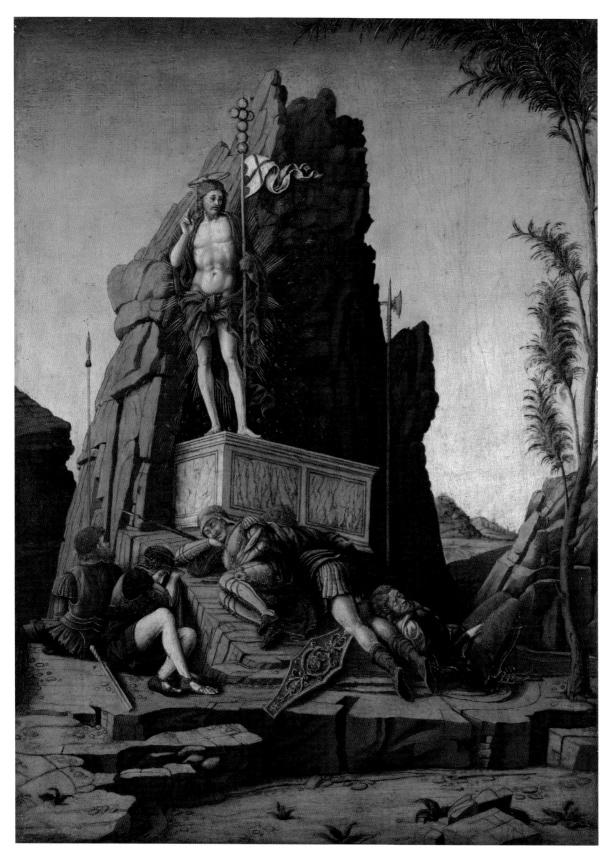

Imitator of Andrea Mantegna, *The Resurrection*, perhaps 1460–1550,
oil on wood, 42.5 × 31.1 cm, National Gallery, London

Paolo Veronese, *The Resurrection*, c. 1580, oil on canvas, 273.4 × 156.2 cm, Chelsea and Westminster Hospital, London

would be opened subsequently by the angels for the benefit of the Marys and disciples, as indicated in Matthew's gospel.) The sense of dynamism and upward movement is imparted by the vertical streaks of light painted below the figure of Christ, and is heightened by the curve of the robe over his right foot, as he looks down to bless the Earth.

In his semi-narrative work, the follower of Mantegna lost this effect of upward movement. Also, significantly he set Christ's figure against dark rock. By using a gold background Jacopo di Cione emphasized Christ's risen glory. However, he also pointed the way to further symbolic and narrative possibilities for later artists. He indicates by the gold on the side of the trees towards Jesus, and the paler patches on the mountain slopes, that light radiates from the body of the risen Jesus at a time of semi-darkness. This accords fully with the gospels, which all mention that the women went to the tomb at the first light of dawn, the earliest time after the Sabbath permitted by Jewish law.

Later artists were to see, as with night-time Nativity pictures, the possibility of illuminating the whole scene of a Resurrection with radiance from the figure of Christ himself. Moreover, the straight horizontal line of the back of the tomb in Jacopo's painting offers a clear dividing line, below which we have the soldiers sleeping on the dark earth. Later artists also saw that the strong line of the lid of the tomb, open or closed, could more emphatically symbolize the division of the old dark, earthbound world of the Roman Empire, still spiritually asleep, from the new Christian world of enlightenment, represented by the figure of a dynamically risen Christ, who in darkness radiates light from his own glorified body. One of the most striking of such Resurrection paintings is that by the great Venetian master Paolo Veronese (1528–88), in Chelsea and Westminster Hospital in London. This painting, from around 1558, makes full use of the contrast just outlined. It does, thereby, show a traceable debt

to our work, produced two hundred years earlier. In fact, Jacopo, tackling one of the most difficult tasks in religious painting, had more success than many subsequent painters, on several of whom he had a major influence.

Easter is the greatest feast of the Christian year. The Resurrection was the proof of Christ's divinity offered by Peter to the Jews, and by Paul to the Gentiles. Its acceptance caused the remarkable spread of Christianity through the Roman Empire in spite of three centuries of persecution. Jacopo's vision of the explosive, sunlike glory of Christ, miraculously risen from the dead and emerging from the closed tomb, is a marvellous example of the powerful union of artistic talent and imagination with religious faith.

Titian
Noli me Tangere
c. 1514

Oil on canvas, 110.5 × 91.9 cm

The Crucifixion took place on a Friday, and Jewish law dictated that Jesus had to be buried quickly before sunset, the start of the Sabbath. Mary Magdalene and her companions, who had witnessed the death and burial of Jesus, had to rest on the Sabbath in accordance with the law. It was, therefore, only early on the following morning, the Sunday, that they could go with ointment and spices to anoint his body.

The four evangelists give slightly different details of the events of that Easter morning, and only St John narrates the precise incident pictured here. He tells us that Mary Magdalene went to the tomb, found the stone rolled back, and ran to tell Peter and John. They in turn ran to the tomb, found it empty and saw the linen cloths lying on the ground, with the napkin from Jesus's face folded nearby. John and Peter went away, but Mary stayed weeping. When she looked into the tomb again, she saw two angels who asked why she was weeping. She answered: 'They have taken my Lord away, and I don't know where they have laid him.' As she spoke, she turned and saw Jesus, whom she took for a gardener, and said: 'Sir, if you have carried him off, tell me where you have put him and I will go and take him away.' Jesus said to her, 'Mary!' She answered, '*Rabbuni!*' ('Master!'). Jesus said, 'Do not touch me because I have not yet ascended to the Father.' Those first words – 'Do not touch me' – is the normal translation of the Latin Vulgate '*Noli me tangere*', the title of this picture and others showing the same scene.

One feature of this painting by Venetian master Tiziano Vecelli (1488–1576), known in English as Titian, which might cause initial surprise, is how little of the gospel background the painter chose to include. It is quite normal for an Italian artist of the sixteenth century to set a New Testament scene in a typical Italian landscape. Few painters or patrons would have first-hand knowledge of Palestine and, as noted previously, preachers from the religious orders encouraged the faithful to envisage the events from the

gospels as taking place within their own environment. One would, however, expect that there might be some suggestion of a tomb, of nearby Calvary, or of the walls of Jerusalem. Instead, the hillside with its buildings, on the right-hand side of the painting, is part of a kind of general-purpose landscape, and appears in almost identical form in the *Dresden Venus* by Giorgione (*c.* 1477/8–1510), and again only slightly modified in that artist's *The Sunset* (*see page 132*). Titian was a pupil and collaborator of Giorgione's, and it is uncertain which artist painted that section of the relevant works.

Titian does give Jesus a kind of hoe, as a reference to the 'gardener' for which Mary had mistaken him. But he makes no real effort to suggest that this meeting is actually in the garden near Calvary, where John tells us Jesus' tomb was situated. The setting seems more like the side of a road, which would not be without its own symbolic significance. What Titian leaves out of this beautiful painting, however, merely emphasizes the things that he regarded as important in his depiction of the scene. Indeed, the whole composition serves to reinforce the dramatic situation implicit in the title. The fact that the verb *haptomai* in the original Greek can mean to 'lay hold on' or 'embrace', as well as 'touch', has led some modern versions to translate Jesus' words as 'Do not cling to me.' It is clear, though, that Titian's Magdalene is not trying to embrace the knees of Jesus in joy at finding him, but is reaching out simply to touch him, probably to see if he is really flesh and blood. Jesus does not step back or repulse her in any abrupt or forceful way. He merely inclines his body slightly away from her, and draws his white garment between them. That tableau of Jesus leaning away from the kneeling Mary has a clear visual echo in the background, where the bush with its shadow repeats the lines of her red robe, and the line of the tree, which leans away from the bush, is close to a vertical reversal of the line of Christ's body.

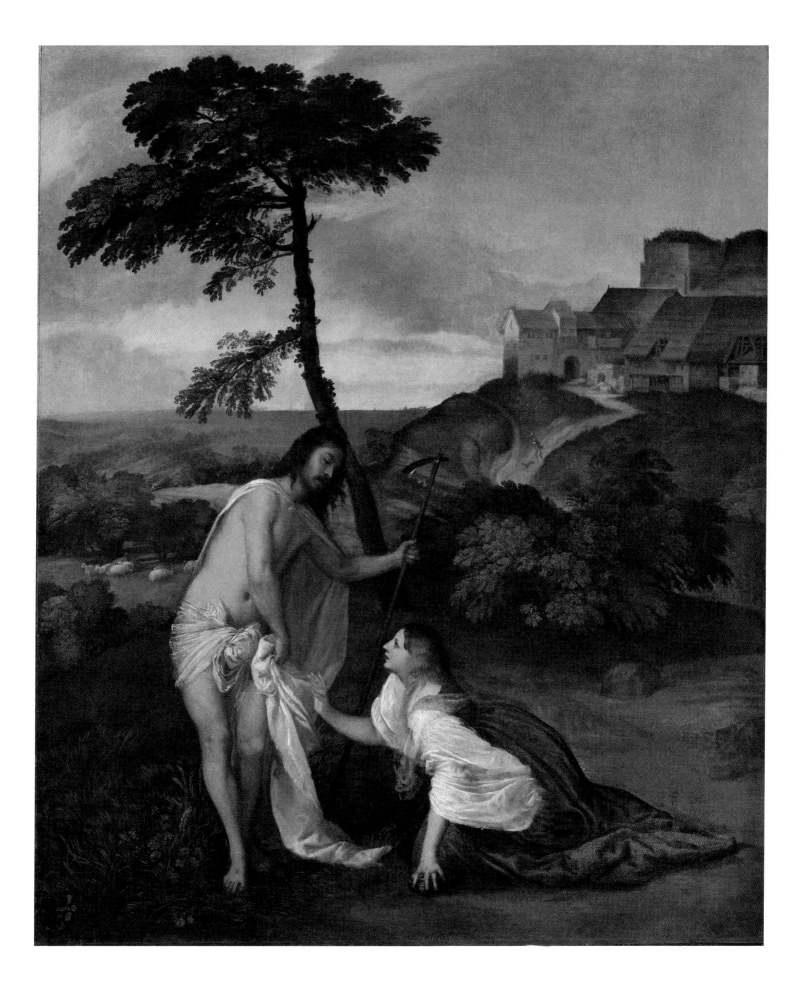

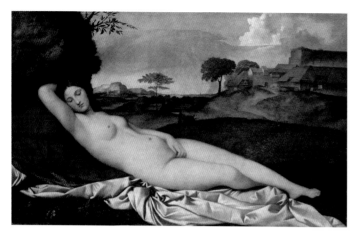

Giorgione and Titian, *Dresden Venus*, *c.* 1510, oil on canvas, 108.5 × 175 cm, Gemäldegalerie Alte Meister, Dresden. According to the usual account, Giorgione left the *Dresden Venus* unfinished at his death, and Titian completed the sky and landscape, although some scholars believe that Titian may have been responsible for the nude as well.

Giorgione, *The Sunset*, 1506–10, oil on canvas, 73.3 × 91.4 cm, National Gallery, London

The tree performs a very interesting function in the painting. In terms of the composition of the picture, it unites the two figures, leading us from the face of Mary to that of Jesus. But psychologically and in narrative terms, it serves to separate them, joining the handle of the hoe to form a clear dividing line. Mary attempts to reach across this line, and Jesus gently says she must not do so. Mary kneeling on the ground is still very much bound to earthly existence. But the tree leads us from the now glorified, resurrected Jesus to the sky, the heavens through which he will, as he indicates to Mary, shortly ascend to his Father.

One notices also that, although the line of the tree leads us upwards from Mary, there is no actual overlap between its form and hers, whereas both the head and arm of Jesus are in contact with the tree on the picture surface. This close association of Christ with the tree, which is given such a dominant role within the composition, suggests that Titian wanted the spectator to be reminded of the tree of the cross, and probably also to make the connection with the tree in the Garden of Eden, and hence with Christ as the second Adam. The very obvious flock of sheep that Titian has included behind Jesus, and the slight resemblance of his hoe to a crook, may also constitute a reference to Jesus as the Good Shepherd.

The jar on which Mary's left hand rests also serves a dual function. Within the narrative, it is clearly intended to contain the spices or ointment that Mark and Luke tell us that Mary and her companions took to anoint the body of Jesus. However, the popular identification of Mary with the woman who anointed his head with spikenard and wiped his feet with her hair, has made a jar and long hair the two constant attributes in representations of this saint.

Much, and probably too much, has been made of the contrast between the emphasis on *design* of the Renaissance painters in Florence and that on *colour* by those in Venice, of whom Titian is often taken as the prime example. It is the wonderful fusion of both of those two elements that has created such a beautiful and powerful representation of the single moment, and single phrase, that St John regarded as so specially significant that it had to be included in the culmination of the Easter narrative, and hence familiar to all students of Christian painting.

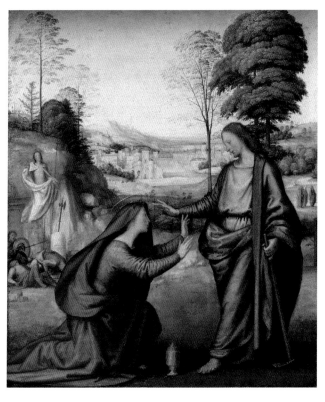

Fra Bartolomeo, *Noli me Tangere*, c. 1506, oil on panel, 57 × 48 cm, Musée du Louvre, Paris. The painter of this delicate version was a Dominican friar in the Convent of San Marco in Florence. His work greatly influenced the younger Raphael, who befriended him shortly after this picture was painted.

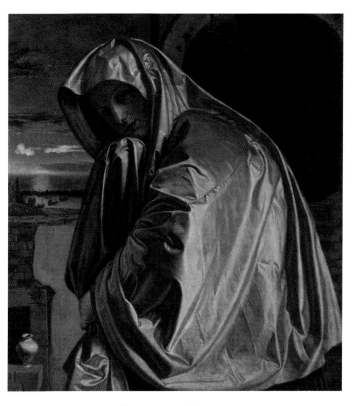

Giovanni Girolamo Savoldo, *Mary Magdalene*, c. 1535–40, oil on canvas, 89.1 × 82.4 cm, National Gallery, London. With this unusual and striking depiction of the scene, the viewer stands in the place of Christ, who is represented by the shimmering light reflected in the Magdalene's cloak.

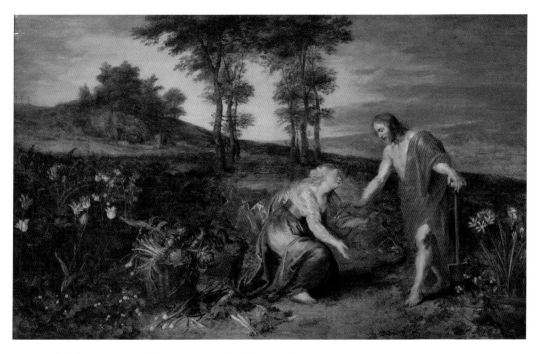

Jan Brueghel the Younger, *Noli me Tangere*, c. 1631, oil on panel, 57.5 × 92.7 cm, Fine Arts Museum of San Francisco. Flemish artist Brueghel painted more than one version of this composition in which the Magdalene is on the verge of touching Christ, who stands resolute in his red robe, arm extended to prevent her.

Caravaggio
The Supper at Emmaus
1601

Oil and tempera on canvas, 141 × 196.2 cm

Michelangelo Merisi da Caravaggio (1571–1610) was recognized as a major painter in his lifetime and for some years afterwards, but he faded from prominence, for his originality and influence to be fully appreciated only in the twentieth century. Even then, his artistic importance was partly overshadowed by the details of his colourful life. The present picture was painted in Rome, where he worked from the early 1590s to 1606. He then spent several years on the run from a charge of murder, and died at the early age of thirty-eight, while returning to Rome, probably in the hope of a pardon.

The painting here is based on the final chapter of the gospel of St Luke and concerns later events on the day of Christ's resurrection. Luke tells us that two of his disciples set off to walk to a village called Emmaus, seven miles from Jerusalem. As they were talking about what had happened, Jesus joined them on the road, 'but their eyes were prevented from recognizing him'. Jesus asked what they had been discussing. Downcast, they expressed astonishment that even a stranger to Jerusalem had not heard about the teaching, works, and crucifixion of Jesus, the one they had hoped would be the Messiah. They added that some women from their group had found the tomb empty, and seen a vision of angels who said Jesus was alive. Jesus rebuked them for not having understood the prophets, who had taught that the Christ must suffer before entering into his glory. Then, beginning with Moses, he took them through all the passages in the scriptures that referred to himself.

When they arrived at the village, Jesus made as if to go on with his journey. But they begged him to stay with them as evening was approaching, and Jesus agreed. At supper, he took bread, blessed it, broke it and gave it to them. Immediately, they recognized him, but he disappeared from their sight. They said to one another, 'Did not our hearts burn within us, as he spoke to us on the way and opened up the scriptures to us?' Setting off at once back to Jerusalem, they found the eleven apostles gathered with other disciples, who told them that Jesus had indeed risen and had appeared to Simon Peter. They then recounted what had happened to them, and how they had recognized Jesus in the breaking of the bread.

Our current painting is the earlier of two representations of the scene by Caravaggio. The later work, from 1606, is in the Pinacoteca di Brera in Milan. There are many similarities between the two pictures. However, one of the main differences concerns arguably the most striking feature of our painting: the face of Jesus himself, which Caravaggio has here represented without a beard. Probably the earliest extant artistic representations of Jesus are in the catacombs in Rome. Among those images seemingly intended to represent Christ, some show him bearded, others clean shaven. But from the thirteenth century onwards, a strong tradition developed for images of Christ always with a light beard. This tradition was much strengthened by several apocryphal writings, mistakenly believed to be eyewitness descriptions of a bearded Jesus. The one outstanding representation of Jesus without a beard is that in Michelangelo's great *Last Judgment* fresco in the Sistine Chapel, from 1541. But this was exceptional even for Michelangelo. One notes that in his 1501 painting *The Entombment* in the National Gallery in London, as well as in his famous *Pietà* sculpture of 1499 in the Vatican, and the later sculptures of the same subject from the 1550s, Christ has the traditional light, forked beard.

Whereas, therefore, many artistic images would be immediately recognized as being of the face of Christ, one could not say that in reference to the present painting. The face of Jesus here is atypical not only in being clean shaven. It is also far more oval, youthful, and full-fleshed than is customary. Caravaggio may be thinking that a beardless,

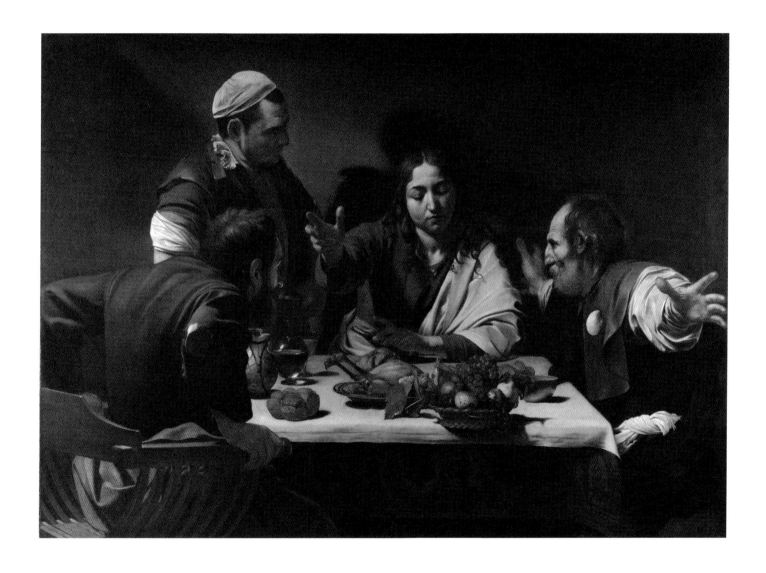

more youthful face would be more appropriate for the glorified, risen Jesus, as well as being a contributory factor to the disciples' lack of recognition of Jesus on the road. He may also have wanted us to share the experience of the disciples in not immediately realizing that we are looking at the face of Jesus. On first seeing the painting, without its title, we might well wonder who the central figure is. Then on observing that this seems to be a meal in an inn, that the outer characters are expressing joy and astonishment, and that the central figure is blessing what is on the table, we too can 'recognize him in the breaking of the bread'.

Whether Caravaggio represented Christ in this way of his own accord or at the request of the Roman nobleman Ciriaco Mattei, one of the most prolific art collectors of the day, who commissioned the painting, we cannot be sure. In either case, and whether or not he used a specific model, Caravaggio had the difficult task of producing an image of Christ from his own imagination, rather than one adapted from a stereotype. The extent to which the viewer will be pleased or displeased with the result is inevitably subjective. But Caravaggio's approach certainly challenges the viewer. What aspects of Christ's character is the artist trying to bring out? To what extent do we find that this image of Christ conforms to the person we know from the gospels in general, and from this narrative moment in particular?

What is clear is that the whole structure of Caravaggio's painting makes us focus on the figure of Jesus and very specifically on his face. The outstretched hand of the disciple on the spectator's right leads us into the painting. It also

begins the strong, broad, upward diagonal that takes in the profile faces of that disciple and the innkeeper, both turned inwards to the full face of Christ in the centre. Our eye is already attracted to that central area by the white tablecloth. The receding line on the right of this takes us, via the continuation of the white in Christ's outer garment, to a vanishing point on his right cheek. It is here also that light falls from an unseen source at the upper front left.

The painting is simultaneously both intimate and dramatic. Caravaggio here uses a similar technique to that which we saw employed by Bellini in his *Circumcision* (*see page 43*). He has set his figures very close to the picture plane. Then, demonstrating his command of foreshortening, he makes the left hand of the older disciple, and the right elbow and chair of the younger one, apparently intrude from the illusionistic space of the painting into our real space as spectators, thereby involving us closely with the scene.

In the moment that Caravaggio depicts, the innkeeper looks at Christ intently with a slightly uncomprehending curiosity. In contrast, the disciples react dynamically, gazing at Jesus with wonderment and joy. The one on the right throws his arms apart in amazement. The one on the left rises instinctively from his chair. In doing this, he has apparently caught the table with his knee, making the basket of fruit, as we can see from its shadow, tilt into the air and teeter on the edge with the risk of falling.

Both the drama and intimacy are emphasized by Caravaggio's use of chiaroscuro. Strong contrasts of dark and light always tend towards the dramatic, while having an illuminated central area surrounded by dark shadow isolates the scene from the areas behind and to the sides, and opens it to us who stand in front.

The painting has, of course, a clear religious purpose. At the Last Supper, three nights before the incident depicted, Jesus had taken bread and blessed it. Then, having given

By medieval times, this was the established badge of a Christian pilgrim, particularly one who had made the pilgrimage to the Spanish shrine of Santiago de Compostela in Galicia, the supposed burial site of the apostle James. It is, of course, totally anachronistic for an incident on the day of Christ's resurrection. However, it does remind all Christians that they are on a journey to try, in several senses, to meet Jesus face to face, and that the Christian Church is, in the words of the mass, 'a pilgrim church', on its way to, not at, its destination.

The other feature to which Caravaggio directs us, both by its position and its relation to the action, is the basket of fruit. In his early years in Rome, Caravaggio had specialized in painting still lifes, so on one level this is a demonstration of another aspect of his artistic prowess. Almost certainly, however, Caravaggio is also employing symbolism as well as gospel associations here. First, there is the special emphasis on grapes, of which there are three bunches: a large bunch

thanks (in Greek *eucharistesas*) and broken it, he gave it to the apostles saying, 'This is my body, given up for you. Do this in commemoration of me.' Christians regard that moment as the institution of the sacrament of the Eucharist or Holy Communion, which constitutes for many Christians the central part of the liturgy. Jesus had similarly taken a chalice of wine and said 'This is my blood'. One notes, therefore, the glass of wine to the left of the loaf that Jesus is blessing. Furthermore, the embroidered cloth along the front of the table underneath the white covering makes the table resemble a traditional altar.

Caravaggio's composition draws attention to two other features of the painting. The first is the somewhat shabby clothing of the two disciples. Our attention is specifically drawn to the hole in the protruding jacket elbow of the disciple on the left. Like Tintoretto, Caravaggio was criticized in his own time for portraying Christ's disciples (completely in accord with the gospels, it should be said) as ordinary working men. In respect of the clothing, one might also mention the cockleshell worn by the older disciple.

dominates the top of the pile of fruit; one small bunch, dislodged by the jolt, hangs over the bottom right edge of the basket; and another on the left spreads its attached vine leaves onto the white cloth. Grapes often appear in Christian art with reference to the wine consecrated in the mass, and thus to Christ's blood, shed in his passion and crucifixion. We observe here that the basket of fruit shares the near section of the table with the bread in front of the younger disciple. This is also in line with the water and wine, thus completing the three elements of the consecration. Caravaggio is going out of his way to stress the Eucharistic nature of this event. Moreover, he is reminding us of Christ's words to the apostles at the Last Supper: 'I am the vine, you are the branches.' In the front left of the basket is a ripe fig, and we recall how Giovanni Bellini included the fig tree in his *Agony in the Garden*, in connection with Christ's passion (*see page 102*). To the right of the fig is an apple, and just above is another one; both have obvious blemishes. The apple is, of course, associated with the sin of Adam, while Christ is frequently referred to as 'the second Adam', who brings redemption to humankind. Behind the apple on the left is a very large pomegranate, which has burst open to reveal its many seeds. We noted, with reference to our Annunciation painting, the two symbolic meanings given to the pomegranate (*see pages 78–9*). On the one hand, originally through the pagan myth of Proserpina, it symbolized resurrection. On the other, through the notion of many united in one, it came to symbolize the Christian Church.

Here, on the very day of his resurrection, Christ as priest celebrates the great sacrament of his Church, and the sacrifice of his own body and blood, so both lines of symbolism are powerfully in play.

However, after we have considered some of the other areas of our painting, it is to that central figure of Jesus that we return. Jesus was condemned by the scribes and Pharisees for sitting down to table with all kinds of people, including known sinners and prostitutes. One cannot help thinking that this struck a special chord for Caravaggio, whose table companions apparently embraced an equally wide social range. The pomegranate in Caravaggio's fruit basket is wide open to reveal its many seeds, and the blemishes on some of his fruit are very clear. We us the word 'church' to translate the Greek *ekklesia* (and Latin *ecclesia*), which simply means 'assembly'. But the assembly of the Church symbolized here is, as Jesus made clear, open to all, and we all have our blemishes. He similarly emphasized that we often do not recognize him, and that when we act, or fail to act, for those in need whom we meet, we do it, or fail to do it to him.

As Caravaggio painted this picture, he would have had the hand of Jesus, in its moment of blessing, stretching out towards himself, a man conscious of his own blemishes. His painting reminds us of the support of Christ's Church and its sacraments. It also tells us to rejoice that, when we recognize Jesus in himself and in our fellow human beings, his welcoming hand of merciful blessing is always stretched out to us in love and forgiveness, in spite of all our blemishes.

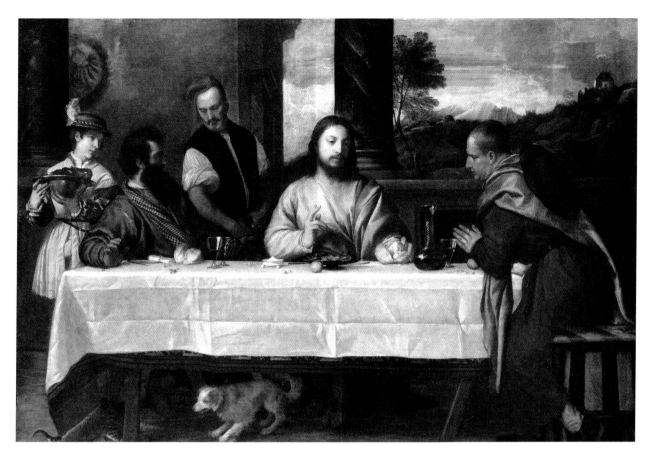

Titian, *Supper at Emmaus, c.* 1530, oil on canvas,
169 × 244 cm, Musée du Louvre, Paris. Titian's
earlier depiction similarly takes a frontal view
of the supper but without the sense of dynamic
drama that pervades Caravaggio's scene.

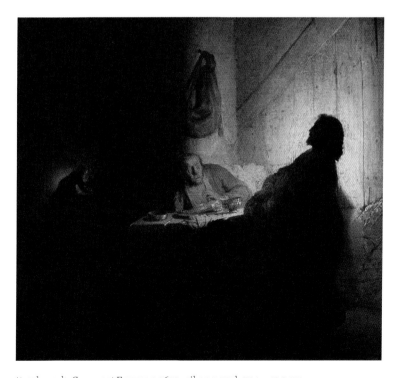

Rembrandt, *Supper at Emmaus*, 1629, oil on panel, 37.4 × 42.3 cm,
Musée Jacquemart-André, Paris. Rembrandt, on the other hand,
uses light and shade to create a highly dramatic interpretation.
Christ is bathed in darkness and we cannot see his face, while the
startled apostle is fully illuminated to reveal his astonishment.

Jacopo di Cione
The Ascension
1370–1

Egg tempera on wood, 95.5 × 49 cm

The Feast of the Ascension of Our Lord and Saviour Jesus Christ, also known as Ascension Day or Ascension Thursday, is celebrated in most Western churches on the fortieth day of Eastertide. Some denominations have moved the observance to the following Sunday. It commemorates the bodily ascension of Jesus into heaven.

We have already discussed Jacopo di Cione's *Resurrection* (*see page 125*) from his magnificent *San Pier Maggiore Altarpiece* of 1370–1, now in the National Gallery, London (*see page 143*). We noted that in that great polyptych, *The Coronation of the Virgin* is the central scene of the lower main tier, just above the predella. However, the middle tier of the altarpiece, which contains *The Resurrection*, also houses five other paintings of episodes from the life of Jesus. At 95.5 × 49 cm each, these panels are a substantial works in their own right. The penultimate image in the sequence is the only representation of Christ's ascension in the National Gallery.

Jacopo employs a similar landscape background for this to that for the two preceding panels, those showing the Resurrection and the Marys at the Holy Sepulchre (*see page 143*). It is, therefore, interesting to compare *The Ascension* with the other two. In doing so, we can see that the background trees, which have completely green foliage in the panel of the Marys, appear in the Resurrection panel, and still more here in *The Ascension*, with foliage on the side nearest to Christ turned to gold by the light of his glory. Jacopo uses downward streaks of this same golden light to convey the sense of Christ's upward movement both in the Resurrection panel and again even more in the current painting. We can also see that the four angels who accompany Christ, both physically and musically as he ascends, have brightly coloured garments. The two standing behind the apostles on the left of the painting are dressed in white. These are clearly intended to be the 'young men in white' to whom St Luke refers in his gospel.

Since St Peter is a key figure in this altarpiece as a whole, the story of his life appearing across the predella at the base of the work, the artist would naturally pay considerable attention to the way he is represented here. He is, unsurprisingly, placed in a central position between the Virgin Mary and the youthful, beardless St John, wearing blue and yellow robes. What is surprising is that while they, along with all the other apostles, continue to look upwards towards the ascending figure of Christ, Peter has already turned his head down towards John. What is Jacopo trying to indicate by this marked distinction? The likeliest answer seems to be that, with Christ's ascension Peter is aware that a special burden of leadership is already beginning to fall on him. In the main tier of the altarpiece (*see page 143*), Peter is placed foremost in the ranks of saints, in the foreground to the right hand of Mary as she is crowned by Jesus. Again wearing blue and yellow, he holds his normal attribute of a large key in his hand and a model of a church on his knee. This latter is clearly intended on one level to represent the church of the altarpiece itself, San Pier Maggiore, of which Peter is patron saint. But it naturally, on another level, also represents the universal church that Christ wanted to build, and for which he chose Peter, the rock, as the foundation stone. In this Ascension panel, Jacopo seems to envisage Peter as becoming suddenly aware of the responsibility he has been given, along with 'the keys of the kingdom of Heaven', once Christ is no longer with them.

The elongated and pointed shape of *The Ascension* offers both advantages and challenges in terms of the subject matter. From a narrative point of view, it has the advantage that a scene with a group of figures at ground level and a single figure above is well suited to a vertical panel tapering at the top. However, in terms of visual composition, it has the difficulty that, in emphasizing the separation between the group and the individual, the very central section of the

Reconstruction of Jacopo di Cione's *San Pier Maggiore Altarpiece,* including the predella at the base showing scenes from the life of St Peter

painting, where it would be natural to concentrate visual interest, has to be left blank. Jacopo deals with this problem in a variety of ways. Of particular importance here are the streaks of gold light referred to earlier. These not only provide the figure of Christ with that sense of upward movement, but draw the eye to follow them from the centre of the painting to the figure above. In doing this, they are aided by Jacopo's use of a device that came to be employed quite frequently in the early Renaissance and subsequently. The more central of the two 'young men in white' on the left points to the important event depicted, directing the eyes of his companion, and similarly the eyes of the spectator, towards Christ. The upward glances of the group of apostles naturally have the same effect as well.

Colour also plays a major role here. When we look at a painting, our eyes tend to be drawn both to the lightest area of the painting and to the section with the brightest colours. In this panel, the former area is that where the white-robed figure of Christ stands out against the gold background. The latter is that occupied by the brightly robed apostles. Our eyes tend, therefore, to move naturally back and forth between the upper and lower sections of the painting, as Jacopo doubtless intended.

However, although one can gain many insights by examining a panel like this in isolation, one must never forget that it was devised as only an element of a much greater whole, and one needs also to see its relation to the rest of altarpiece. As we noted earlier, the pinnacle panel of the altarpiece depicts the Trinity. It shows the dove of the Holy Spirit hovering between a kinglike God the Father and a crucified Christ. Below we move through the life of Christ

from his birth to his ascension, and on to the beginning of the life of the Church at Pentecost. Then, below that, in the main tier we have a representation of the Coronation of the Virgin. This apocryphal but highly symbolic event came, particularly later through the popularity of the rosary, to be seen in some sense as the culmination of the narrative. In that panel the great representatives of Christ's Church, apostles, martyrs, founders of religious orders, popes, and bishops, attend on Christ as he crowns his blessed mother Queen of Heaven. They do so with Peter as their leader. Peter's story is then told in more detail in the foundation unit of the altarpiece, the predella at its base.

In the Acts of the Apostles, St Luke shows the continuation of the special relationship that seems to have developed after Christ's crucifixion between St Peter and St John, the former fishermen partners from Galilee. No wonder then that as Christ, ascending to his Father, raises his hand in a gesture of blessing and farewell to his mother and friends, the first glimmer of the leading role that he is about to play in the story of salvation makes an awestruck Peter turn towards his young friend for reassurance and support.

One cannot know whether it was the commissioners of the painting, Jacopo himself, or a contemporary preacher who had the idea of emphasizing the significance of Christ's ascension in that particular way. It can, however, still give us pause for thought today. Jacopo here represents the moment at which the responsibility for spreading the good news passed from Jesus himself to the members of the Church that he had founded, the followers of Jesus both then and today. That thought is surely enough to make all Christians share Peter's look of concern.

Jacopo di Cione, the main panels from the *San Pier Maggiore Altarpiece*, *c.* 1370–1, egg tempera on wood, original altarpiece approximately 500 × 400 cm, National Gallery, London.

The work is one of the largest polyptychs produced in fourteenth-century Florence, and was probably commissioned by the Albizzi, the leading family in the city before the rise of the Medici. The main panels are now in London, but the predella showing the life of St Peter is in other collections around the world.

Giotto di Bondone and workshop
Pentecost
probably *c*. 1310–18
Egg tempera on poplar, 45.5 × 44 cm

We remember that Christ was crucified at the time of the great Jewish feast of the Passover. The Jewish law as stated in the Old Testament book of Leviticus says that a special offering is to be made seven weeks after the Passover: 'You shall count fifty days to the day after the seventh Sabbath and then you shall offer Yahweh a new cereal offering.' The name Pentecost is derived from *pentecosta*, the Greek for fifty. In the second chapter of the Acts of the Apostles, St Luke tells us that it was on Pentecost Day, ten days after Christ's ascension, that the apostles were gathered together, and there came a sound like a great wind that filled the whole house where they were sitting. There appeared to them separated tongues as of fire, that rested on each of them. And they 'were all filled with the Holy Spirit and began to speak in different languages as the Spirit enabled them'. All the foreign visitors to Jerusalem were astonished to hear this group of Galileans speaking their own languages.

Giotto di Bondone (*c*. 1270–1337), known simply as Giotto, was an Italian painter and architect from Florence. He is credited with being the first to break decisively with the prevalent medieval Gothic and Byzantine styles of iconic painting to depict scenes and figures in a more naturalistic, non-stylized fashion, initiating 'the great art of painting as we know it today', as Giorgio Vasari wrote in his *Lives of the Artists* of 1568. His most influential work is the fresco cycle in the Scrovegni Chapel in Padua, also known as the Arena Chapel, which he completed around 1305. It depicts various episodes from the life of the Virgin Mary and Jesus, divided into thirty-seven scenes. It is regarded as one of the masterpieces of the early Renaissance and heralded a new interest in painting and drawing accurately from close observation of life that characterized art for centuries to come.

It is interesting to compare Giotto's representation of Pentecost with a version of the scene by fellow Italian

Barnaba da Modena (active 1361–86). Although the latter artist was painting at least fifty years after Giotto, and was clearly influenced by his prestigious predecessor, his version is far less satisfying from both an artistic and narrative point of view (*see page 146*). Both artists are working before Filippo Brunelleschi had rediscovered the laws of linear perspective, but Giotto is clearly more adept at using an instinctive approach in suggesting real bodies and depth on a two-dimensional surface, and locating his figures within a believable space. Barnaba includes the Virgin Mary at the centre of his group, as later became traditional, but Giotto does not do so. Barnaba also shows us more of the apostles, although in a somewhat ambiguous manner. At first glance, the furthest rank of figures appears to be standing. However, the Virgin Mary is clearly seated, and St Peter on her left (our right), also appears to be sitting. Barnaba's method does allow him to give us a good view of the faces of eleven of the apostles and a partial view of the twelfth. The overall effect, though, is to make the whole group appear cramped in a very confined space. Moreover, the darker background and ruddier gold of Barnaba's painting make it more difficult to pick out clearly the dove of the Holy Spirit at the top of the painting, and the red tongues of fire against the redder gold of the haloes. Indeed, slightly confusingly, Barnaba gives us not only a very small white dove, which hovers above the Virgin's halo, but above this the segment of a ball of fire. From this latter, more than twenty fiery lines radiate, some but not all terminating in one of the tongues. In contrast, Giotto has exactly twelve lines of light radiating from his centrally positioned dove, which is clearly defined against the black beams of the ceiling.

Giotto, like Barnaba, ignores the laws of optics in making the heads of the back row of apostles larger than those nearest to us; in fact, he makes the heads of the

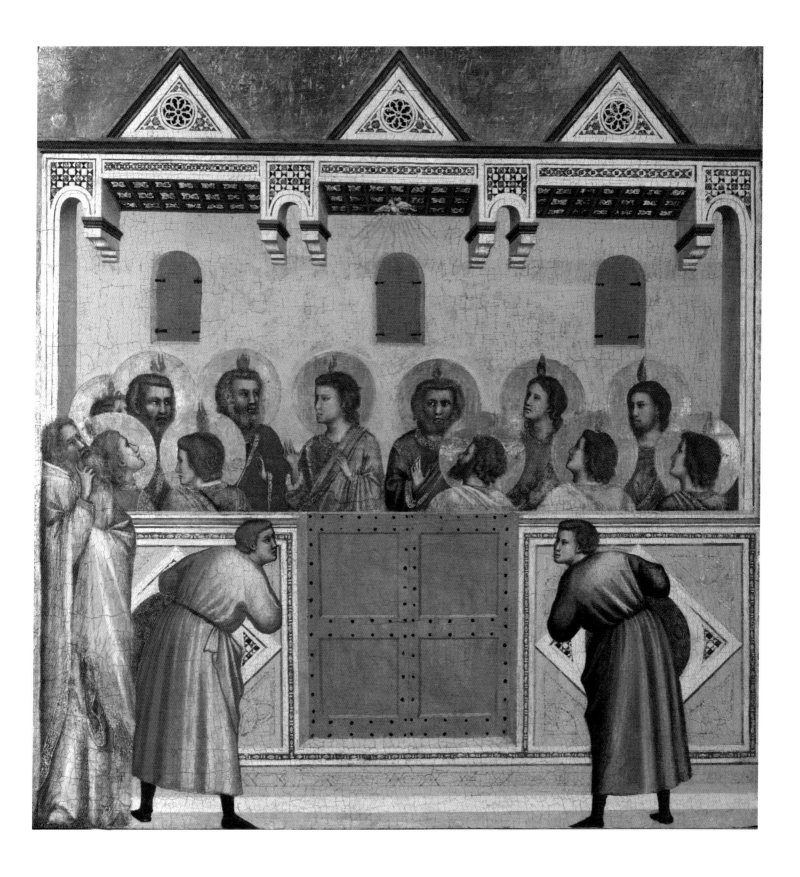

Barnaba da Modena, *Pentecost*, 1377 [?], egg tempera on
wood, 54.4 × 50.1 cm, National Gallery, London

foreground figures smallest of all. Like Barnaba, he succeeds
in showing eleven apostles clearly, although his twelfth
one is almost completely hidden. However, Giotto's
composition is far more balanced. Although it is not quite
clear whether his further row of apostles is intended to be
sitting or standing, the whole group fits far more comfortably
into the illusionistic space provided for them. One notes
that, while the beams of Barnaba's ceiling might suggest a
greater depth to his room, all his figures give an impression
of being pressed up against the picture plane; while Giotto's
apostles appear to have far more space, both above their
heads and between themselves and the spectator.

When one examines the two paintings in terms
of how they represent the gospel account, the superiority of
Giotto's work is even more evident. Although dealing with
a narrative subject, Barnaba offers little more than an iconic
representation of the event. We see the group with the
tongues of fire on their heads, all looking upwards at the

dove with hands joined in prayer, but nothing more. Giotto, on the other hand, tells us the story. Luke states that the apostles were sitting in a house. Giotto makes a very interesting choice by situating the apostles in the ground floor loggia of that house. This then enables the passers-by to hear the group of Galileans, as they turn to one another and, unexpectedly, begin to speak in other languages. So Giotto's two central foreground figures both, in astonishment, turn an ear to be sure that they are hearing aright. Similarly, the tall foreground figure on the left, wearing what appear to be priestly robes, looks upwards as he scratches his beard in attentive puzzlement.

There are twelve apostles present at the event because, although Judas had committed suicide he had, as narrated in the previous chapter of the Acts of the Apostles, now been replaced by Matthias. We can be certain that in the paintings by both Giotto and Barnaba, the central apostles are intended to be Peter, on the right with a beard, and a clean-shaven John on the left. One could not, however, be sure whether any of the other apostles were intended to be specifically identifiable, and any attempt at identification would be somewhat speculative.

From the size of these two paintings we might suppose each to be a panel from a predella, originally supporting a large altarpiece. However, this seems not to be the case. Barnaba's painting was almost certainly from a composite work, another panel of which is probably an Ascension scene in the Capitoline Museum in Rome. Modern technology allows us to be more certain about Giotto's picture. This was part of an early type of altarpiece known as a 'dossal'. Dossals, also called 'retables', were oblong works of no great height, designed to fit along the back of the altar table. They were usually divided into several different scenes. X-ray photographs have shown that this painting was the final one of a group of seven, all painted on a single plank of wood. The first six show scenes from the life of Christ, in chronological order from the Nativity to the Descent into Limbo after the Crucifixion. The paintings were separated, probably in the seventeenth century. Three are now in Germany, one in Italy, and two in the United States.

To complete a series of paintings of the life of Christ with a representation of Pentecost has great significance. The coming of the Holy Spirit in the form of tongues of fire is, of course, doubly symbolic. When the Holy Spirit comes upon the apostles, he does indeed give them the gift of 'tongues', in the sense of 'languages' as Giotto illustrates. However, that the spiritual 'tongue' that each has received is a tongue of fire is about to be demonstrated by Peter. Luke goes on to tell us that, as some of those who heard the apostles speaking said they must be drunk, Peter stood up and addressed the crowd. He spoke with fire and passion of the death and resurrection of Christ, quoting the lovely lines in which the prophet Joel tells of the coming of the Spirit and says: 'Your young men shall see visions and your old men shall dream dreams.'

Because that fiery speech of Peter converted many of those who heard it, and this was the first occasion on which the apostles obeyed the command of Christ to 'teach all nations', the descent of the Holy Spirit at Pentecost is regarded as the foundation day of the Church. As mentioned in a previous chapter, our word 'church' is used to translate the Greek *ekklesia*, which has the basic sense of 'assembly'. The image, therefore, of a group of people gathered together in a building, in the light, and under the sheltering wings, of the Holy Spirit, has also particular significance for that concept. It is St Paul who, while stressing the importance of the physical resurrection of Christ, gives us the powerful image of the Church as the Body of Christ. Giotto began his dossal with the birth of Christ's physical body. He ends it with the birth of his spiritual body.

ORDINARY
TIME

Francesco Pesellino and Filippo Lippi
The Santa Trinità Altarpiece
1455–60
Egg tempera, tempera grassa and oil on wood, main panel 184 × 181 cm

Trinity Sunday is the first Sunday after Pentecost in the Western calendar. It is the day that Christians celebrate the central mystery of their faith, the doctrine that God is three distinct persons, or hypostases – the Father, the Son (Jesus Christ), and the Holy Spirit– as 'one God in three Divine Persons'.

How can a painter represent realistically the infinite and eternal Supreme Being, omnipotent, omniscient, omnipresent, and simultaneously three and one? It is clearly impossible. All that the artist can do is to provide a coded representation. The depiction of the Son is comparatively straightforward. Jesus Christ lived on the Earth as a human being, and though we have no authentic description of his appearance, a strong artistic tradition, partly based on apocryphal writing, has developed over the centuries. This means that we can recognize a painting as being an image of Jesus without needing to see the title. When the physical features associated with Christ belong to a crucified figure, there is no possibility of doubt or confusion.

The situation with paintings of the Father and Holy Spirit is a little different. A painting of a white dove in, say, a landscape painting would not immediately be taken to be a representation of the Holy Spirit; nor would every painting of an imposing bearded man sitting on a throne be automatically read as God the Father. But when that male figure supports the cross of the crucified Christ, and the dove hovers between them, we do immediately recognize an image of the Trinity. That is the approach taken here by the Florentine painter Francesco Pesellino (1422–57), and it was beginning to become a standard formula for representing the Father, Son, and Holy Spirit. Not all artists followed that path, however. Before considering the Pesellino in more detail, let us look at two other relevant pictures.

One of these paintings cannot really be called a picture *of* the Trinity at all. Rather it touches on the problem already highlighted. That painting of around 1520 is by the late Renaissance and early Mannerist painter from Ferrara, in northern Italy, Benvenuto Tisi (*c.* 1481–1559), known as Il Garofalo, and is normally referred to as *The Vision of St Augustine* (*see page 152*). It deals with the legend that St Augustine, while struggling to write a theological work, saw a vision of a child by the shore attempting to empty the sea into a hole in the sand. When Augustine told him that he was attempting the impossible, the child replied that it was no more ridiculous than Augustine's attempt to explain the doctrine of the Trinity.

The second painting is, from a theological point of view, far less satisfactory as a representation of the Trinity than Pesellino's painting and those that adopted the same formula. That work, painted by Hans Baldung Grien in 1512, is actually entitled *The Trinity and Mystic Pietà* (*see page 152*). It depicts the dead Christ, supported by his mother and St John. God the Father stands behind and between Jesus and St John, and the dove of the Holy Spirit hovers further behind, above, and slightly to the left. This has two theological weaknesses. First, the position of the dove fails to emphasize that the Holy Spirit 'proceeds from the Father and the Son', as stated in the Nicene Creed. It also means that the three persons of the Trinity do not form a single, separate, compositional unit, as they do in Pesellino's work and other similar Trinity paintings, such as that by Jacopo di Cione (*see page 143*). Thus it fails to signify that the Trinity is one God.

Pesellino, however, goes out of his way to emphasize not just the unity of the three persons in one God, but also the different nature of their being. Whereas Baldung gives the three persons of the Trinity the same type of halo as St John and the Virgin Mary, Pesellino employs an aureole.

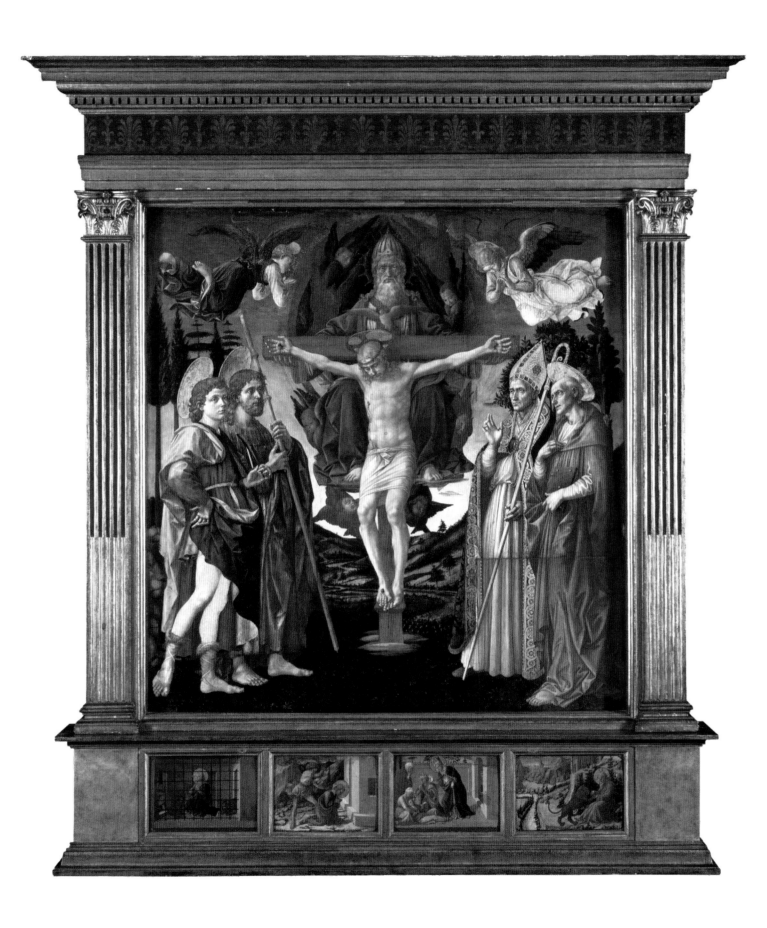

Il Garofalo, *The Vision of St Augustine*, c. 1520, oil on wood,
64.5 × 81.9 cm, National Gallery, London

Hans Baldung Grien, *The Trinity and Mystic Pietà*, 1512,
oil on oak, 112.3 × 89.1 cm, National Gallery, London

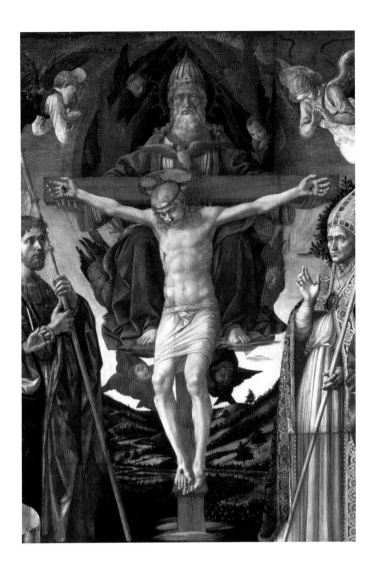

This is the surrounding oval of small radiating lights that is normally reserved for depictions of the Divinity, although very occasionally used also for representations of the Virgin Mary. Moreover, whereas Baldung has God the Father in the same, seemingly earthly space as the Virgin Mary and St John, Pesellino ensures that he is completely surrounded by sky, and so in 'the heavens'. Here is a domain where the angels give glory to God in a different way from the saints, who are represented with their feet very firmly on the ground. It is interesting to note here, however, that Pesellino in this painting does not seem to content himself with tackling the mystery of the Trinity, but also to approach the mystery of the hypostatic union of Christ's divine and human natures. So while the whole of the upper part of Christ's body is united with the Father and Holy Spirit inside the aureole, and surrounded by 'the heavens', his feet are nailed to a cross that is planted very solidly in the same ground on which the very human saints stand.

In thus clearly representing Christ as both God and man, Pesellino makes very clever use of his mandorla, the almond-shaped unit that is surrounded, at least for the whole of its upper part, by the aureole. The mandorla is able to suggest a canopied throne, although much of its outline is composed of winged cherubs. Where the throne ends, the feet of God the Father rest on a horizontal surface. However, below the two cherubs who seem to support that surface, the curve of the earthly landscape completes the form of the mandorla. As God, Christ shares infinity and eternity with the Father and Holy Spirit; as man, he occupies a specific time and place like other human beings.

This painting has many points of interest for an art historian. In the first place, Pesellino died in 1457 at the young age of just thirty-five, before finishing the painting. The work was then completed by his more distinguished contemporary, and former teacher, Fra Filippo Lippi.

There is also very obviously quite a large patch in the bottom right-hand corner of the painting where a damaged section, fortunately only involving the robes of the two saints, had to be replaced. We are, however, fortunate in that this is one of the few paintings of the mid-fifteenth century for which much of the relevant documentation, including the original contract, has survived. This shows that the painting was commissioned by the company of Priests of the Trinity, in the Tuscan city of Pistoia. It furthermore explains the choice not only of the central subject of the Trinity, but also that for one of the rather unlikely attendant saints.

Those saints, reading from left to right, are St Mamas, St James, St Zeno, and St Jerome. St Jerome is one of the

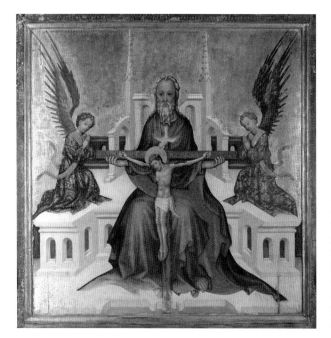

Unknown Austrian artist, *The Trinity with Christ Crucified*, *c.* 1410, egg on silver fir, 118.1 × 114.9 cm, National Gallery, London. Like the *Santa Trinità Altarpiece*, this early fifteenth-century Austrian Trinity panel depicts a seated God the Father supporting the crucified Christ, and the dove of the Holy Spirit between them, a type of image known as the Throne of Mercy or Throne of Grace.

saints most frequently represented in Renaissance painting. The appearance of St James is rather less frequent but not uncommon. St Zeno was a fourth-century bishop of Verona. He was, however, credited with having saved Pistoia from a catastrophic flood, so his appearance in a Pistoian altarpiece is unsurprising. One might note in passing the way in which Zeno's bishop's crozier is used here, compositionally, to balance St James's attribute of the pilgrim's staff and helps the framing effect of the mandorla.

But what of St Mamas? According to tradition, he was a third-century Christian martyr, who was able to pacify the lions by whom he had been condemned to die. As we see here, therefore, his attribute in art was a lion, an attribute also often associated with St Jerome. Mamas was better known in the Eastern Church than in the Western, so why should he be chosen for an altarpiece in Pistoia? We have, as indicated, a rather unusual amount of documentation for this painting. We learn, therefore, that St Mamas was the patron saint of the particular member of the community of the Trinity who headed the committee entrusted with responsibility for commissioning the altarpiece, and negotiating on its behalf. He obviously decided that this was a wonderful opportunity to make sure that his own patron saint should be given some recognition. Here, then, possibly in the only instance in Western painting, this little-known martyr is given a place of honour alongside major saints: the saviour of Pistoia, one of the great doctors of the Church, and one of the leading

apostles. The four panels of the predella depict episodes from the lives of each of the four saints, with Mamas in the first panel on the left, shown with lions coming into his prison cell.

One of the obvious problems in attempting to represent God is that one cannot actually do so without in some way limiting the Being who is, by definition, limitless. If one paints God the Father as an old man in the sky, will people think of him as an old man in the sky? Possibly. And that danger might have been even greater in the fifteenth century than in the twenty-first. When Pesellino and Lippi painted this altarpiece, it was generally believed that the sun went round an earth that was at the centre of a universe some four thousand years old. Now we know that the Earth is, in physical terms, an insignificant speck in a universe billions of years old, and billions of light years in extent. However, in many ways, Pesellino and Lippi still got it so right. God, they tell us, is of a totally different nature of being from humanity, even though, in our terms, he looks on us with the justice, love, and mercy of a father. Only Jesus Christ can, through his death on the cross and resurrection, bridge that gap between God and humanity. Only the Holy Spirit, proceeding from the Father and the Son, can give us some understanding of this and inspire a painter to help us to that understanding. That painter can also, in reminding us of the reason he had to include St Mamas in his painting, put a delightful example of human weakness in a universal context for us.

Peter Paul Rubens, *The Holy Trinity*, 1620, oil on panel, 158 × 152 cm, Royal Museum of Fine Arts, Antwerp. The dead Christ, blood oozing from his wounds, lies in a shroud held up by God the Father. The Holy Spirit appears in the form of a white dove. The angels on each side hold the Instruments of the Passion: the whip, the crown of thorns, and the lance of Longinus on the left, and the nails of the crucifixion on the right.

Masaccio, *Trinity*, 1425, fresco, 667 × 317 cm, Santa Maria Novella, Florence. Perhaps the most celebrated painting of the Trinity from the Renaissance, this depiction was produced by Masaccio just before his untimely death at the age of just twenty-seven. It is considered the artist's masterpiece because of its striking trompe l'oeil effect that creates a sense of space and depth behind the figure of God the Father supporting the cross on which Christ is crucified.

Hendrick van Balen, *Holy Trinity*, 1620s, oil on panel, dimensions unknown, Sint-Jacobskerk, Antwerp. The composition of this Flemish Baroque painting is centred on the dove of the Holy Spirit, with Christ, God the Father, and the angels creating a diamond around its glowing form. Despite the picture's otherworldly air, the painter places the feet of God and Christ on a globe, thus connecting the power of the Trinity with those on Earth.

Giovanni Bellini
The Blood of the Redeemer
probably 1460–5

Egg on poplar, 47 × 34.3 cm

Falling on the Thursday after Trinity Sunday, the Feast of Corpus Christi celebrates the institution of the Eucharist (Holy Communion). The feast is an ancient one, traced back to the early years of the Church, when it was celebrated on Holy Thursday. Because it became overshadowed by other elements of Easter, there was pressure in the thirteenth century for a new date to be fixed for the celebration, and it became firmly established in the early fourteenth century.

When we see a painting only in reproduction, we may gain a false impression of the size of the work. But equally, when we view an early picture in a gallery, we may regard it simply as an individual painting in its own right, without being aware of its original context. This early work by Giovanni Bellini illustrates both these points.

Coming upon the painting in a book, with no indication of its dimensions, one might assume it to be quite a large altarpiece. In fact, it is only forty-seven centimetres (roughly eighteen inches) in height. Therefore, seeing it on the gallery wall, we might well assume that it is a small work designed for private devotion; or, if we are familiar with the origin of many such pictures, we should probably guess it to be a subsidiary panel from a much larger work. Actually, the clue to its likely origin lies in the combination of its dimensions and unusual subject. It was, in fact, probably a tabernacle door. Although most such doors in the fifteenth century were, as today, made of gilded metal, various examples of painted or gilded wooden ones have survived.

It is a very striking and unusual painting, and Bellini prevents it from being taken as a comparatively simple iconic image by introducing various symbolic and allegorical elements, as well as some almost narrative ones, such as the walking figures in the middle ground on the right. The body of Christ dominates the centre of the painting. It is emphasized by its pallor against the dark wood of the cross and the darkness of the lower background. Christ's left

arm clasping the cross takes our eyes to the wound in his side, while his extended right arm guides us to the kneeling angel, catching the blood from that wound in a golden cup. This central focus on the body and blood of Christ very clearly establishes the connection of the painting with the Eucharist. Moreover, Christ's embrace of the cross unites it to his body, indicating the relationship between the mass and Christ's sacrifice on the cross. Indeed, Jesus might be thought here to be speaking the words of one of the synoptic gospels, or the almost identical words of consecration in the mass, and be actually saying: 'This is my body' and 'This is the cup of my blood, poured out for you.'

A particularly unusual and interesting element in the painting is the central marble parapet and frieze. Because of its height, marble top, and central gap, this is obviously suggestive of altar rails, which would link naturally with the idea of the faithful receiving Holy Communion. For Bellini and his contemporaries, this would, as noted in the Introduction, have been accepted as the real body and blood of Christ. However, the frieze offers a clear depiction of classical figures, some apparently involved in a pagan ritual. What are we to make of this?

On one level, we could point out the way in which the marble parapet divides the foreground from the background. Christ with his cross can be seen in the foreground as making his sacrifice historically within the old, classical Graeco-Roman world; possibly, indeed, as if situated here within Pilate's praetorium. Then, in the background, we see on the right the ruins of the old pagan Roman world, and on the left (over Christ's right shoulder), the buildings of a Christian church, solid and well defended. Through the sacrifice of Jesus on the cross, Christianity has replaced paganism. There may, however, be other forces at play.

The left-hand frieze panel shows the Greek god Pan, playing his twin pipes beside quite a low altar. On the

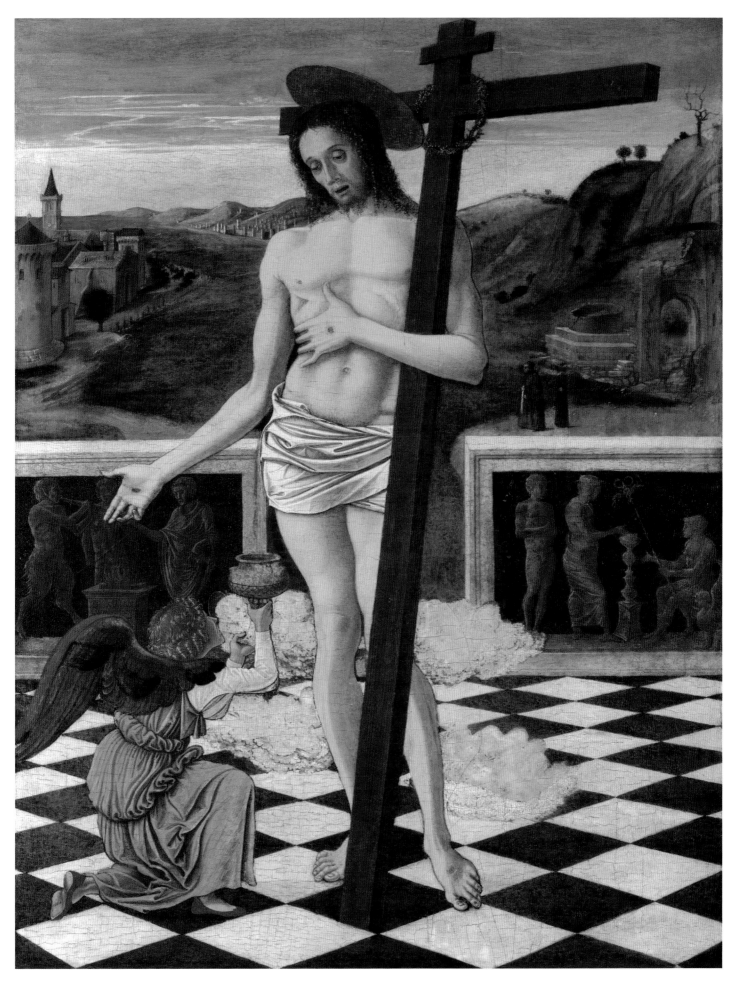

opposite side of this altar, a robed figure appears to be sprinkling something, possibly grain, into the fire with the right hand while the left pours a libation of wine on the ground. Behind the altar stands a nude male figure holding a long spear. This points towards the side of Jesus, so naturally suggests the lance with which he was pierced by the soldier on Calvary. The altar bears a Latin inscription. The first line is very difficult to make out, although the first word appears to be 'Dis', the alternative Latin name for Pluto, the god of the underworld. The second line, partially hidden by the angel's wing, appears to be just the name 'Aurelius'. Marcus Aurelius was a Roman emperor of the second century AD, who, although a pagan, was admired by Christians for his unusually virtuous life and character.

The right-hand panel of the frieze, on the opposite side of the canvas, shows three male figures. From his unusual helmet, peaked at the front and with wing tips visible at the back, we can identify the central one as the Greek messenger god Hermes (whose Roman equivalent was Mercury). One of the main tasks of Hermes / Mercury was to accompany dead souls to the underworld. From this, it has been surmised that the nude figure behind him is a person newly dead and that the seated figure is guarding the entrance to the underworld. He could, therefore, most probably be Aeacus, one of the three judges who assisted Hades (or Pluto), the ruling god of the mythological underworld. Aeacus was the judge of European souls, and is mentioned by Socrates in Plato's *Apologia*. What is particularly

interesting is that this seated figure is holding the *kerykeion* (in Latin *caduceus*), the special staff that belonged to Hermes. The head of this combines two intertwined serpents with the wings of a dove. Why has Hermes handed over his staff? Is it some sort of pledge, which he is about to redeem? Is he placing something in the bowl on the stand or handing something direct to the seated figure? Answers to all these questions must remain speculative.

Nevertheless, while detailed interpretation of what seem allegorical scenes on the two panels may be impossible, informed guesses can be made about their general meanings. It has been suggested with a high degree of probability that this tabernacle door was from a Dominican church, and that the left-hand panel should be read in terms of a theological dispute, current when Bellini was working in the middle of the fifteenth century. The dispute concerned whether Christ's redemptive sacrifice was effective from the moment of his death, as the Dominicans maintained, or only from the moment of his resurrection, as other theologians argued. Jesus is shown here as 'the Man of Sorrows' of his passion and crucifixion, rather than the glorified Jesus of the Resurrection. The implication therefore may be that, from the very instant of his death, Christ's sacrifice was effective to redeem not only Christian believers and the souls of the virtuous dead that he released from Limbo, but also the good pagans who were to come after him. Of this latter group, Aurelius, to whose name Christ's hand also directs us, was a prime example.

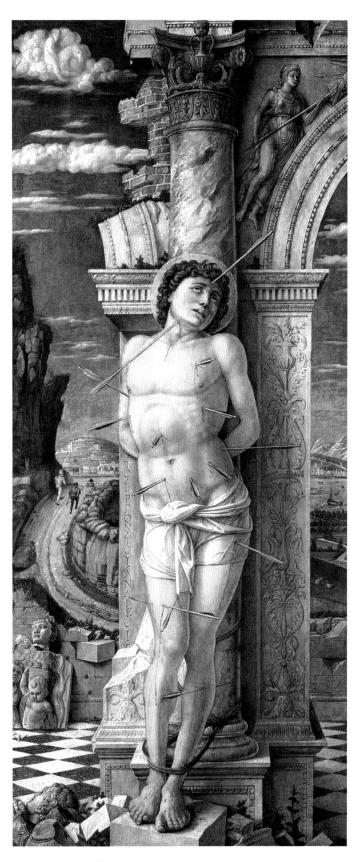

For the right-hand panel, another element in the Italian intellectual world of the period may be relevant. In the 1460s, the full impact of the rediscovery of ancient Greek learning was being felt in Italy, particularly in Florence and Venice. One of the greatest figures of the Renaissance, Cardinal Bessarion, had settled in Venice, where key works from his vast library of major Greek texts were being translated. At the same time, in Florence, there was particular enthusiasm for attempts to see in Greek myths and legends predictions and foreshadowings of the coming of Christ, and to reconcile the teachings of Plato with Christianity. In fact, in 1463, Cosimo de' Medici, the first of the Medici dynasty who would be de facto rulers of Florence during much of the Italian Renaissance, established an academy to develop and promote such ideas.

Again it is interesting to consider here a painting by Bellini's brother-in-law, Andrea Mantegna: *Saint Sebastian*, dating from around 1459, another comparatively small-scale work. Although there are major differences in content and mood between the two paintings, there are also striking similarities. Both are dominated by a male figure in a loincloth, attached to a strong, vertical pictorial element, with a background of sky and a landscape containing two figures walking along a road. But the clearest indication that Bellini was directly influenced by Mantegna's painting is surely that he used identical flooring for his foreground area. In Mantegna's painting, this was also separated from the background by a solid barrier with part of a classical frieze, albeit only a fragmentary piece. Mantegna almost certainly painted this work very shortly before his move to Mantua, while still living in Padua. Padua had close links with its neighbour Venice, by which it had been politically controlled since 1405. However, it also had at this time very close artistic and intellectual links with Florence, and Mantegna is known to have been involved with relevant intellectual groups there.

Andrea Mantegna, *Saint Sebastian*, 1457–9, tempera on panel, 68 × 30 cm, Kunsthistorisches Museum, Vienna

The clear indication of his enthusiasm for Greek culture when painting *Saint Sebastian* lies not only in the many classical elements he incorporates, but in the fact that he actually signs it down the left side of the central column in Greek capitals: TON ERGON TOU ANDREOU (The work of Andrea). We cannot be certain that Bellini met neo-Platonist ideas principally through Mantegna, but the indication that he certainly did meet them is provided in the right-hand frieze panel by the presence of the *kerykeion / caduceus*. The juxtaposition on this of the dove and the serpents had made it a traditional symbol of concord. However, the neo-Platonists also related it to Christ's instruction to his disciples to be 'wise as serpents and innocent as doves', thus seeing it as a symbol of the concord between the teachings of Christianity and those of Plato and other Greek writers.

One point of general art-historical interest in Bellini's painting concerns the bare patches in the central foreground. These came to light only in 1978 when the canvas was cleaned, having been painted over at some stage to match the rest of the tiles. It seems that these patches originally contained gilded clouds with red and blue angels, and had been repainted some time after the completion of the picture, possibly when the gilding began to flake.

But surely the most striking aspect of Bellini's painting is the face of Jesus. To paint Christ is an awesome undertaking for any painter. To find a way of representing the face of a conscious, sacrificial Christ, after the Crucifixion but before the Resurrection, offers still greater challenges. So many of the representations of Jesus from the seventeenth century onwards take on an ever-increasing blandness. By contrast, this face by Bellini, from the mid-fifteenth century, rewards long study and offers a never-ending source of meditation, particularly in its context of the Eucharistic sacrifice.

It is, however, also fascinating that Bellini seems to be representing that sacrifice not only as central within a Christian religious and liturgical context, but also within the whole context of Western culture and civilization. He may well be saying that we should see Greek and Roman ideas about liturgical sacrifice for the souls of the dead as having a quasi-prophetical role in regard to the redemptive sacrifice of Jesus: the sacrifice of his body and blood on the cross, which, as Bellini shows, he willingly embraced, and to which are related the Eucharistic offerings in the form of wine and of the bread which, when consecrated, was housed behind this very tabernacle door.

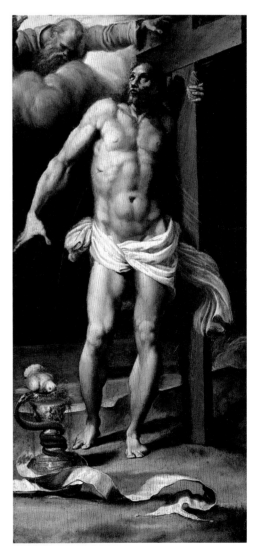

Peter Paul Rubens, *The Glorification of the Eucharist*, c. 1630–2, oil on wood, 71.1 × 48.3 cm, Metropolitan Museum of Art, New York. This sketch was a design for an altarpiece in the church of the Calced Carmelites in Antwerp. Rubens shows the risen Christ triumphing over sin and death, represented by the snake and the skeleton. He is flanked by Melchizedek, Elijah, St Paul, and St Cyril of Alexandria, all of whom were associated with the Eucharist.

Bartolomeo Passerotti, *Blood of the Redeemer*, sixteenth century, oil on panel, 34.3 × 15.6 cm, Museum of Fine Arts, Boston. Passerotti (1529–92) worked primarily in his native Bologna. The elongated figure and stylized pose of Christ are typical of the artist's Mannerist style.

Carlo Crivelli
Saints Peter and Paul
probably 1470s
Tempera on poplar, 93.3 × 47 cm

The Feast of Saints Peter and Paul is a liturgical feast in honour of the martyrdom in Rome of the apostles Peter and Paul. Anglicans, Roman Catholics, and Lutherans all regard 29 June as a major feast day in honour of the two saints. Peter Paul Rubens was named as such because he was born on the eve of the feast in 1577.

Someone seeing the painting *Saints Peter and Paul* by Carlo Crivelli (*c.* 1430/5–*c.* 1494) for the first time might well think it looks rather uncomfortable as a picture. It has an unusual composition, with both saints facing in the same direction, apparently concentrating on the book that St Peter holds in his left hand. But the slightly awkward arrangement is explained by the fact that the work was only one element in a larger altarpiece. It was originally the left-hand panel of a polyptych, the central panel of which contained an image of the Madonna and Child. It was natural, then, to have the flanking saints facing inwards towards Mary and Jesus. The complete work was the main altarpiece for the church of San Giorgio in the central Italian town of Porto San Giorgio, on the east coast between Ancona and Pescara. The corresponding right-hand panel depicted the town's patron saint, St George.

Many modern visitors, in our secular times, would be dependent on the wall note in the gallery to identify the two figures in the painting. However, Christians should be able to identify them by their traditional attributes: St Peter carries the symbolic keys, metaphorically conferred on him by Jesus, while Paul carries the sword of his martyrdom by beheading. Both saints are shown holding books, as each wrote epistles contained in the New Testament. Although at the time it was painted, spectators would be accustomed to identifying saints by such attributes, they would probably have been able to identify these two even without this help. All artists are influenced by their predecessors in a variety of ways. In the fourteenth and fifteenth centuries, young apprentice artists learned by copying the work of their masters and that of other leading figures. Cennino Cennini, in his famous painter's manual written in Florence in the 1390s, advised young artists to copy from just one artist, but to choose 'the one who has the greatest reputation'.

Arguably the two painters of the early fourteenth century with the greatest reputations were the Sienese Duccio and the Florentine Giotto. In his wonderful multi-panelled *Maestà* from 1308–11, Duccio consistently represented St Peter with curly white hair in a pudding-basin style and an equally white moustache and close beard, and wearing a green cloak over a blue robe (*see page 83*). The saint is represented in almost identical fashion in the same artist's 1300–5 polyptych, now in the Pinacoteca Nazionale, Siena's principal museum of art (*see page 164*). In that same painting, we also have St Paul, in a dark-green robe and reddish-brown cloak, represented with some dark-brown hair at the back of an otherwise bald head, a dark-brown moustache, and flowing beard. In the polyptych that Giotto painted in 1330–5 as an altarpiece for the church of Santa Maria degli Angeli in Bologna, and now in the Pinacoteca Nazionale in that city, St Paul has different garments, but the same type of bald head with dark-brown hair and long beard. St Peter has the same white, pudding-basin hair and beard, although again different coloured garments. This model of St Peter, in terms not only of the head but even of the garments, was replicated almost exactly by Masaccio nearly a century later in his famous fresco cycle of the life of St Peter painted for the Brancacci Chapel in Florence in the mid-1420s.

One does not, however, need to look beyond London's National Gallery to see the way in which St Peter's curly white whiskers and hair, sometimes, as here, with a bald crown, and St Paul's high-fronted bald head, with long dark-brown beard, had come to be taken for granted by the

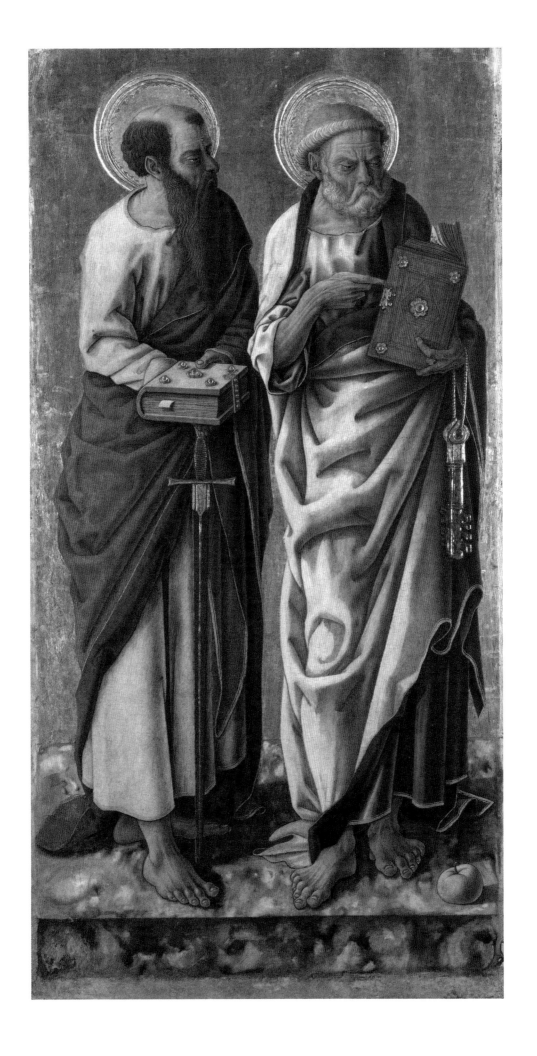

163

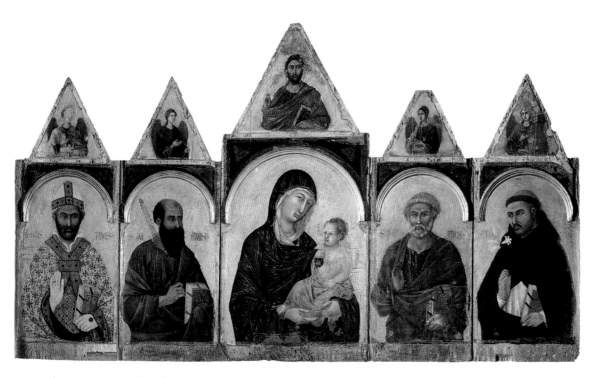

Duccio di Buoninsegna, *Polyptych No. 28*, 1300–5, tempera
on wood, 143 × 242 cm, Pinacoteca Nazionale, Siena

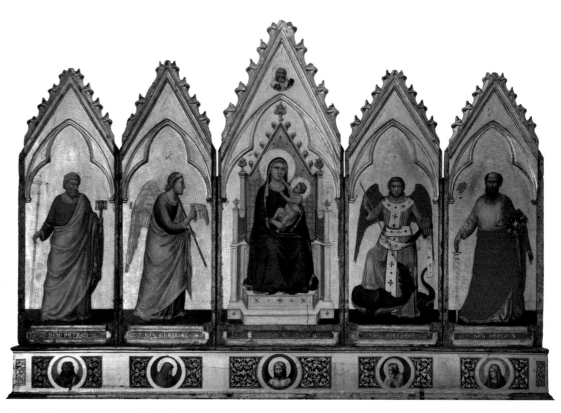

Giotto di Bondone, *Bologna Polyptych*, c. 1330–4, tempera and
gold on panel, 146.5 × 217 cm, Pinacoteca Nazionale, Bologna

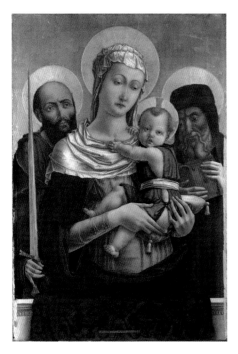

Bartolomeo Vivarini, *The Virgin and Child with Saints Paul and Jerome*, c. 1460s, tempera on wood, 95.3 × 63.5 cm, National Gallery, London

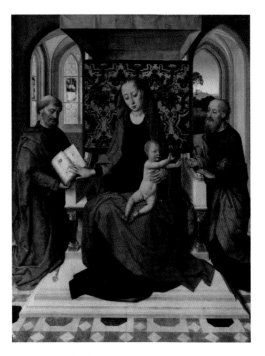

Workshop of Dirk Bouts, *The Virgin and Child with Saint Peter and Saint Paul*, c. 1460s, oil on oak, 68.8 × 51.6 cm, National Gallery, London

Master of the Saint Bartholomew Altarpiece, *Saints Peter and Dorothy*, 1505–10, oil on oak, 125.7 × 71.1 cm, National Gallery, London

Antonio Vivarini and Giovanni d'Alemagna, *Saints Paul and Jerome* (detail), c. 1440–6, tempera on poplar, 140.3 × 45.7 cm, National Gallery, London

time Crivelli was painting in the 1470s. Of particular interest in this context are the paintings by the Venetian Vivarini family. Crivelli was born in Venice around 1430 and, though he probably trained with Francesco Squarcione in Padua, he was very influenced by Antonio Vivarini (1440–80), Antonio's son Alvise (1446–1502), and younger brother Bartolomeo (1432–99). The National Gallery has twin panels by Antonio (and his partner Giovanni d'Alemagna) of four saints, one of whom is St Peter; and a *Virgin and Child* by Bartolomeo Vivarini, which includes St Paul and St Jerome. It is also interesting to look at the museum's *Virgin and Child with Saint Peter and Saint Paul* by the workshop of Dirk Bouts, and *Saints Peter and Dorothy* by the Master of the Saint Bartholomew Altarpiece. The former picture was painted in the Netherlands in the 1460s. The latter, a delightful work in which a very avuncular St Peter looks at the attractive young St Dorothy with a slightly roguish smile, was painted in Germany around 1505–10. In all of these cases, the representation of our two great saints are largely variations on the features given them in Tuscany in the early 1300s.

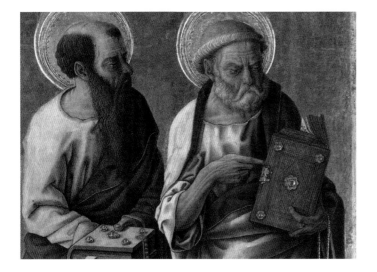

Our contemporary plaster statues of Jesus and the Virgin Mary are usually far from being great works of art. However, some present-day Christians find them useful aids to prayer and meditation. If such people have, say, a particular devotion to Jesus under the title of the 'Sacred Heart', they would be quite upset to go into a church and find a statue purporting to be *The Sacred Heart* yet looking totally different from the traditional image. In the same way, it must have been comforting to anyone in the fifteenth century with a devotion to St Peter or St Paul to arrive in Porto San Giorgio from another part of Italy, or even another part of Europe, and find in Crivelli's altarpiece an image they could immediately relate to.

There are several other points of both art-historical and religious interest in this work. One very obvious stylistic feature is Crivelli's use of *pastiglia*. That is the incorporation in the painting of elements, such as the glass jewels on St Peter's book and St Paul's sword, that actually stick out from the surface of the picture, coming from the artist's illusionary space into our real space. Crivelli often liked to show off his virtuosity and skill in foreshortening. So, as both saints are depicted as almost up against the picture plane, various painted elements, particularly St Paul's book with its bookmark, give the illusion that they also protrude into our realm – a device to unite the painted figures more closely with the spectator, which we have seen in two of our earlier pictures (*see pages 43 and 135*). At the bottom of the painting is an apple, almost identical to the one in Crivelli's *Annunciation*

(*see page 77*). While this is a common and obvious symbol of the Fall of Adam, and so has a clear reason for inclusion in a painting linked to Christ's incarnation as the redeeming 'second Adam', there seems less logic for it here. Most probably Crivelli is making a link between Christ's redemption and these two founding fathers of his Church.

Level with the apple at the base of the picture are the very interesting feet of the two saints. Bare feet were traditionally used to indicate humility. Crivelli pays great attention to them here, again showing off his skill in foreshortening. He does, though, also give St Peter a very unusual little toe on his left foot. This digit even seems to merge in a strange way with the stone beneath the foot. To see a reference here to Peter's name as 'Rock' may seem far-fetched, although any other special significance is difficult to divine.

What is, however, of major interest in this painting is the relationship depicted between Peter and Paul. Peter, his brow furrowed in concentration, points the forefinger of his tense right hand at a particular passage in his book, at which Paul also looks with a challenging expression. Is Crivelli thinking of the end of Peter's second Epistle? There, Peter pays tribute to Paul's wisdom and refers to him as 'our beloved brother'. He does, however, add that there are, 'certain things in his Epistles which are hard to understand'. We can see that in our painting there is a bookmark in the copy of the New Testament that Paul is holding. Does Crivelli see this as marking the passage just

El Greco, *Saints Peter and Paul*, 1590–1600, oil on canvas, 116 × 91 cm, Museu Nacional d'Art de Catalunya, Barcelona

Giuseppe Cesari, *Madonna and Child with Saints Peter and Paul*, 1600, oil on canvas, 174 × 120 cm, Nelson-Atkins Museum of Art, Kansas City

mentioned, with Peter opening his own copy of the New Testament to point out one of Paul's more obscure passages? Certainly the impression given is by no means one of great harmony. We also remember, at this point, that although at the apostolic Council of Jerusalem around AD 50, Peter and Paul were both supporters of the final decision – that, among other things, Gentile converts to Christianity were not obligated to keep most of the Law of Moses, including the circumcision of males – we learn in St Paul's Epistle to the Galatians that they later had a public argument in Antioch.

The Christian Church is, as we have already said, a 'pilgrim church', in the words of the mass. It is on its journey, not at its destination. Today we sometimes find leading churchmen, of all denominations, on different sides on major

moral or theological issues. Should we be surprised, remembering that the one apostle whom Jesus appointed leader of his church and the one he called separately to carry Christianity through much of the Roman Empire were such very different characters and had disagreements on the big issues of their day? Jesus chose them very specifically to do the jobs they did. He built his church on one, and spread its message via the other. In the end, both of them had the strength to die for their faith in him. Does a church built on such foundations need to fear even substantial disagreements among its members and leaders?

Duccio di Buoninsegna
The Transfiguration
1307/8–11

Egg tempera on wood, 48.5 × 51.4 cm

The episode of the Transfiguration is described in the three synoptic gospels. Jesus took the apostles Peter, James, and John up a high mountain (probably Mount Tabor in lower Galilee). There he was transfigured in glory, and the great Old Testament figures of Moses and Elijah appeared talking to him, one on either side. A voice came from heaven saying: 'This is my beloved son. Listen to him.' Moses and Elijah were particularly appropriate companions here, as they were the two people in the Old Testament given a direct experience of the presence of God. Each had that privilege, some four hundred years apart, both on Mount Horeb.

As we have already seen, one of the most important and influential paintings of the early Renaissance was the double-sided altarpiece painted by Duccio for the cathedral of his native Siena, the *Maestà* (*see pages 82–3*). The predella panels on the front showed scenes associated with Mary's life, interspersed with depictions of prophets. Above the main section was a row of apostles. On the rear, the main section consisted of a series of pictures tracing Christ's passion, and the predella contained New Testament scenes, ending with *The Raising of Lazarus*. The two preceding scenes were of Christ's cure of the man born blind and this panel, *The Transfiguration*. These last two are closely connected. The man born blind is actually depicted twice in his panel (*see page 171*): first in the moment when he stands, stick in hand, as Christ puts the paste made with spittle on his eyes; then again at the right of the picture, looking upwards with opened eyes, after he has followed Christ's instructions to wash in the pool of Siloam. Here his stick rests against the edge of the pool. Modern X-ray photography shows us that Duccio moved the stick from the original position in which he had painted it so that it pointed directly at the figure of Christ in the neighbouring *Transfiguration*, at whom the man's glance is also directed. He made similar efforts within *The Transfiguration* itself to draw our attention towards

Jesus. The eyes of all the other participants are directed towards him, and all gesture in his direction with one hand.

Duccio is consistent in his representations of the apostles in all the panels in which they appear on the altarpiece, and actually puts names beside their individual representations on the front. We could, therefore, identify Peter, James, and John from internal evidence, even if we did not know from the gospels that, as in the Agony, they were Christ's three chosen companions at the Transfiguration.

The identification of Moses and Elijah is less straightforward. Most commentators assume that Moses is the figure on the left, as we look at the painting, and Elijah on the right. One could offer some evidence to support this reading, particularly from the way Moses is represented with a flowing beard in later works, such as Michelangelo's magnificent statue in St Peter in Vincoli, in Rome. However, there is good reason to take the right-hand figure as Moses. Duccio has two later paintings, a small triptych also in the National Gallery, and an altarpiece in the Pinacoteca Nazionale in Siena, in which Moses is represented. In both of these, he is shown with a white fluffy beard and moustache, and a high bald forehead, as is the figure on the right here. Moreover, that figure holds an open scroll. This is a common attribute of those who wrote one of the books of the Old Testament, and is used by Duccio in this way for the prophets on the front of the *Maestà*. While Elijah features in the two Books of Kings, he did not write any part of them, whereas Moses is credited with writing the Pentateuch. Christ, who is obviously central to the New Testament but did not write it, holds a closed book. In the same way, the left-hand figure holds a closed scroll. What is more, in his altarpiece for Santa Croce in Florence (*see page 170*), Ugolino di Nerio depicted Moses with high bald forehead and fluffy white beard and moustache, very like Duccio's right-hand figure here, and he has a scroll with the same text.

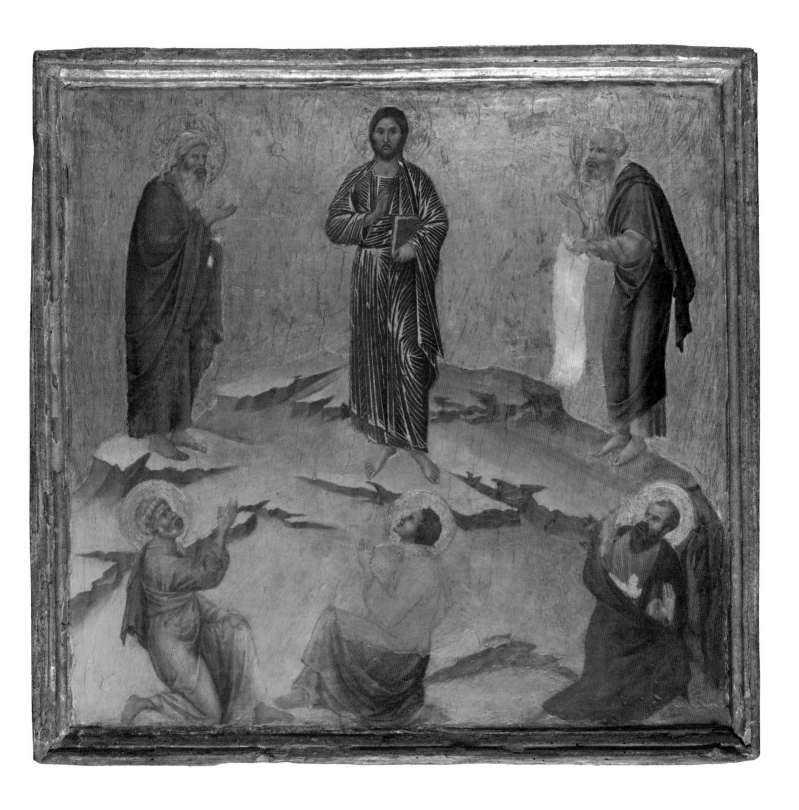

Ugolino di Nerio, *Moses* from the *Santa Croce Altarpiece*, *c.* 1325–8, egg tempera on wood, 55 × 31.4 cm, National Gallery, London

Although this work was painted for a Florentine church, Ugolino was Sienese, and was clearly much influenced by Duccio. He may even have worked under him on the *Maestà* when he was young. Furthermore, the outer garment of the left-hand figure has a lining very reminiscent of the garment of camel hair as traditionally depicted in paintings of St John the Baptist. Both Matthew and Mark, in their accounts of the Transfiguration, tell of the discussion about Elijah between Jesus and the three apostles as they come down from the mountain. Matthew is quite explicit in saying that Jesus' response to the questions about Elijah was a reference to John the Baptist.

Duccio is certainly both consistent and thoughtful in the way he represents Christ himself throughout his altarpiece. We note that while Christ with the blind man wears a blue cloak with a gold edge over a red tunic, in *The Transfiguration* both of these garments are shot with gold, as they are in all the panels showing Christ after his resurrection. It is clear that the three apostles are being given a privileged preview of Christ in his glorified body, with light radiating from his garments. Duccio, in all the New Testament scenes on his great altarpiece, drew on all four gospels, and all four contribute to these two paintings in content and positioning. Both Matthew and Mark's accounts of the Transfiguration speak of Christ's garments as becoming brilliantly *white*. Luke, however, speaks of them as 'shining like lightning', and it is this description that Duccio appears to adopt here. Matthew, Mark, and Luke all make the Transfiguration follow closely on Peter's great profession of faith in Christ as the Messiah, and on Christ's first prophecy of his own passion. But it is Mark who immediately precedes Peter's profession with the cure of a blind man. However, the cure that Mark describes is specifically located in Bethsaida, in Galilee. The narrative of Duccio's painting obviously seems to be that of 'the man born blind', whom Christ cured with the paste of spittle and sent to the pool of Siloam, in Jerusalem, roughly a hundred miles from Bethsaida.

Only St John (who does not actually recount the Transfiguration) gives, in Chapter 9 of his gospel, a very vivid account of this miracle and its aftermath. Then in Chapter 10, he has Jesus stating explicitly to the Pharisees, 'the Father and I are one'; and in Chapter 11, he recounts the raising of Lazarus. As noted, this great miracle, shortly before the greater one of Christ's own resurrection, is the subject of the next and final panel on Duccio's predella.

What Duccio appears, therefore, to be stressing in his predella is the apostles' growing realization of the divinity of

Duccio di Buoninsegna, *The Healing of the Man born Blind* from the *Maestà* altarpiece, 1307/8–11, egg tempera on wood, 45.1 × 46.7 cm, National Gallery, London

Duccio di Buoninsegna, *The Raising of Lazarus* from the *Maestà* altarpiece, 1307/8–11, egg tempera and gold on panel, 43.5 × 46.4 cm, Kimbell Art Museum, Fort Worth

Jesus. John tells us that the man born blind said to Jesus after his cure, 'Lord, I believe', and worshipped him. Mark tells us that Peter, immediately after the cure of the blind man in Bethsaida, said: 'You are the Christ', and Matthew adds 'the son of the living God'. Just as Duccio shows that the eyes of the blind man have been opened so that he can see Christ in physical reality, while able also to look beyond his own physical circumstances to the glorified Christ of the Transfiguration panel, so the eyes of the apostles, first metaphorically opened to Christ's divinity, now have a physical demonstration of it. As St Peter's second epistle says: 'He was honoured and glorified by God the Father when the Supreme Glory itself spoke to him and said, "This is my son, the Beloved; he enjoys my favour." We heard this ourselves, spoken from heaven, when we were with him on the holy mountain.'

What else does Duccio emphasize here? As we saw earlier, the whole composition of the painting is designed to direct us to the central figure of Jesus, towards whom all five attendant figures gaze and gesture. The two figures from the

Old Testament hold the scrolls that represent those books that concern them. However, unlike Peter and Paul in our previous painting, the three apostles do not hold books. Though they are major figures in the gospels, and all three wrote epistles, they are here living men in a living story, a narrative not yet written down. Jesus, very unusually, holds that closed book. But he is also shown as the glorified Christ of the Resurrection. Part of the book that Jesus holds has yet to be written. But that book is not just the New Testament. It is surely meant to be the whole Bible, with new and old testaments united in a continuous narrative, as the prophets and apostles are united in the gospel moment that Duccio represents here. This small painting resonates with the single great story that began with Abraham's covenant with the one true God, almost two thousand years before Jesus. It culminated, though it did not end, with the resurrection of Jesus in glory. It continued in the story of those apostles in the second part of the book that Jesus holds. It continues today through the many branches of the Church that he founded.

Matteo di Giovanni
The Assumption of the Virgin
probably 1474
Tempera and gold on wood, 331.5 × 174 cm

Francesco Botticini
The Assumption of the Virgin
probably *c.* 1475–6
Tempera on wood, 228.6 × 377.2 cm

The tradition that, although the Virgin Mary died a natural death, her body did not taste corruption but was *assumed* into heaven can be traced back at least to the sixth century AD. This 'corporal assumption' was defined as an article of faith for Catholics by Pope Pius XII in 1950. However, the feast of the Assumption on 15 August had been celebrated for many centuries before that, and in many countries it still today remains one of the great public holidays.

Our two paintings of *The Assumption* were probably painted within a year of each other, but they are quite different. As with many religious paintings of their period, one needs some knowledge of pious myths, particularly those contained in *The Golden Legend* of Jacobus de Voragine, to understand particular details. *The Golden Legend* actually gives several different, often overlapping, versions of one of the main apocryphal accounts of the Assumption, as well as various other associated visions and miracles, rather unusually admitting the unreliability of some of the stories. In the most common version of the main events, an angel comes to Mary. He presents her with a palm and tells her that she is shortly to end her earthly life. She expresses the desire that the apostles should be present at her death, and first St John is miraculously brought to her side; then shortly afterwards, the rest of the twelve apostles are also transported from the various places around the world where they have been preaching, to arrive simultaneously outside the door of the house. Interestingly, St Paul is included along with the original twelve. John tells the others what is happening. They go inside to greet and converse with the Virgin. 'About the third hour of the night', Jesus comes, accompanied by a host of angels, prophets, martyrs, and confessors, together with choirs of virgins. Mary dies as the apostles pray and sing psalms.

Jesus, along with his host of companions, then carries Mary's soul to heaven. But first he tells the apostles to carry her body to the valley of Josaphat, where there is a new sepulchre to receive it. He will come himself in three days. The Virgin's body is immediately surrounded by red roses, 'signifying the army of the martyrs', and lilies of the valley 'signifying the hosts of angels, confessors and virgins'. The apostles do as they are instructed. John leads the way, bearing the palm given by the angel, while Peter and Paul carry the bier. They all stand guard over the tomb until, after three days, Christ comes in glory with angels to assume his mother's body into heaven.

One variant of the story says that St Thomas, who was present at the burial, was absent at the assumption. He refused to believe what the other apostles told him and demanded that the tomb be reopened. When the tomb was opened, there was no body inside, just the shroud and burial garments. As Thomas looked at these, still not wholly convinced, the Virgin Mary appeared above, called to him and threw down the girdle binding her robe. He caught it, and was finally convinced by this material evidence. A still further variation says that when the tomb was reopened, it was found to be filled with roses, as Francesco Botticini shows it (*see page 174*). *The Golden Legend* does not say that the Virgin's girdle was dropped down by Mary herself, simply that it 'fell'; nor does it give the version of the reopened tomb being filled with roses, although, as we have seen, it does refer to roses and lilies of the valley in an earlier part of the myth.

Botticini's painting was produced as the altarpiece for a side chapel in the church of San Pier Maggiore in Florence, the main altarpiece of which, by Jacopo di Cione, we have already seen (*see pages 125, 141, and 143*). Botticini shows us two distinct scenes. In the upper section, in a tableau reminiscent of several versions of the Coronation of the Virgin, Christ receives his holy mother in the heavenly kingdom, blessing her as she kneels in adoration before him. Christ holds an open book. The page on the left as we look at

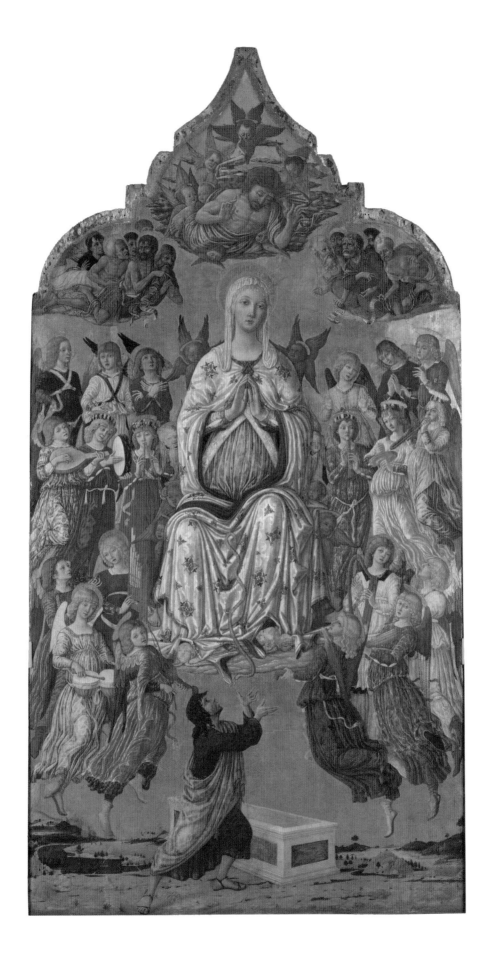

Francesco Botticini, *The Assumption of the Virgin*, probably *c.* 1475–6, tempera on wood, 228.6 × 377.2 cm, National Gallery, London

it contains an A. This is almost certainly intended as the Greek capital alpha, as the other page contains what is probably intended as the Greek theta. That letter has the oval form and horizontal crosspiece as shown here, though here a vertical downstroke has been added to make a cross. Because of the perspective that Botticini gives us, Christ's halo is actually a sideways version of this character, while both of these forms echo the oval shape of heaven.

Although the first and last letters of the Greek alphabet, alpha and omega, are commonly seen in Christian imagery, because Christ said of himself, 'I am the alpha and omega, the first and the last', alpha and theta are a very unusual combination, The most obvious possible meaning for the theta would be *theos*, 'God', or *theou*, 'of God'. It is also very likely that the inserted vertical is intended as a capital iota, the first letter of the name Jesus in Greek

capitals. This letter appears very commonly in Christian imagery in the monogram IHS, the first three letters of the name Jesus in Greek. Another common Christian monogram combines the first two letters of the name Christ in Greek – the Chi Rho symbol (☧) – so there is a precedent for such a combination. Given the clarity with which the characters are formed, they are obviously intended to have significance. It is, however, difficult to see what word beginning with alpha would work in conjunction with either theta alone, or theta iota, in this context.

The central figures of Jesus and Mary are surrounded by three bands, each consisting of three of the nine orders of angels. Two references to these occur in the discussion of the Assumption in *The Golden Legend*. The first consists of a quotation from the eleventh-century bishop and martyr St Gerard, who tells us that: 'The heavens welcomed the

Blessed Virgin joyfully: Angels rejoicing, Archangels jubilating, Virtues honouring, Thrones exalting, Dominations psalming, Principalities harmonising, Powers playing their lyres, Cherubim and Seraphim hymning and leading her to the supernal tribunal of the divine majesty.' Unusually, and in most cases anachronistically, various saints have been intermingled with the angels in the lower two bands. When one is close to the painting, it is possible to recognize many of these individuals from their attributes. One who predeceased Mary was King David. He can be found quite centrally in the lowest of the three ranks of the middle band, directly below the Virgin herself. He wears a deep-pink outer garment and clasps his harp to his blue-robed chest. However, others are more easily recognizable when they hold attributes that can be seen in the space above the ranks. So, two places to our right of David, but in the back row, we see St Philip with his cross. He is separated by an angel from the next saint to the right, St Bartholomew holding the knife with which he was flayed, while another angel comes between him and St James the Less, who holds the means of his death, a club. We can also recognize his companion as St Jerome by his cardinal's red hat and cloak.

For the lower section of the painting, Botticini offers a completely different viewpoint and perspective. Here the twelve apostles stand on a mound next to the rose-filled tomb, deep in conversation about the miraculous events they have just witnessed. At a distance, on either side, kneel the 'donor figures', the Florentine official Matteo Palmieri and his wife, who had commissioned the painting. The landscape behind Matteo is apparently based on his family estates in Tuscany. We are also given here a distant view of the (then walled) city of Florence. We can, in fact, just make out the shape and colour of Brunelleschi's wonderful cathedral dome. The landscape behind Palmieri's wife resembles the lands that she brought with her as a dowry. Palmieri held slightly heretical views regarding the origin of humankind as angels who were neutral at the time of Lucifer's rebellion and fall. The way in which both future saints and Old Testament figures are intermingled with the six lower orders of angels has been interpreted as a deliberate attempt to express that view.

Matteo di Giovanni's painting was originally the central panel of a triptych altarpiece, of which the two outer wings still remain in their original home of Ascanio, just outside Siena. In telling the story of 'Doubting Thomas' and Mary's girdle, Matteo produces a slightly uneasy relationship between the very iconic presentation of the impassive, praying Virgin borne by angels and the narrative element of St Thomas concentrating on catching her girdle beside her tomb on the ground. There is a marked similarity between this marble-panelled tomb and the one that Botticini painted probably a year later. There are also similarities in their landscape backgrounds, each with a river winding across it. However, the contrasts between the two paintings are much greater than the similarities.

Matteo di Giovanni, *The Assumption of the Virgin* (detail), probably 1474, tempera and gold on wood, 331.5 × 174 cm, National Gallery, London

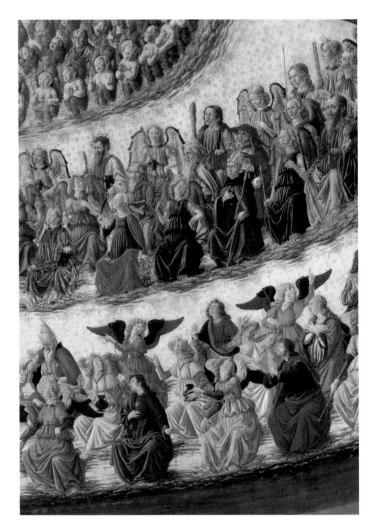

Francesco Botticini, *The Assumption of the Virgin* (detail), probably *c.* 1475–6, tempera on wood, 228.6 × 377.2 cm, National Gallery, London

Of particular note is the contrast between Matteo's and Botticini's representation of the human inhabitants of heaven. Among Botticini's serried ranks, we can quickly spot a papal tiara, several bishops' mitres, at least two monastic habits, and several female saints. Matteo di Giovanni limits himself to ten male figures, who look down from above on either side. All but one are Old Testament figures, three of whom hold the scrolls of their writings. The one New Testament figure is John the Baptist, identifiable at the front in the left-hand group by his, here quite abbreviated, camel-hair garment. Although John the Baptist appears frequently in religious paintings alongside other individual Christian saints, in massed representations of saints he is often included with the Old Testament figures, both because he was regarded as the last of the line of prophets, and because he died before Christ (and also, therefore, before Mary). Matteo here keeps all these human figures separate from both the angels who bear the Virgin and those who accompany the observing Christ in the top central section. And whereas Botticini gives Mary the blue robe that was, because of the preciousness of blue pigment made from lapis lazuli, traditional for paintings of the Virgin in her earthly life, Matteo di Giovanni clothes her in white and gold, which is rather more common in representations of the heavenly Mary of Assumption and Coronation paintings.

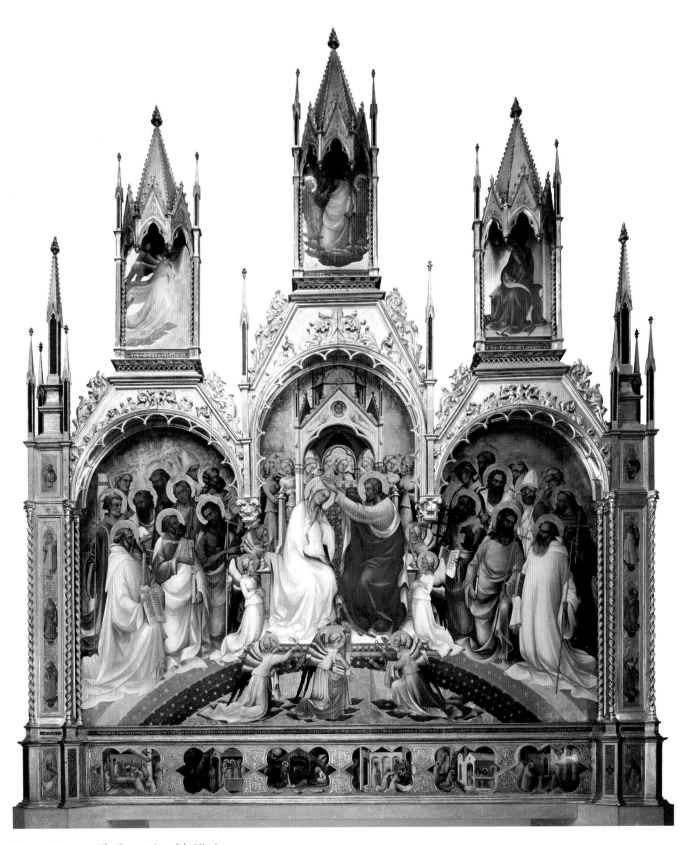

Lorenzo Monaco, *The Coronation of the Virgin*, 1414, tempera on
panel, 506 × 447.5 cm, Galleria degli Uffizi, Florence

Ambrogio Bergognone
The Virgin and Child
c. 1488–90
Oil on poplar, 55.2 × 35.6 cm

Milanese painter Ambrogio Bergognone (1453–1523) painted his *The Virgin and Child* for the great Carthusian monastery the Certosa di Pavia in northern Italy. The claim by some commentators that the right-hand background scene of Bergognone's picture shows the construction of the Certosa is not quite precise. There is no actual sign of building work, and the Certosa was largely finished by 1490, although one can see that the marble facing of the church facade is not yet complete. It will be noted that, in addition to the prominent rosary beads, the painting has the opening four and a half words of the prayer to the Virgin Mary, the Hail Mary (*Ave Maria* in Latin), on the Madonna's halo.

The panel has a rather special interest to both the history of the rosary and the history of Western European painting. From the late fifteenth century to the early twenty-first, the devotion of the rosary remained virtually unchanged. It involved reciting the Hail Mary one hundred and fifty times while meditating on fifteen episodes, principally from the life of Christ. Those episodes were divided into three groups of five, referred to respectively as the Joyful, Sorrowful, and Glorious Mysteries. The Joyful Mysteries comprised the Annunciation, the Visitation, the Nativity, the Presentation, and the Finding of the Child Jesus in the Temple; the Sorrowful Mysteries were the Agony in the Garden, the Scourging at the Pillar, the Crowning with Thorns, the Carrying of the Cross, and the Crucifixion; and the Glorious Mysteries consisted of the Resurrection, the Ascension, the Descent of the Holy Spirit on the Apostles, the Assumption, and the Coronation of the Virgin in Heaven. In 2002, Pope John Paul II introduced five new 'Luminous Mysteries'.

The rosary as a rite developed in stages. From very early Christian times until well into the Middle Ages, a common devotion, particularly among religious orders, was the recitation of the Old Testament's one hundred and fifty psalms. In the eleventh century, it became common for lay brothers in the orders to recite the *Pater Noster* ('Our Father') one hundred and fifty times as a less-demanding alternative, and to use a string of beads on which to count these in tens and fifties. This practice gradually extended among the general populace and the use of such beads, known as 'paternosters', became so widespread that their manufacture was an established industry in parts of major cities, such as Paternoster Row in London. During the twelfth century, as devotion to Mary increased, the habit grew of saying the Hail Mary in Latin the same number of times as a *Psalterium Mariae*, also counted on a paternoster. The imaginative idea took hold that, in reciting the prayer over and over, one was weaving a spiritual crown or garland of roses (*rosarium*) for the Virgin. In some countries, a set of rosary beads is still called a *corona* (crown).

The Hail Mary itself had also developed over time. From the early Christian period, Gabriel's salutation at the Annunciation ('Hail [Mary], full of grace, the Lord is with thee') was used liturgically as a prayer. It was common throughout Europe as an independent prayer by the twelfth century, when was added the second part of Elizabeth's salutation at the Visitation: 'blessed is the fruit of thy womb'. During the fourteenth century, the name 'Jesus' was also added, giving us the first half of the prayer as it is used today. The concluding part of the prayer took its final form in the sixteenth century.

However, two major developments in the rosary occurred in the fifteenth century. In 1415, a Carthusian monk, Dominic of Prussia, based at Trèves (Trier), composed fifty 'Jesus clauses', all beginning *who* or *whom*, and designed to follow the then final word of the Hail Mary, which was 'Jesus'. So, for example, the first 'clause' followed 'blessed is the fruit of thy womb, Jesus,' with 'whom you conceived by the Holy Spirit upon the Angel's annunciation. Amen.'

179

Carlo Crivelli, *Saint Dominic*, 1472, tempera on wood, gold ground, 97.2 × 32.4 cm, Metropolitan Museum of Art, New York

The twenty-third was, 'who went into a garden with his disciples and, praying there at length, sweated drops of blood'. There may have been isolated previous instances where meditation on the life of Christ was associated with the *Psalterium Mariae* / rosary, but it was the circulation of the fifty 'Jesus clauses' of Dominic of Prussia that made such meditation widespread throughout Europe by 1450.

The second major development came about in 1465, when a slightly odd character, the Dominican Alain de la Roche (possibly through genuinely confusing the Carthusian Dominic of Prussia with St Dominic founder of his own order), was responsible for the myth that St Dominic had introduced the devotion of the rosary on the instruction of the Virgin Mary seen in a vision. Alain de la Roche then set about establishing rosary confraternities, the first in France in about 1468. These spread rapidly throughout Europe, and helped the gradual standardization of the subjects for meditation as the 'joyful, sorrowful and glorious mysteries' of today. One of the earliest confraternities in Italy was founded in 1480 in Venice.

Bergognone was heavily involved with work for the Carthusians, producing both easel paintings and frescoes for the Certosa di Pavia from 1488 to 1491. It is then probable that our present painting was part of an attempt by the Carthusians, seen in their white habits in the background of the picture, to re-establish the major link of their order with the swiftly growing devotion of the rosary, in the face of a determined Dominican takeover. One also notes that the open book on the parapet contains well-known passages in Latin from Psalms 51 and 70 (50 and 69 in the Vulgate). The Carthusian commissioners of Bergognone's painting may have wished to remind viewers not only of their order's links to the rosary, but also of the origins of the *Psalterium Mariae*.

Their struggle was, however, destined to be lost. Prior to the establishment of the rosary fraternities by Alain de la

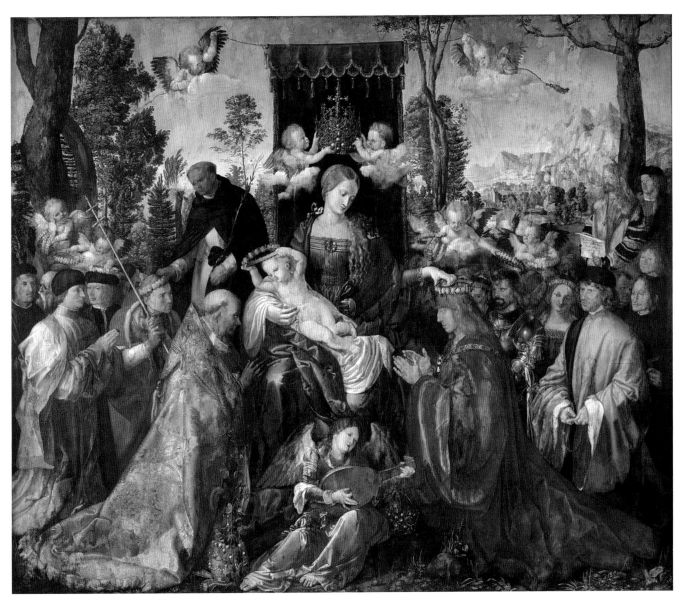

Albrecht Dürer, *Feast of the Rosary*, 1506, oil on panel,
162 × 194.5 cm, National Gallery, Prague

Roche, none of the many paintings of St Dominic associated
him with the rosary. There is, for example, still no sign
of it in Carlo Crivelli's 1472 painting of the saint in the
Metropolitan Museum, New York. However, in 1506 the
German painter and printmaker Albrecht Dürer produced
for the German merchants in Venice his *Feast of the Rosary* to
celebrate the feast of Our Lady of the Rosary. The painting
(now in Prague) shows St Dominic helping the Virgin Mary
distribute crowns of roses to notables including Pope Julius
II, the German emperor Frederick III, and the Patriarch of
Venice. Over the next two hundred years, hosts of paintings

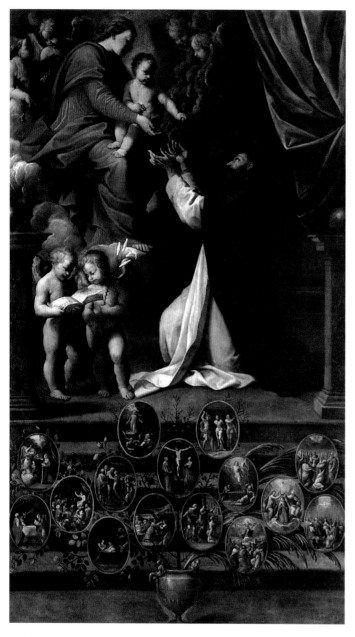

Guido Reni, *Rosary Madonna*, 1598, oil on canvas,
260 × 220 cm, Sanctuary of San Luca, Bologna

appeared throughout Europe showing Mary handing
a rosary to St Dominic. Of the best-known examples, one
is by Guido Reni from 1596 in San Luca, Bologna; another,
dated 1679–88, is the version by the Spaniard painter
Acisclo Antonio Palomino, currently in Seattle.

Although Bergognone's painting reminds us of the
historical background, it was almost certainly intended both
to encourage the saying of the rosary and to provide an image
in front of which the devout with their beads in the Certosa
could be helped in their meditations. Giovanni Bellini's
Agony in the Garden, dated as 'around 1465' (*see page 102*),
has been described as 'an example of a new kind of devotional
painting'. That leads one to ask: 'What produced the need
for such a kind of small-scale religious painting in the middle
of the fifteenth century?' A very probable answer to that
question would be: 'Almost certainly the growth of the
devotion of the rosary around this time'. Although Bellini's
Agony was probably painted before the establishment of his
local rosary confraternity in 1480, it was certainly painted
at a time when the recitation of the rosary, and the associated
meditation on key episodes from the life of Christ, including
the Agony, was very common among all types of people
in Italy. It would, therefore, be natural, when meditation
on the relevant episodes in the life of Jesus had become
such a normal part of the devotional life of many Christians,
that the relevant images were mentally present to both
the artists and the commissioners of painting in a much more
immediate way than they had been prior to that time.

In fact, one sees a very marked increase in the
proportion of religious images that relate to the episodes
of either the mysteries of the rosary or the, only slightly more
extensive, 'Jesus clauses' in the period after 1440 compared
with those before 1440. This is true both for the large church
altarpieces and the smaller-scale works such as that by
Bellini, which were painted for family chapels, religious and

professional guilds and fraternities, and the private homes of wealthier citizens. The growth of the actual rosary fraternities must certainly have had a major effect. While many of the older fraternities crossed social boundaries, a good number did not, and almost none were open to women. The very rapid creation and expansion of fraternities that welcomed all members of the populace, including women, must have had an enormous impact on the demand for relevant small devotional images, for the chapels and rooms in which they met.

One of the most interesting increases in small-scale religious paintings in general is that of simple iconic pictures of the Virgin and Child, such as this one by Bergognone. Although the basic image is very ancient, such a very marked emphasis on it surely requires some explanation. The image does not, after all, relate to any particular episode in the gospels. But if one wishes, while meditating on Christ's life, to hail Mary and to bless the fruit of her womb who is with her, then paintings such as this by Bergognone are indeed very relevant.

However, aside from all historical or polemical considerations, Bergognone's painting performs its true devotional purpose. Christians hail Mary because she is the mother of Jesus, who died for humankind on the cross. Not only does Bergognone emphasize the mother-and-child relationship by the compositional unity of the two figures, and the binding quality of the flesh tones, but he positions

both within his pictorial scheme at the centre of a dark cross. Moreover, on the beads, which appropriately also unite Mary and Jesus, both of whom hold them, the prayer decades are not divided by the customary insertion of a larger bead but by small gold crosses. Three of these are clearly visible: one close to the child's left hand and one on each thigh. If one assumes that Bergognone is being precise in his depiction of the rosary, then the unseen cross that ends the decade begun by the cross near Jesus' left hand must be in the grasp of the finger and thumb of his right hand, being held up behind the first bead of the next decade. Although this actual holding of the cross would make good symbolic sense, it may be that we need to allow for either a lack of uniformity in fifteenth-century rosaries or a little artistic freedom on Bergognone's part. Nevertheless, the emphasis on the cross is clear and is reinforced by the shape of the central gold binding of Mary's blue robe.

What Bergognone offers us, therefore, is a painting that fuses the history of the rosary with its form and content, encouraging the faithful to recite on their beads the prayer on Mary's halo, while thinking of the redemptive sacrifice of her son on the cross, and the words of the Psalmist in the open Psalter: '*Domine labia m[ea] aperies et os meum annuntiabit laudem tuam*' ('You, Lord will open my lips and my mouth shall declare your praise'); and '*Deus in adjutorium meum intende Domine ad adiuvandum me festina*' ('Oh God, come to my aid! Oh Lord, make haste to help me!').

Fra Angelico
Christ Glorified in the Court of Heaven
1423–4
Egg tempera on wood, 33 × 251 cm

The final feast day in our liturgical calendar, All Saints' Day is dedicated to the honour of the saints, both known and unknown. Its celebration stems from a belief that there is a strong spiritual bond between the present-day Christians on Earth, the 'Church Militant', and all the dead who are united forever with Christ in the divine presence, the 'Church Triumphant'. The tradition dates back to at least the beginning of the eighth century, but the holy day was not established until Pope Gregory IV formalized the Feast of All Saints in AD 837 and ordered its general observance. It is celebrated on 1 November by Anglicans, Roman Catholics, Methodists, Lutherans, and members of some other Protestant churches. It should not be confused with All Souls' Day, which is observed on 2 November and is dedicated to the faithful who have died but have not yet reached heaven.

The subject of All Saints is not often treated in its own right in a painting. An image of massed saints most often forms an element of pictures of *The Coronation of the Virgin*, such as the one by Lorenzo Monaco in the Uffizi in Florence (*see page 177*), or that by the saintly Dominican, Fra Angelico, in the Musée du Louvre in Paris. It is, however, another work by the latter artist that is probably one of the nearest images we can get to a representation of All Saints. The title usually given to that painting, in the National Gallery in London, is *Christ Glorified in the Court of Heaven*, although, as so often with older paintings, the title is not one provided by the artist himself. Also, as we have seen, it is quite common to find that an early religious painting, hung in a gallery as if it were an individual picture in its own right, is in fact one part of a much larger work. A clue that this is the case here lies in its very long, narrow format. This painting, which is in five sections, was originally produced for the predella of an altarpiece in the church of San Domenico in Fiesole, just outside Florence. The main image of that altarpiece was also by Fra Angelico, though later modified by Lorenzo di Credi. It showed the Virgin and Child with four saints: St Dominic himself with two other great Dominicans, St Thomas Aquinas and St Peter Martyr, along with St Barnabas, to whom the church was originally dedicated. This painting is still in the church in Fiesole. Although we tend to associate Fra Angelico with the Convent of San Marco in Florence, where many of his most famous frescos are located, San Domenico in Fiesole was actually his own friary.

The format of our present painting makes it difficult to reproduce in a way that does it justice. We can, however, see that the central section of the work shows Christ in glory surrounded by angel musicians, singing and playing on various instruments. The two outermost panels (*see page 189*) have representations of those members of the Dominican orders, both male and female, who had been declared 'blessed'. The other two panels shown opposite, which come on either side of the central image, show ranks of saints looking inwards towards that central image of Christ.

The casual viewer, giving the picture little more than a cursory glance in passing, might be aware of some hundred or so haloed figures. They might also be instinctively impressed by the harmony of form and colour of the serried ranks against the gold background without looking further. However, anyone affording the figures a few moments of attention would quickly become aware of the individuality of each one of them. And a Christian with only a slight knowledge of the saints would realize how many individuals could be almost immediately identified. Traditionally, special symbols or 'attributes' were carried by particular groups of saints. So, for example, martyrs were often shown carrying a palm frond, while virgins and celibate clergy carried a lily. The apostles, evangelists, and writers of epistles would often hold a book, as would the founders of religious orders who

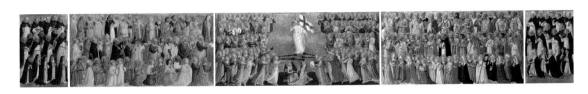

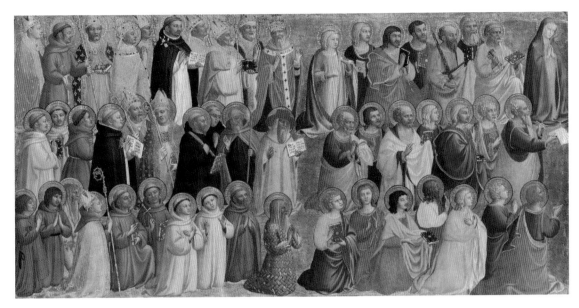

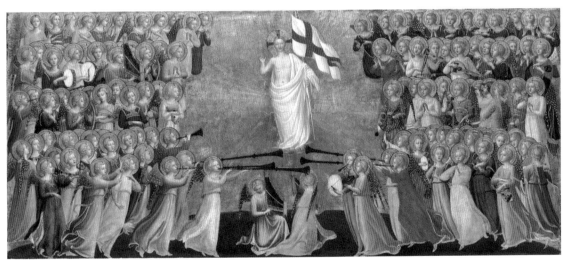

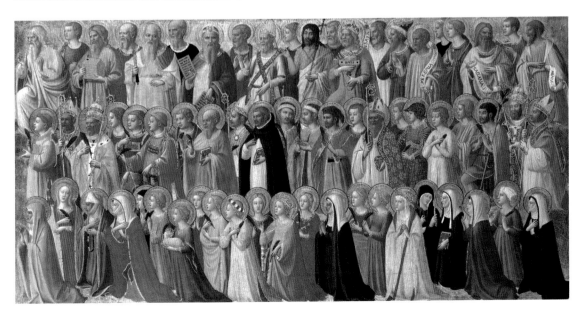

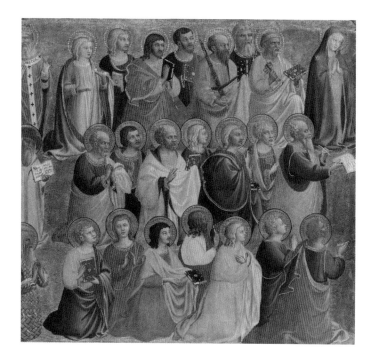

had supplied a rule for their followers. However, many individual saints also had their own particular attributes by which they could be recognized. Furthermore, as we saw in the case of saints Peter and Paul (*see page 162*), a tradition would also develop regarding the physical appearance of the most frequently represented saints.

Here the first large panel on Christ's right (our left as we look at it), has the Virgin Mary as the first figure in the back row with, immediately behind her, St Peter holding the book of his epistles as well as his traditional attribute of the keys. Next but one behind St Peter is St Paul, also holding his book of epistles together with the sword of his execution. The four figures who surround St Paul are usually taken as the four evangelists. However, since it seems here that, as often, all the apostles have been given a book to hold, a good case can be made that it is St Andrew who comes between Peter and Paul. If so, it would be most likely that St John the Evangelist is the saint at the head of the second row who holds out a copy of the Apocalypse, which he wrote as an old man. He would be appropriately placed in proximity to both his close associate St Peter and to the Virgin Mary, whom Christ on the cross committed to his care. Then the other three evangelists would be the three figures who also hold a quill pen behind and below St John. In this panel, Fra Angelico seems to have deliberately left a small gap

in each row, with seven male saints on the right of it and ten on the left. Those on the right seem to include the twelve apostles, along with the two evangelists who were not apostles, and other New Testament figures. It would, however, be difficult, in the absence of attributes, to identify all of these with certainty.

We can speak with more assurance about many of the saints on the left of the division. In the fifth place beyond that division in the top row, and made prominent by being provided with more space than most other figures, we have St Dominic, founder of the Dominicans, who also features in the main panel of the altarpiece. He holds both the lily of the celibate and an open book. The latter attribute refers to the rule that he established for his order. However, the Latin text that is legible in the painting is Verse 30 of Psalm 36 (in some versions 37). This reads: *Os iust[i]*

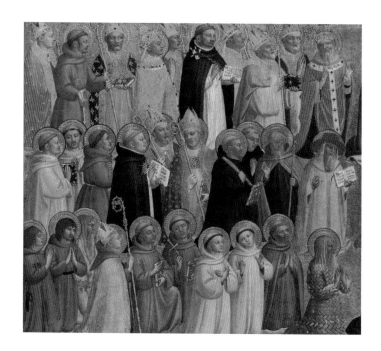

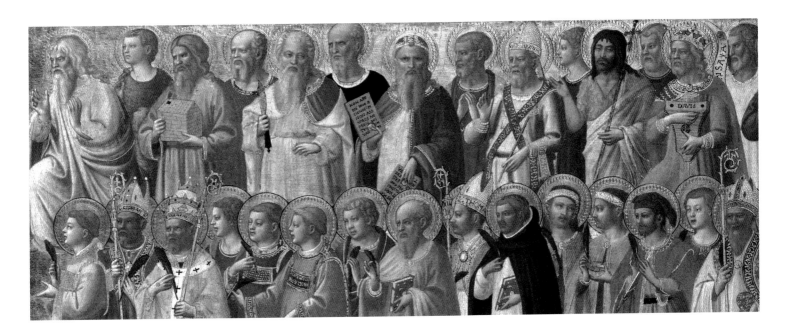

meditabit[ur] sapientia[m] et lingua ei[us] loquet[ur] [iudicium] – 'the mouth of the just man shall meditate wisdom and his tongue speak judgment'.

Both Dominican and Franciscan paintings naturally tended to glorify the members of their own orders, but they frequently showed great respect towards the other order's founder too. So here, only a few places behind St Dominic, is St Francis of Assisi. He is easily identified by his brown Franciscan habit and the visible evidence of the stigmata, seen most clearly in his side and left hand. Many of the saints represented can be identified in this way by their traditional dress or attributes. Fra Angelico, where he does not include such attributes, sometimes helps us by providing written names, as with St Sylvester, given the most prominent position in the group of popes and bishops in this top row by the extra space that the division affords.

Just below, in the second row of this section, the corresponding prominent position belongs to the great doctor of the Church and author of the Latin translation of the Bible, St Jerome. He wears his traditional (if unhistorical) cardinal's red hat and holds that famous Vulgate translation. We might not immediately identify the figure also quite prominently placed just in front of St Jerome in the blue robe and pink cloak. Those able to see the whole painting in its original setting would, however, have recognized that he is one of the four saints also on the main panel, St Barnabas, the original patron of the church for which the altarpiece was created. He is on the right of the dividing gap as, like St Paul, he features in the New Testament in the Acts of the Apostles. Six places behind Jerome, another figure from the main panel, St Thomas Aquinas, in his Dominican habit, holds open his great work, the *Summa Theologica*. In the third and lowest row, immediately recognizable beneath St Jerome, is St Paul the Hermit in his garment woven from leaves. Behind him are mainly saints from the various religious orders.

The back row of the panel to Christ's left is occupied by the Old Testament patriarchs and prophets led by Adam, whose young son Abel comes just behind him, followed by Noah holding the ark. Particularly prominent positions in this row are given to Moses and David. The former is one-third of the way along in blue robes. He holds the tables of the Ten Commandments, one in each hand and written in legible Latin. Six places further on, David is given his name, although he is also recognizable by his harp, which is of a slightly different design from the one that he clasps in Francesco Botticini's *Assumption* (*see page 177*). Just in front of David, St John the Baptist, instantly known by his hair shirt and long-handled cross, is included here in his capacity (as in Botticini's *Assumption*) as the last of the great line of prophets preparing for the Messiah, rather than being placed, as in some other cases, with figures from the New Testament.

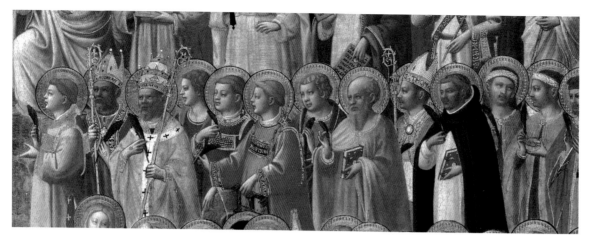

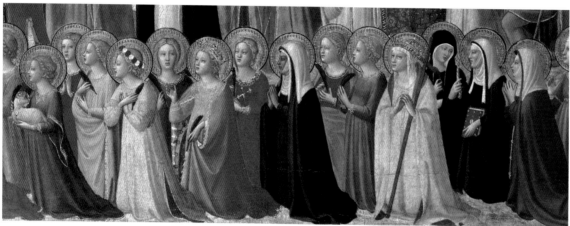

The saints of the second row on this side all hold the traditional martyr's attribute of a palm branch. These are led by St Stephen, the first Christian martyr. We recognize him by his traditional green deacon's vestment, known as a dalmatic, and the wound on his head from his stoning. Immediately behind him, and again identified by name, are the martyred popes Cyprian and Clement. In second and third places after Clement, we have two more famous deacons, St Vincent in blue with his millstone and St Lawrence in red. He rests his hand on the gridiron on which he was roasted to death. Four places further, another prominent position is occupied by St Peter Martyr, who, as we saw, also features in the main altarpiece. We can identify him by his Dominican habit, martyr's palm, and wound to his head. This does not have, as in many less subtle representations, the weapon still embedded in it. The bishop immediately in front of St Peter Martyr is St Thomas of Canterbury, identified by the name on his

mitre, while behind St Peter Martyr, identical twins hold a box of ointment – the doctor twins, Cosmas and Damian.

The third row on this side has female saints. Although many of these carry the martyr's palm, only a minority carry specific attributes, so identification here is somewhat problematic. Probably the most easily recognized is St Agnes. Her name is actually derived from the Greek for *chaste*, but because of its similarity to the Latin for a lamb (*agnus*), that is her traditional attribute. Three places behind her is St Cecilia, not with the musical instrument she often holds, but known by her other attribute: a coronet of red and white roses. Two places behind her, and in a red robe, comes St Catherine, with arguably the most famous of all saints' attributes, the wheel associated with her martyrdom. Further to the right is St Helena. She is credited with rediscovering the True Cross on which Jesus was crucified, so holds a cross as her main attribute, though she also wears a royal crown as the mother of the Emperor Constantine. Next but

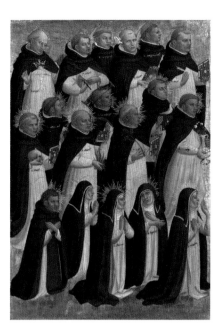 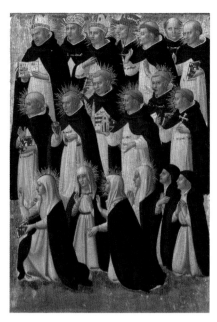

one behind Helena, the saint in the black habit and white headdress, holding a book, is almost certainly intended to be St Scholastica. She was the sister of St Benedict and founded the female branch of the Benedictine order. Although she clasps the book, it is thought that she and her nuns simply followed the rules established by her brother. Behind her in the brown habit is St Clare. She was founder of the female branch of the Franciscans, which is named after her, the Poor Clares. Her attribute here is the staff of an abbess. This has a palm on the top, not because she was a martyr, but because she took her vows on Palm Sunday.

On the two small outer panels of the work are those Dominicans declared 'blessed'. Many of these carry their attributes and most are identified by name in cursive script. We might mention here that it is thought probable that the writing provided on all four of the outer panels here was undertaken by Fra Angelico's brother, Benedetto, a fellow Dominican and a skilful scribe.

It is particularly appropriate that this should be the final image in this book. Fra Angelico, who was renowned during his life for his holiness, was actually beatified (declared 'blessed') by Pope John Paul II in 1982, so could now take his own place alongside those other Dominicans.

In 1984, Pope John Paul II also made him the patron of painters, so he could also stand as a worthy representative of all the great artists that we have been studying.

Although Fra Angelico has gone out of his way to identify individual saints for us, the main altar for which this work was created was separated from the nave of the church by the choir area, to which only the friars themselves had access. The effect of the image when seen at the normal distance of the congregation from the altar would, therefore, be not of separate individuals, but rather, and more appropriately, that of a mass of the faithful united in giving glory to the risen Christ. The image would have its strongest liturgical impact when the faithful were the closest they would ever come to it, kneeling at the altar rails to receive Holy Communion. Then indeed, gazing on the heavenly ranks in front of them, with whom they were united in the wonderful 'communion of saints', they would be conscious of joining with them in glorifying through the mass the crucified and risen son of God, Jesus Christ. They would also be aware on All Saints' Day of the rapid approach of Advent, when the great cycle of the liturgical year would start again. Fra Angelico does indeed give us, in more than one sense, a glorious end to our journey through the Christian year.

 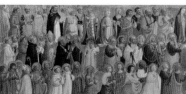 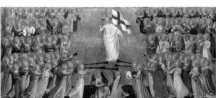 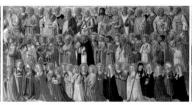

INDEX

Numerals in **bold** refer to main entries and page ranges;
numerals in *italics* refer to illustrations

For Margaret Mary Aloise, with all my love

ACKNOWLEDGMENTS

In 2006 Kevin Flaherty, editor of the *Catholic Times*, invited me to write for that paper a series of articles on religious paintings, following the liturgical calendar. Many of the commentaries in this book have grown out of those articles. I should like to thank Kevin for his original faith in me, and for all his continuing support.

I should like to express thanks also to Rachel Giles, Jan Green, and Claire Young of the National Gallery, London, for constructive comments on an early draft of this work, and to all the members of the National Gallery Press Office for their unfailing courtesy and willing assistance over many years.

I have received words of advice and encouragement from many individuals in the course of preparing the book, but a special expression of gratitude is due to the late Bernardine Bishop, Bill Chambers, John McEwen, Joyce Simpson, and Jeremy Davies.

I am particularly grateful to Dr Polly King of Crantock, many of whose suggestions have influenced the final text.

For the overall layout of the book, the choice of many of the subsidiary paintings, and the careful revision of the final text I must express the deepest gratitude to Andrew Brown of Art / Books. His professionalism, expertise, and patience have served to produce a work of beauty.

Finally I must pay tribute to my wife Margaret, without whose constant support and advice the book would never have been written. She is always my wisest, most honest, and most constructive critic and her help and encouragement over the years have been invaluable.

First published in the United Kingdom in 2018 by
Art Books Publishing Ltd

Copyright © 2018 Art Books Publishing Ltd
Text copyright © 2018 John Dixon

Art Books Publishing Ltd
18 Shacklewell Lane
London E8 2EZ
Tel: +44 (0)20 8533 5835
info@artbookspublishing.co.uk
www.artbookspublishing.co.uk

British Library Cataloguing-in-Publication Data
A catalogue record for this book is available from
the British Library

ISBN 978-1-908970-34-3

Design and repro by Art / Books

Printed and bound in Latvia by Livonia

Distributed outside North America by
Thames & Hudson
181a High Holborn
London WC1V 7QX
United Kingdom
Tel: +44 (0)20 7845 5000
Fax: +44 (0)20 7845 5055
sales@thameshudson.co.uk

Available in North America through
ARTBOOK | D.A.P.
75 Broad Street, Suite 630
New York, N.Y. 10004
www.artbook.com